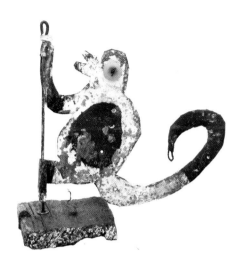

Black Folk Art in America
1930-1980

Supported by grants from Atlantic Richfield Foundation and
the National Endowment for the Arts, Washington, DC, a federal agency.

Black Folk Art in America
1930-1980

By Jane Livingston and John Beardsley

With a Contribution by Regenia Perry

Published for the
CORCORAN GALLERY OF ART
by the
UNIVERSITY PRESS OF MISSISSIPPI, JACKSON
and the
CENTER FOR THE STUDY OF SOUTHERN CULTURE

ITINERARY OF THE EXHIBITION

CORCORAN GALLERY OF ART, Washington, D. C.
January 15–March 28, 1982

J. B. SPEED MUSEUM, Louisville, Kentucky
April 26–June 13, 1982

THE BROOKLYN MUSEUM, Brooklyn, New York
July 4–September 12, 1982

CRAFT AND FOLK ART MUSEUM, Los Angeles, California
November 30, 1982–February 3, 1983

THE INSTITUTE FOR THE ARTS, Rice University, Houston, Texas
March 4–May 15, 1983

cover:
Bill Traylor, *Serpent*, 1939–42. Pencil, cray-
on and gouache on paper, 11¾ x 10″. Charles
Shannon, Montgomery, Alabama. Cat. no.
319.

page 1:
David Butler, *Monkey Climbing Pole*, c.
1975. Painted tin, wood and button, 8½ x
10″. William Fagaly, New Orleans. Cat. no.
45.

Contents

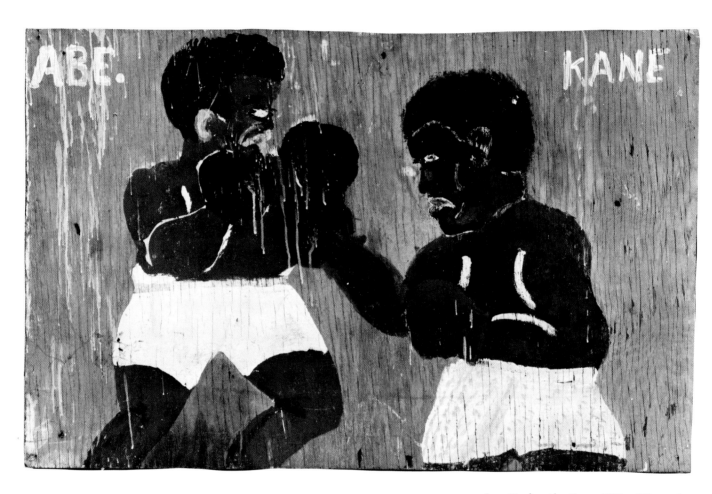

Sam Doyle, *Abe Kane*, 1970s. Oil on ply-
wood, 30⅛ × 48″. Leo and Dorothy Rabkin,
New York. Cat. no. 90.

Foreword

It is rare for an individual or an institution to discover something truly important and previously unknown. I believe this exhibition does just that. It defines a body of fine art created by black Americans in the twentieth century, a phenomenon which is not even mentioned in most histories of American culture.

This art will probably disturb many viewers because it is so different from what we usually find in art museum collections. There are few visual conventions, the incongruities are rampant, and the rules of art history do not help us understand what we are looking at. Without a scholarly primer and a seal-of-art-history approval, black folk art could easily remain unnoticed by the broad American public, except for the fact that the best of this art is an important contribution to American culture.

The entire project required enormous amounts of research and travel by Associate Director Jane Livingston and Curator John Beardsley. They received valuable assistance from numerous sources as they tracked down one artist after another throughout the south and mid-west. Their watchword was quality. The nearly 400 objects that comprise this show represent only a fraction of the work they saw.

Because the artists were untrained in the art-academy sense, they were seldom known by other artists. Because they were often not handled by art dealers, they were not known by curators or the art-buying public. Their art graced their homes and yards and work spaces, almost never traveling beyond its place of creation. When outsiders did see it, either by chance or curiosity, they seldom saw it for what it was. To discover it meant to see it as a significant artistic expression.

What Livingston and Beardsley began to conceptualize was a group or "school" of artists each working in isolation from the other, guided by instinct and raw talent, and creating a unique American esthetic. As the following essays by Regenia Perry, Jane Livingston, and John Beardsley indicate, this art evolved from many sources. Forms from Africa, American popular arts, photojournalism, advertising, voodoo, and the landscape itself blend with the oral traditions of black culture: rural legends, popular history, Biblical stories, and revivalism. Each artist in his or her own way has constructed an art-world unlike anything else we know. This inventive capacity to create vital new forms—forms that seem to breathe—is what makes these objects art.

PETER C. MARZIO

7

Acknowledgments

This exhibition came together through an extraordinary process of word-of-mouth information-gathering; without an elaborate, if informal, network of people willing to share their knowledge and enthusiasm with us, the unearthing of twenty artists working in a single spirit, to say nothing of locating their works of art, could never have occurred. We were impressed from the onset of our search with the seemingly unending cooperativeness of many individuals and organizations whom we contacted in the task of tracking down both the objects and their makers. Dealers, private collectors, curators and folklorists—all were unstinting in their help and advice.

Several individuals have been so supportive and so profoundly committed to the larger goal which this occasion serves that they are an integral part of our exhibition and book. Dr. Regenia Perry, Professor of African and Afro-American Art History, Virginia Commonwealth University, Richmond; William Ferris, Director of the Center for the Study of Southern Culture, Oxford, Mississippi; Herbert W. Hemphill, Jr., of New York; Michael and Julie Hall, Cranbrook Academy, Michigan; Phyllis Kind, of Chicago and New York; and Alex Castro, catalogue and exhibition designer, have all helped inestimably to make recent black folk art in America an event whose spirit and artifacts will be preserved and understood. Robert Bishop, Director of the Museum of Folk Art in New York, has also encouraged us unfailingly.

In the course of our research and travel, the following people provided generous assistance: Patti Black, Gregg Blasdel, Jeff Camp, Georganne Fletcher, Estelle Friedman, Dr. Gladys-Marie Fry, Elinor Horwitz, Worth Long, James Pierce, Judy Peiser, Judy Smith, Maude Wahlman and Elsa Weiner.

Many of these individual artists have had specially devoted friends, collectors or patrons, some of whom have been responsible for our knowing of them or gaining access to work. We are indebted to the following for their assistance with the respective artists listed here: for Jesse Aaron, Stuart Purser; Steve Ashby, Ken Fadeley; David Butler, William Fagaly; Ulysses Davis, Virginia Kiah; William Dawson, David Kargl; Sam Doyle, Mr. and Mrs. Leo Rabkin and John Trask; William Edmondson, Jym Knight; James Hampton, Lynda Hartigan; Sister Gertrude Morgan, Alan Jaffe; Leslie Payne, Patricia Olsen; Elijah Pierce, Jeff Wolf; Nellie Mae Rowe, Judith Alexander; Mose Tolliver, Mitchell Kahan; William Traylor, Charles Shannon; George White, Murray Smither; and George Williams, Roland Freeman.

The photographers Joel Breger and Melinda Blauvelt have made indispensable contributions to this catalogue, Joel in his dozens of consistently excellent photographs of individual objects, Melinda in her inimitably sensitive location shots of artists in their milieus.

It is difficult to single out members of the Corcoran Gallery staff and interns who have labored more diligently than others in various capacities to realize this complex project, but the following have been intensely involved: Lynn Berg, Pamela Lawson, Costanza Stein, Willow Johnson, Cathy Card Sterling, Toni LaMotte, Barbara Moore, Carolyn Campbell, Judith Riley, Einar Gomo, Tony Blazys, David Tozer and Richard Skinner. We thank them.

We wish particularly to mention the constant support and the welcome intervention in this long undertaking of the Corcoran Director, Dr. Peter Marzio. Peter has mysteriously comprehended the special difficulties and rewards implicit in this pathfinding endeavor, and has smoothed our way on many occasions, most importantly by securing the generous participation of the Atlantic Richfield Foundation.

Finally, we want to express our sincere gratitude to each of the lenders to this exhibition. As always, it is their generosity which makes the museum's efforts visible. They are ultimately the ones who protect and, by sharing, disseminate esthetic values.

JANE LIVINGSTON

JOHN BEARDSLEY

LENDERS TO THE EXHIBITION

WILLIAM ARNETT, Atlanta
JUDITH ALEXANDER, Atlanta
ALEXANDER GALLERY, Atlanta
AUSTIN PEAY STATE UNIVERSITY, Clarksville, Tennessee
ROBERT BISHOP, New York
JEAN and BILL BOOZIOTIS, Dallas
MR. and MRS. CHRISTOPHER BOTSFORD, New Orleans
ROGER BROWN, Chicago
LUCINDA BUNNEN, Atlanta
JEFFREY and C. JANE CAMP, American Folk Art Co., Tappahannock, Virginia
LAURA CARPENTER, Dallas
DONALD CAVANAUGH, Gainesville, Florida
CENTER FOR SOUTHERN FOLKLORE, Memphis
CENTER FOR THE STUDY OF SOUTHERN CULTURE, Oxford, Mississippi
COLUMBUS MUSEUM OF ART, Ohio
SUSANN E. CRAIG, Chicago
ULYSSES DAVIS, Savannah
DELAHUNTY GALLERY, Dallas
KEN and DONNA FADELEY, Birmingham, Michigan
WILLIAM FAGALY, New Orleans
JOHN WILEY FENDRICK, Chevy Chase, Maryland
FENDRICK GALLERY, Washington, D.C.
FIRST TENNESSEE BANKS, Memphis
JANET FLEISHER GALLERY, Philadelphia
ROLAND FREEMAN COLLECTION OF BLACK FOLK ART, Washington, D.C.
JOHN FREIMARCK, Mechanicsville, Virginia
LEE FRIEDLANDER, New City, New York
ESTELLE E. FRIEDMAN, Washington, D.C.
DR. GLADYS-MARIE FRY, College Park, Maryland
THE HALL COLLECTION OF AMERICAN FOLK AND ISOLATE ART, Bloomfield Hills, Michigan
HERBERT W. HEMPHILL, JR., New York
HIRSHHORN MUSEUM AND SCULPTURE GARDEN, Smithsonian Institution, Washington, D.C.
DR. AND MRS. THOMAS M. HOOTON, Atlanta
MR. AND MRS. ROGER HORCHOW, Dallas
ELINOR L. HORWITZ, Chevy Chase, Maryland
ALAN JAFFE, New Orleans
MITCHELL D. KAHAN, Montgomery, Alabama
KANSAS GRASSROOTS ART ASSOCIATION, Lawrence
VIRGINIA KIAH, THE KIAH MUSEUM, Savannah
PHYLLIS KIND GALLERY, New York and Chicago

MR. AND MRS. WALTER G. KNESTRICK, Nashville
JENNIE LEA KNIGHT AND MARCIA NEWELL, Rectortown, Virginia
SCOTT H. LANG, Washington, D. C.
DR. AND MRS. VIRGIL S. LE QUIRE, Franklin, Tennessee
MARILYN LUBETKIN, Houston
MR. AND MRS. JOHN MCCARTY, Delaplane, Virginia
SIDNEY MINDLIN, Pittsburgh
MISSISSIPPI STATE HISTORICAL MUSEUM, Jackson
H. MARC MOYENS, Alexandria, Virginia
MUSEUM OF AMERICAN FOLK ART, New York
NATIONAL MUSEUM OF AMERICAN ART, Smithsonian Institution, Washington, D.C.
NEW ORLEANS MUSEUM OF ART
PATRICIA OLSEN, Richmond
MARTIN AND ENID PACKARD, Comstock Park, Michigan
AMELIA PARSONS, Bedford Hills, New York
REGENIA PERRY, Richmond
THE ELIJAH PIERCE ART GALLERY, Columbus, Ohio
STUART AND MARY PURSER COLLECTION, Gainesville, Florida
LEO AND DOROTHY RABKIN, New York
CHRISTINA RAMBERG AND PHILIP HANSON, Chicago
CHUCK AND JAN ROSENAK, Bethesda, Maryland
LUISE ROSS; R. H. OOSTEROM INC., New York
NELLIE MAE ROWE, Atlanta
SAN ANTONIO MUSEUM ASSOCIATION
SAL SCALORA, Storrs, Connecticut
GEORGE SCHOELKOPF, New York
CHARLES SHANNON, Montgomery, Alabama
MURRAY SMITHER, Dallas
MRS. ALFRED STARR, Nashville
MR. AND MRS. ELLSWORTH TAYLOR, Lexington, Kentucky
DR. AND MRS. CLARK B. TIPPENS, Nashville
UNIVERSITY OF TENNESSEE, Knoxville
WEBB AND PARSONS, New Canaan, Connecticut
MRS. GEORGE WHITE, Dallas
MR. AND MRS. JOSEPH H. WILKINSON, Fairfield, Connecticut
JEFFREY WOLF AND JEANY NISENHOLZ-WOLF, New York
MR. AND MRS. ALAN ZIBART, Nashville
MR. AND MRS. CARL ZIBART, Nashville

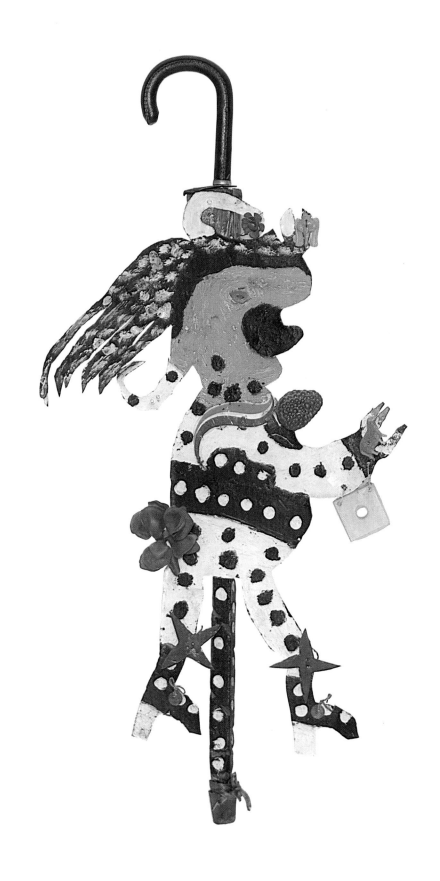

10

What it is

Of all the major traditions in American art since colonial times, encompassing the early portraitists and limners and the great nineteenth century landscape and genre painters, the Ash Can school, early modernism, social realism, abstract expressionism and its many aftermaths—in all this, one important episode has been dominated, in authenticity and in sheer numbers of practitioners, by black artists. That aspect of American art is a certain kind of self-generated or "folk" expression. It is an esthetic paradoxically based in a deeply communal culture, while springing from the hands of a relatively few, physically isolated, individuals. This phenomenon has effloresced particularly in the present century. It cannot be coincidental that perhaps fully half of the truly great artists in the recent American folk genre, from the early 1920s to the present, are blacks and predominantly Southern blacks. The style I am characterizing has to do not with crafts or traditional utilitarian artisanship, but with full-fledged gratuitous art objects, paintings and drawings and sculptures. The artists working in this esthetic territory are generally untutored yet masterfully adept, displaying a grasp of formal issues so consistent and so formidable that it can be neither unselfconscious nor accidentally achieved.

Many of the artists in this genre, whether black or white or Hispanic, tend to have begun making art at a relatively mature stage in their lives. Virtually every artist in this exhibition claims to have been commanded by an inner voice or by God to make art. On the face of it, we discover a nearly unanimous testament to personal revelation, some sudden imperative. Even when latent from childhood, the irresistible impulse to make art usually occurs first in ripe adulthood, often following some loss or private calamity. The body of work that falls within this historical frame is generated out of literal trials in personal maturation, but reflects also a wider cultural maturity. It remains to us now more realistically to understand this esthetic, not as a byproduct of the fantasies of eccentrics or naifs but as the achievement of artistic masters. The notion of revelation in these cases may often be professedly religious, but it is probably not so different from the venerable secular concept of the visitation of the muse. All art requires unbidden miracles to assist in its realization.

A close observation of the works of the artists here, in terms of subject, style and the biographic patterns that inform them, reveals many striking affinities. The predominating connection among these personalities is their shared lack of recognition as the masterful and original artists they

are; not only is this the first major exhibition of this important group of American artists, but many of the figures in it have never received attention in their own regions. Even the best known among them, William Edmondson and Elijah Pierce, are hardly famous personages in the context of contemporary American art; the rest are more or less obscure. And yet they are members of the last two generations of a vivid tradition that reaches back virtually to the first era of slavery in the United States; it is not too much to say that the underground development of visual expression among American Southern blacks parallels the evolution of black music in America, particularly in the Gospel and blues forms. The visual art admittedly occurs in a more limited and sporadic pattern than American black music, and never attains the classicism or overtly influential character of jazz, but it is a truly formed American style which requires analysis and authentication as such. Like black music, the art is full of inside jokes and slyly vernacular allusions, but somehow these images are almost always, if not literally readable to those outside the subculture, intuitively legible and provocative to the widest audience.

The esthetic sense which asserts itself in the present exhibition, bringing together the work of twenty artists, spanning five decades, is inevitably complicated, given the range of the artists' individual dispositions and backgrounds. By definition these artists lack the pressure of mutual influence which characterizes artists operating in the official art arena. And yet there is the overarching atmosphere of a single tradition, even of a single style. It is an esthetic which seems to understand the beauty which inheres in intentional crudeness or indecorum; at times it assertively denies "the beautiful." It is in great measure an esthetic of compassionate ugliness and honesty. It is not an esthetic which worships or even emphasizes physical craftsmanship. Perhaps the widest operational disparity among the figures here could be exemplified in the difference between two artists who seem to represent the poles of the spiritual and the carnal. James Hampton's life work took the form of one vast rough monument informed by a single epiphany, meant to constitute a kind of personal tribute to an elaborate system of divine revelations; Steve Ashby was a constitutionally worldly artist whose odd icons are coarse, playful, often overtly humorous and risque. But even in their physical banality, Ashby's sculptures live through their transcendent certainty of underlying abstract values. Oddly enough, Hampton and Ashby were working only fifty miles apart, one in urban Washington, D.C., the other in rural Virginia.

What continues to amaze us as we look at the work of each of these self-taught artists is the elaborately developed ability to make esthetically successful drafting compositions and sculptural forms. Hampton and Ashby in their respective positions of artistic loneliness or independence, know innately what art is: their inventiveness is always tempered by a sense of proportional correctness, of what makes an interesting shape, of how to express their ideas unerringly through abstract means. A sense of intelligible gesture is uncannily *right* in so much of this work; we instantly know what is intended. The artist achieving the most consistently prodigious command of abstract sculptural form is Edmondson; he establishes a place somewhere between Hampton's relentlessly accretive environment, and Ashby's more relaxed, sporadically object-oriented approach. Edmondson not only comes closest to true monumentality in his individual pieces, but is the consummate craftsman of the lot. And he is as great an artist as we are going to discover in the history of American folk sculpture.

facing page:
William Edmondson, *Angel,* c. 1940. Limestone, 39 x 24 x 12". First Tennessee Banks, Memphis. Cat. no. 123.

13

Bill Traylor, *Man and Large Dog*, (recto), 1939–42. Pencil and gouache on paper, 28⅝ x 22½". Courtesy Luise Ross; R. H. Oosterom Inc., New York. Cat. no. 302.

In coming to terms with the character of apparently inexplicable sophistication found in the work of these untutored and often enisled figures (William Traylor in this respect personifies the mystery beyond mysteries) it is tempting simply to invoke an idea of a kind of prolonged childhood which these artists enigmatically sustain. We are familiar with the phenomenon of the child's drawing, which can be so satisfying in its fresh, thoughtless spontaneity; and we are fascinated to observe that as the child matures, some genetically predetermined transformation corrupts his ability any longer to be unselfconscious in his visual expression. But we accept still more automatically an idea of universal maturation: thus it is neither theoretically nor practically feasible to assume that the so-called "folk" artist has somehow escaped one inevitable result of aging, which is to introduce into each person's creative consciousness a reflexive element, an inveterately self-analytical habit of thought. The folk artist often demonstrates in the evolution of his style a development similar to that of the academic one, which may commence haltingly in a somewhat

facing page:
George White, *Old Pioneer Days*, 1962. Oil on carved wood relief, 24 x 25". Mr. and Mrs. Roger Horchow, Dallas. Cat. no. 330.

14

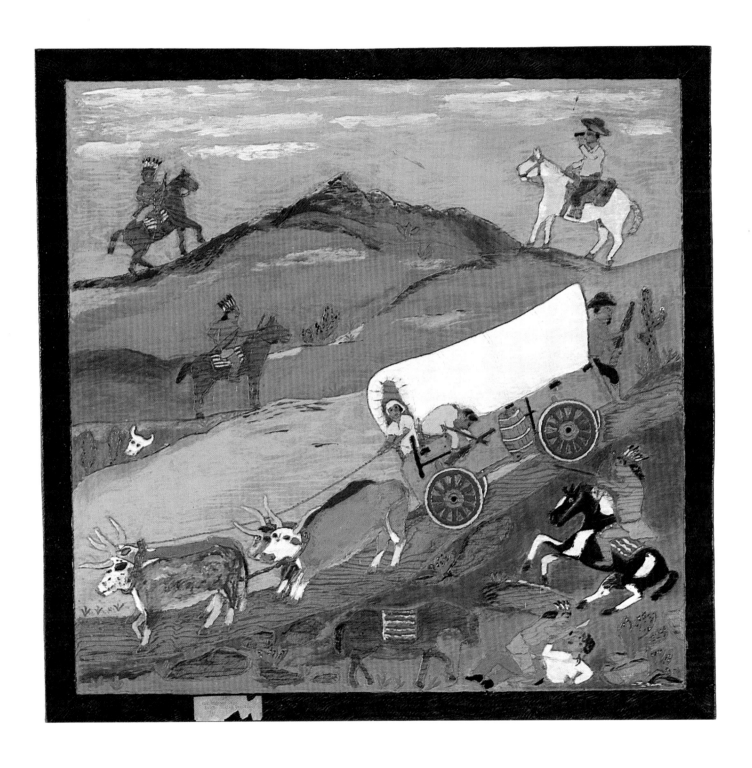

stilted, even contrived mode, becoming more and more fluent and obviously self-confident. (This is by no means an unexcepted rule: some among these artists created their best work in their earlier productive years.) The difference between the academic and the self-taught artist is that often as the latter becomes more proficient and complex, he becomes more *raw*, apparently more clumsy and bold and uninhibitedly prolific; the schooled artist, in contrast, generally becomes more refined and subtle and technically proficient. The folk artist often matures toward an increasingly polymorphous, released style; the academic tends to evolve in a direction of greater and greater intellectual ambition and thus self-consciousness. Both the untutored and the trained are inevitably evolving as artists, albeit in disparate directions. We simply can no longer afford to countenance the notion that folk artists somehow experience a life-long childhood. The successful "folk" art object engages both the maker and the viewer at a level of esthetic recognition that is no different in intensity or prolongation from that which is demanded of the successful "high art" object.

Recent attempts to further our understanding of the difference between folk art and "high art," emphasize a kind of unification between self and object in the folk esthetic, an overcoming of the alienation of the artist from the world through art. This kind of art is associated with play—literally with toys: "The folk art toy represents a renewed unity of sensibility. In the world of modern art, it symbolizes unified expression of being, self-expression of being, self-expression which is not only a recovery of the integral self but the discovery of a world which seems paradise by reason of the self's belonging in it."[1] This argument correctly associates folk art with "popular culture" more generally, and views it thus as perhaps more important in an absolute sense than high art. Certainly the icons and fables of popular usage reach a much greater audience than do the unique manifestations of advanced "pure" art, that is, art that takes as its subject other art. At best, high art moves us through a process of intellectually derived relationships, attaining a kind of ultimate refinement, and often an extreme reductivism; at its best the often additive or accretive folk art object reaches us on an immediately emotive level while also stimulating our esthetic faculties. The folk artist, unlike the self-conscious, dialectically engaged one, views his own artifacts as being inseparable from life itself, as being a kind of recreation of his experience: if his work is childlike or toy-like, it is because it is conceived in a whole-minded connectedness to the world, to emotional experience in the present moment.

There can be little question that the truly successful folk artist in any given society is not only equally valuable to that culture, but is, if anything, more embedded in it than either the avant-gardist or academician. Precisely this engagement with the community of signs and symbols and political realities gives folk art its energy and continually renewable ability to move us: the folk artist repeatedly injects new freshness and new poignance into old themes and symbols. The importance of a "closed," or at least a relatively finite, system of myths and icons and visual touchstones, in providing the conditions for a true renascence of folk expression, is dramatically substantiated in the present array of objects produced by black American men and women within merely two generations and within a rather distinctly circumscribed geographic area. It is in fact curious to what extent the objects they produce resonate to our entire, immensely heterogeneous, American culture, and not just to a circumscribed realm of agrarian or small town American black people. This is

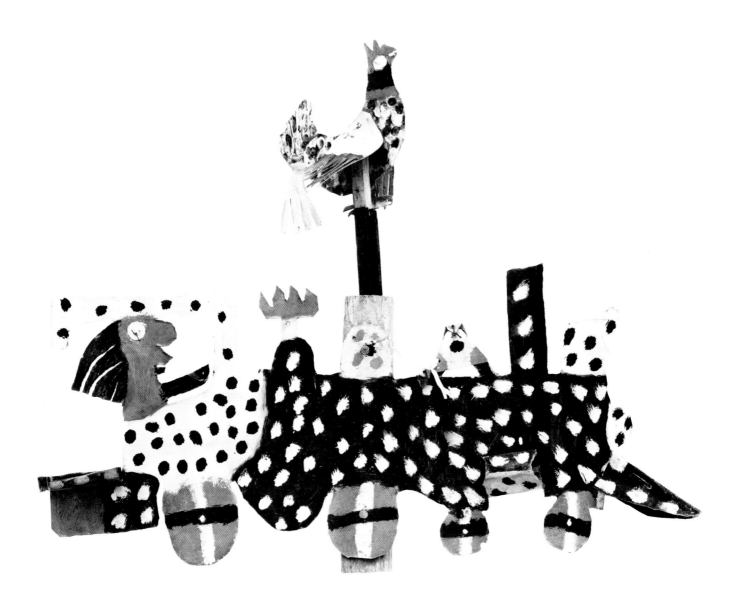

David Butler, *Locomotive Engine with Rooster*, c. 1980. Painted tin and plastic mounted on wooden post, 39½ x 29 x 6". William Fagaly, New Orleans. Cat. no. 53.

not to say that certain specifically rural traditions do not inhere in this constellation of often-repeated images, or that some of their sources and connotations are not invisible to the eye of the outsider. It is because the objects are so authentic as art, as formally self-aware and living manifestations of esthetic consciousness, that they are able to be appropriated in the general world of esthetic intelligence.

The traditions in American black art stemming from various crafts—cane carving, basket weaving, pottery making, quilting, blacksmithing—clearly provide paradigms for the much more independent and improvisatory twentieth century art that is presented in this exhibition. In linking these two phenomena, certain insistently repetitive themes recur. For instance it is useful to note that the ubiquitous snake or lizard begins to appear on canes at an early time and continues to reappear in contemporary folk art; a certain kind of facial expression, one with menacing or at least prominent teeth and concave or inset eyes (typically seen here in James Thomas's clay heads), seems derived from the face-jug tradition; many early quilt patterns suggest the coloristic and compositional approaches which would appear in twentieth century black folk painting. But it is not

the continuities as much as the many examples of novelty and individuation which we find in the work of these twenty artists, which become so assertive as we study the work. The varying complexities within a given oeuvre—that of Sister Gertrude Morgan or George White, of Elijah Pierce or Nellie Mae Rowe—can be simply overwhelming. These are bodies of work whose range of style and subject and technique approaches that of some of the great modernist outputs. They are not bodies of work made in the spirit of generationally inherited artisanship, by anonymous craftsmen; they are artistic oeuvres whose makers are eminently self-aware and self-confident. And a few of these artists diverge rather significantly from the idiom or styles that we associate with a "folk" expression. Luster Willis, in the fluidity and intricacy of his brush handling, is an immensely proficient and refined painter; Joseph Yoakum in the subtlety and lyricism of his landscape compositions can hardly be termed "primitive" in any sense. But it is fair to note that these are exceptions.

Meeting artists like Elijah Pierce or the late Gertrude Morgan or Nellie Mae Rowe, one is struck by a radiant force of will, a palpable sense of courage and self-knowledge. These are artists for whom the forging of a major body of work, and the creation of a serenely productive life, both occurring against monumental odds, constitute a feat which would seem nearly inconceivable. And in fact many commentators on the phenomenon of the journeyman-artist who seems to be obsessed by his work, carving or painting constantly, and in a spirit of apparent unawareness of his own role as an artist, tend to view these people as amusingly eccentric, remarkable in their compulsivity but ultimately quaint. But when one comes to know people like James Thomas or Luster Willis or Sam Doyle or Ulysses Davis, one begins to sense the full measure of hard-won sensitivity and sheer perseverance which are essential to their making a major artistic statement. It is not less but more remarkable that they have managed to produce important art given their lack of training as artists. They are, perhaps, every one of them, at least in certain works, inimitable creative figures. Some among them will be perceived as great artists in the biggest arena.

The esthetic embodied in much of the art in this exhibition may appear to some—especially those unfamiliar with recent art in general—to be virtually impenetrable as fine art, owing to its apparent ingenuousness, its denial of conventional "beauty" or "refinement" or "elegance." But this recalcitrant style is instantaneously accessible to and, more to the point, inspirational to other artists, and in particular to artists operating within the contemporary vanguard. Recent American mainstream art has become additive rather than reductive, and often engages simple decorative repetitions, or produces consciously "bad" or crude or "dumb" object-deployments. This pluralistic movement began as soon as the early 1960s. It is no accident that the several eminent artists of the original Chicago School—the early H.C. Westermann, Jim Nutt, Roger Brown—and such Southern artists as Jim Roche, James Surls, William Christenberry—were among the first people to recognize and value, and ultimately to assimilate, the work of contemporary American folk artists. These artists all freely acknowledge their debt to the artists in the present show. It is not so generally known, but nonetheless there is strong enough visual evidence to contend, that several major New York mainstream artists, such as Ralph Humphrey, Joe Zucker, Rodney Ripps, Jonathan Borofsky or Robert Moskowitz, and many others, have been potently influenced by the inventions of twentieth century American self-taught artists. There is

Mose Tolliver, *Woman with Fish Shape*, c. 1975. Enamel on wood, 24¹⁵⁄₁₆ x 10". Kansas Grassroots Art Association, Lawrence. Cat. no. 281.

18

perhaps a hint of disingenuousness in much of the very fashionable, exceedingly urbane and incipiently decadent "bad" or "new image" or "new narrative" art which captured a recent moment in the vanguard of American art, and which continues to develop. Much of even the best of this consummately sophist art pales in comparison to the nominally "naive" work we are confronting here. One does not suppose that any systematic or truly conscious campaign has been waged to selfishly exploit a creative source—and yet one is inclined to balance the scales, to draw attention to an unjustly ignored artistic episode in America's staggeringly rich contemporary art history.

In analyzing the way in which these folk artists are "major," we cannot always use the same criteria we apply in judging "high art." For the very premises of the endeavor are different for the artist whose tradition has to do with known canonical and mediative values, as opposed to the artist whose impulse and standard of success rely upon embodying a visionary reality, often in a spirit of fiercely obsessive determination. Many self-taught rural American artists draw upon scenes from their own childhoods or contemporary daily life as their primary source: others sublimate this impetus into a repertory deriving from Biblical stories. The third main type of folk art subject is political imagery, and it is perhaps in this aspect of the genre that we glean the most telling insight into the difference between successful self-consciously acculturated art—that is, high art—and successful culture-derived art.

Most of these twenty artists, at one time or another if not frequently, engage political subjects or imagery in their work. While it is true that the predominant content of twentieth century black folk art is related either to Biblical themes or to objects such as animals or people or apparitions taken from daily life transformed by the imagination, we also find that a limited arsenal of subjects excerpted from contemporary popular culture and/or political events, finds expression in this art. The images of Martin Luther King, Abraham Lincoln and John F. Kennedy appear again and again; sports figures are depicted repeatedly as in Elijah Pierce or George White; Ulysses Davis has laboriously carved portraits of each of the Presidents of the United States. A spirit of didacticism pervades this art; for instance, certain images relating to the history of the American blacks' struggle for freedom and equality are obviously depicted with the intent to moralize, to remind, to instruct. But it is evident too that the very recognizability of most of these images—their virtually guaranteed familiarity to everyone, whether an educated or uneducated person—is crucially important to the folk artist. In cases where an artist depicts a relatively complicated or obscure narrative, as with Gertrude Morgan's New Jerusalem paintings, or Sam Doyle's portraits of local characters, the pieces are often captioned, so we will read them clearly in terms of their depictive nature. The only truly obscurantist artist among these is the mystic James Hampton, whose encoded captions have still not been understood, but whose intent was probably in large part to instruct.

That such artists as Hampton or George White or Gertrude Morgan are fully aware of the didactically communicative power of their artifacts is evidenced repeatedly in their own statements about themselves and what they do as artists. Sister Gertrude Morgan constitutes a monomaniacal personification of the artist as teacher, as healer. Even the objects she used in her preaching—megaphones, hand fans—are decorated with images of redemption and transcendence. In other cases, like that of Mose Tolliver or Inez Nathaniel, we sense that both the process and result of the art

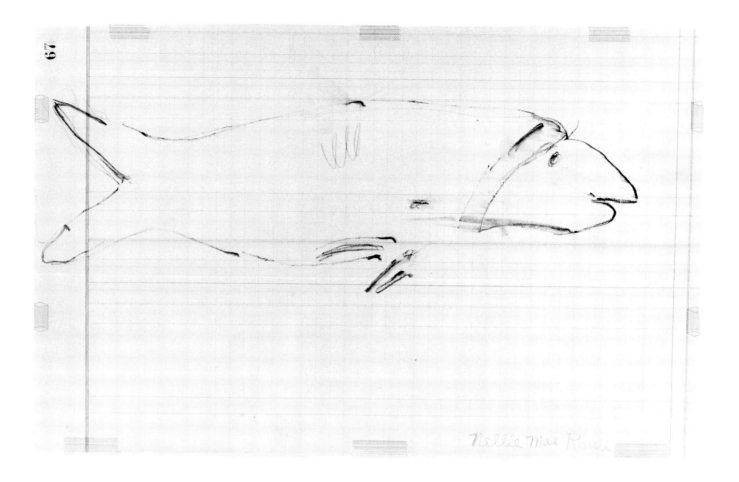

Nellie Mae Rowe

Nellie Mae Rowe, *Fish,* n.d. Ink on graph paper, 8¼ x 13″. Alexander Gallery, Atlanta. Cat. no. 225.

activity function for the artist more as a self-healing, or exorcising, activity, than as a literal means for communicating faith or spiritual insight. Of course these two psychic reasons for making art—to exorcise and to instruct—often lie behind the efforts of securely mainstream professional artists. Yet there remain important differences between the professional and the folk artist. In the case of the isolated and late-blooming artists, all the many culture-imbued factors inherent in the condition of being a trained artist may be absent. The compulsion to *know about other art*—to trace past influences and find new ones, to compete in the economic arena, to understand the critical issues surrounding art's dialectic—this basic constellation of desires seems to be missing from the preoccupation of the folk artist. Nellie Mae Rowe, who has visited art museums in New York, evinced little interest in what she saw: "I can look at my own art," she said.

The generalities we discover in characterizing "folk art" in contradistinction to "high art" provide endless subject for speculation about the meaning itself of making art. "Folk art," however, in its broadest definition, is not strictly synonymous with the phenomenon we are dealing with on the present occasion. It is, admittedly, a newly examined aspect of the American "self-taught" or "isolate" or "naif/visionary" esthetic—at least it is more this than it is an extension of any American "craft" or "folkloric" esthetic. (This confusion needs desperately to be put to rest.) But it is not an occurrence which truly finds parallel in other so-called "folk art" events. Two factors inherent in this project separate it from any familiarly examined category: first, all the artists shown here are black Americans;

20

and second, the work produced falls into a fifty-year chronological period, from about 1930 to the present. We are dealing with a genuinely unique, historically circumscribed occurrence within the history of American art, and the stunning fact remains that it is virtually unexamined. It is unaccounted for sociologically and unknown art-historically.

All art is to some extent self-conscious. Most accepted works of art are grounded in a consciousness of other art; many are also candidly autobiographical. Folk art often directly communicates a kind of societal self-consciousness, rather than any literal sense of being individually narrational. A few of the artists in this group do occasionally depict themselves—Sister Gertrude often incorporates self-portraits into various narrative

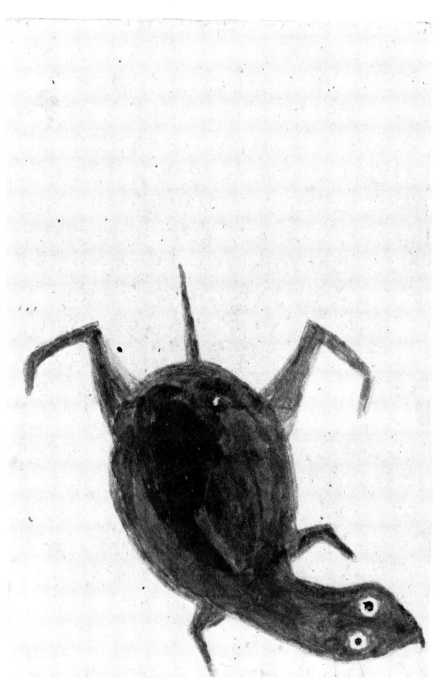

Bill Traylor, *Turtle, Swimming Down*, 1939–42. Pencil, crayon and gouache on paper, 11¾ x 7¾″. Charles Shannon, Montgomery, Alabama. Cat. no. 321.

scenes; George White figures in some of his tableaux—but more often the literal presence of the creator is not introduced. Instead, the shared myths of their friends and acquaintances find their way into the work, and because these stories or legends are often quite specific to American black lore as it has developed apart from the white man's vocabulary, the images can appear obscure. But rarely are they totally personal; generally the references in the work of these twenty artists are to subjects whose origins are in important jokes or serious histories known generally in the subculture and not simply parts of individual experience. Mythical themes have always been an important impetus for visual artistic expression, even within recent abstract painting, but just as often as the academic or avantgarde artist employs communal imagery in his work, he creates entirely intellectually-derived, privately imagined and self-interpretable images. For the "folk" artist, the created subject seems to be somehow *validated through its being at the same time wrested from the artist's own experience and grounded in ideas or icons which are immediately intelligible to others.* The most complex narrative pieces of George White, whose works relate scenes from his own past, speak to a generalized American range of legendary prototypes, the rodeo or butcher shop or the wrestling arena or the front porch. It is in part the *transparency* we perceive in White's elaborate narrative pieces, or in Elijah Pierce's sometimes allegorical carvings, that separates these works from the often intentionally esoteric, certainly willfully opaque, works of their schooled and art-reflexive contemporaries.

In gathering together the material for this exhibition, we found ourselves increasingly responding to the esthetic it represents with a sensation of convulsive recognition, as though one had seen these images before, or as if vestiges of one's own past were reappearing in fragmented segments. There was a nagging experience of recollected feeling, something like hearing long forgotten music. Not one of these twenty artists ever communicates any hint of sentimentality: indeed the underlying irony, toughness, often a conscious crudity or aggression, which especially characterize Mose Tolliver, Steve Ashby and Sam Doyle, are in *conscious* opposition to any sentimentalizing tendency. Yet even these most relentlessly coarse or repellent artifacts finally provoke a wrenchingly nostalgic response; we somehow feel that their authors represent an optimistic aspect of human nature, and that the spirit in which their homely sculptures and paintings are crafted encapsulates a long episode of flashing humor and curiosity and suppressed wisdom. It is a nostalgia perhaps springing from the tense closeness of this art to popular culture, yet without truly being *of* popular culture. Great art is never simply popular art. That the black artist in America, the artist descended from slaves, should emerge in the foreground of the recent American mainstream esthetic, obviously implies a great deal about both the psychology of the so-called folk esthetic, and the psychology of the black esthetic. It suggests, for example, that the ethnically cohesive strata in our society create a truth we need to acknowledge. This art expresses a sensibility to which every one of us can relate on some level, whether out of the most basic or the most specialized capacity to appreciate visual form. Just as an entire global community has been touched by American black music, so might the whole world respond to this astounding black American visual outpouring.

JANE LIVINGSTON

facing page:
Elijah Pierce, *Berry Tree,* n.d. Carved and painted wood, glitter, 37 x 17¾". Jeffrey Wolf and Jeany Nisenholz-Wolf, New York. Cat. no. 211.

1. Donald B. Kuspit, "'Suffer the Little Children to Come unto Me': Twentieth Century Folk Art," in *American Folk Art: The Herbert W. Hemphill, Jr. Collection* (Milwaukee Art Museum, 1981).

See also for a general discussion Daniel Robbins, "Folk Sculpture Without Folk," in *Folk Sculpture U.S.A.* (Brooklyn Museum/Los Angeles County Museum of Art, 1976).

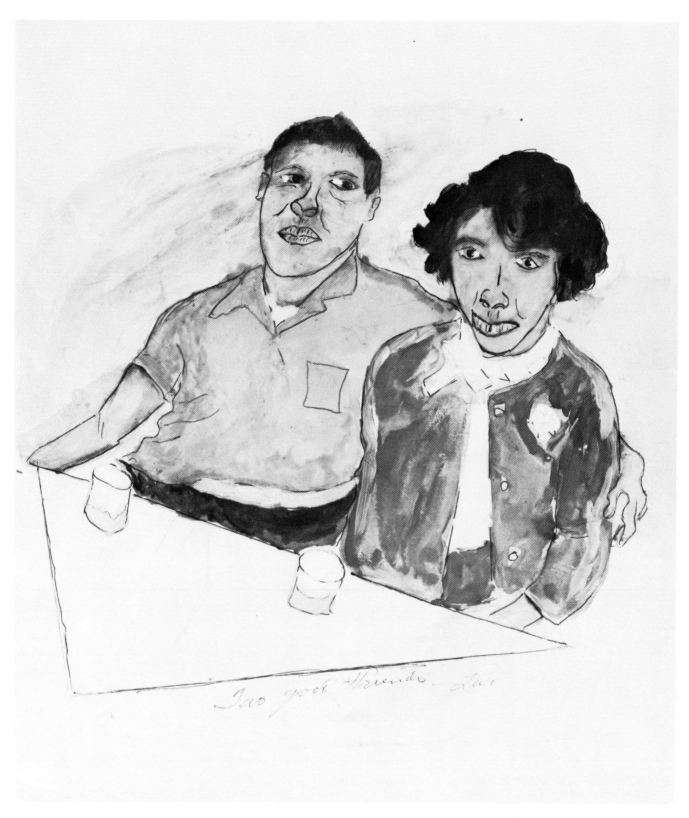

Luster Willis, *Two Good Friends*, c. 1980.
Ink and tempera on paper, 13⅞ × 12³⁄₁₆″.
Private collection. Cat. no. 367.

Black American Folk Art

Origins and Early Manifestations

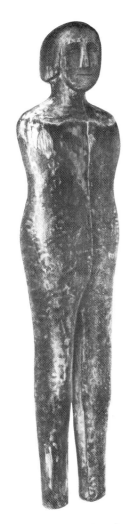

Rendering from the Index of American Design, National Gallery of Art, Washington, D.C., of a wooden doll resembling George Washington. Carved from a single piece of walnut, 29″ high. The piece was found in Missouri.

Although this exhibition is without precedent, twentieth-century Black American folk art as presented here did not spring forth fully developed, like Athena from Zeus' brow. It resulted from an evolution of eighteenth- and nineteenth-century folk art forms that included wood carving, grave decoration, quilting, ceramics, ironwork and basket weaving. The origins of these earlier forms are specifically and undeniably African, modified in the new work by the experience of Blacks in an alien culture. Documentation attests to the fact that African slaves began to fashion art works shortly after their arrival in this country during the early seventeenth century. Indeed, the earliest art produced by Blacks in America was folk art: the number of Black professional artists was very small prior to 1850. Though African forms have evolved considerably over the years and have been blended with European and white American forms, certain compositional devices and subjects still provide a link to the African past.

The purpose of this essay is to provide a synopsis of some of the previous folk art accomplishments of Black Americans, which form the foundation for the development of the works at hand. Some of the pieces in this exhibition are racially identifiable by their subject matter; others are not. However, the majority belong to a school of folk art that is distinctly and innately Black American—the expression at once of being Black and being American. By examining selected eighteenth and nineteenth-century examples, significant Africanisms in Black American folk art will be revealed. The measure of both survival and adaptation of these African forms in the twentieth-century works will then become more clear. An examination of wood carving, for example, will illuminate the accomplishments of contemporary sculptors, particularly the carvers such as Ulysses Davis, Jesse Aaron and Elijah Pierce. Much of their subject matter—monkeys, snakes and lizards, for example—found expression in eighteenth- and nineteenth-century works and has even deeper roots in African beliefs in witchcraft, healing and conjuration. The tradition of face jugs, with their inset eyes of white kaolin clay, provide a precedent for the ceramic skulls of James Thomas, some of which have corn kernels for teeth and eye inserts of tin foil. The compositional techniques of Harriet Powers, as demonstrated in the floating figures of her Bible quilt, suggest a link to the similar devices employed in her paintings by Nellie Mae Rowe, who was herself trained as a quilter.

The twenty artists whose works are included in this exhibition do not comprise the totality of Black American folk Art. Nor can this essay touch upon all aspects of historical Black folk art, nor all the links between the present-day works, their Black American precedents and their African roots. Yet it is hoped that, by this essay, the tradition of Black American folk art and the richness of its present will be better understood.

WOOD CARVING

The most obvious examples of African survivals in Black American art of the colonial period may be seen in handicrafts executed by slaves prior to the Civil War. A survey conducted in 1937 under the auspices of the W.P.A. and now a part of the Index of American Design of the National Gallery of Art resulted in the location of innumerable slave artifacts which were catalogued at the time of the survey.

The W.P.A. survey attributes to a slave carver a large male figure carved from a single piece of walnut and painted grayish-green. This armless figure has a hollow opening which extends almost to the head; it was probably designed to be affixed to a post. The face shows some resemblance to certain portraits of George Washington. The figure is characterized by marked simplicity: the feet are not indicated, and the artist took advantage of some of the natural contours of the wood in the proportioning of the overall design. While the spirit and concept of a figure carved from a single piece of wood are African, the proportions and subject matter are undeniably Western.

A pair of chickens reputedly carved between 1810 and 1815 in New Orleans by a slave of the notorious pirate Jean Lafitte provides an interesting contrast to the "George Washington" figure from Missouri. The cock and hen were each carved from several pieces of cypress which were fitted together. The cock plays a significant role in a number of West African religions, particularly the Yoruba. It is a motif frequently seen in African sculpture and is generally rendered in a realistic manner. It is not certain if the Lafitte slave was recalling African prototypes when he carved the present examples or merely reproducing figures from his new American environment.

One of the most sophisticated examples of pre-Civil War Black American woodcarving is a seated figure of a preacher carved in Kentucky between 1850 and 1860 and now in the Art Institute of Chicago. The work represents a bearded, curly-haired Black American preacher dressed in Sunday-best clothing holding a book on his knees, presumably the Bible. It is carved of pine wood with thin layers of gold paint applied over gesso. Traces of black, brown, red and white paint were recently removed by restorers to preserve the original gold. The old country preacher has an air of dignity and sophistication. His face is gaunt and his broad features are specifically Black American. The hands are clearly delineated while the blocky feet are merely suggested. Although the costume and proportions of the design are Western, the sensitivity of perception in the rendering of the preacher's figure attests to its Black American authorship. The sobriety of gaze and the sensitive, almost portrait-like realism of the preacher's features would almost certainly have been made farcical had the figure been executed by an Anglo-American folk carver. The Chicago preacher is one of the most realistic examples of mid-nineteenth-century Black American figure sculpture in existence; in its quiet dignity it seems a precursor to the carvings of Ulysses Davis, especially Davis's portrait of his father and the figure of Abraham Lincoln.

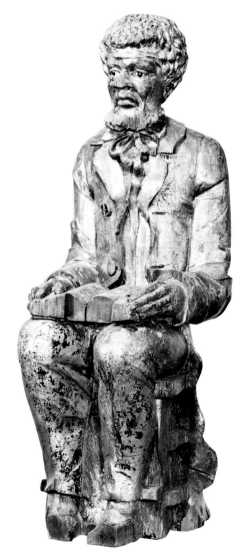

Preacher, 19th century. Carved wood, 29" high. The Art Institute of Chicago.

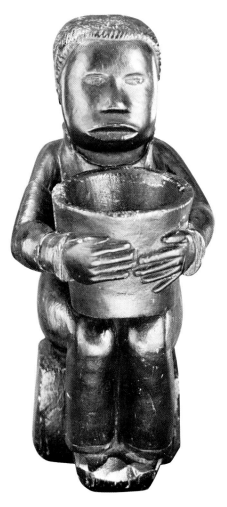

Figure Holding Bowl, about 1860. Carved pine, 8 x 4 x 5½". Abby Aldrich Rockefeller Folk Art Center, Williamsburg.

Another interesting, but less formal, figure sculpture is the *Seated Figure Holding a Bowl* from the Abby Aldrich Rockefeller Folk Art Center in Williamsburg, Virginia. Fortunately, considerable documentation exists concerning this figure. It was reputedly carved in the small town of Fayetteville, New York (near Syracuse), some time between 1836 and 1865. The figure represents a male seated on a block with his arms encircling a large bucket-like vessel held on his lap. The face has a mask-like simplicity. The hair is closely cropped on the large head of the neckless figure. He wears simple cuffed pants and a high-collared shirt. A few traces of dark red pigment are detectable on the piece, which may originally have been painted that color. Although the anatomical proportioning of the figure is Western, the pose of the big-headed figure relates to African examples. Figures holding bowls are commonly seen in the Congo region of Africa, as well as in some Yoruba territories, and are used for utilitarian as well as religious purposes. The gaze and slight turn of the head to the left and the flexed position of the fingers of the left hand give a relaxed atmosphere to the otherwise rigid design. The sensitive, simple concept of the figure, which, like the Chicago preacher, is totally lacking in grotesque or caricature overtones, suggests a Black American maker.

The Williamsburg piece gives rise to speculation as to whether its creator was familiar with similar African examples and whether such a style existed in upstate New York. The provenance of the Williamsburg piece, traced by Robert Farris Thompson,[1] establishes its unusual and non-Southern origin. The figure was previously owned by Hiram Wood, an Anglo-American lumber merchant at Fayetteville, who informed his daughter in 1842 that a hired Black man who worked in one of his mills carved the piece in his leisure time. The town of Fayetteville is less than a mile from the Erie Canal and witnessed a heavy traffic of fugitive slaves during the nineteenth century, which may explain why the unusual and unprecedented carving appeared in Fayetteville. Although the sculpture is a mixture of Western and African influences and predominantly Western, there is no tradition of figures holding bowls in American art. Therefore, the anonymous Fayetteville carver probably did have knowledge of similar African pieces and other arts of the Guinea Coast. The Fayetteville piece is more African-influenced than the Chicago Preacher by reasons of its simplicity, design and monochromy. However, both examples present a sensitive and dignified interpretation which suggests no social gap between the subject and the artist. That feat was almost never accomplished in that period by any other than a Black American artist.

Carved walking sticks, which are still executed in large numbers in Africa, provide the most specific traces of African influence in Black American woodcarving. The most magnificent surviving example of an Afro-American walking stick known to the writer was carved in Livingston County, Missouri, by a slave blacksmith named Henry Gudgell during the 1860's. Records indicate that Henry Gudgell was born a slave in 1826 in Kentucky of an Anglo-American father and slave mother. Around 1867 Henry Gudgell and his mother moved from Kentucky to Missouri and lived on a farm owned by Spence Gudgell. It is also known that Henry Gudgell was a blacksmith, wheelwright, coppersmith, silversmith, and was also skilled in a variety of other crafts. Relatives of the original owner of the cane relate that it was carved for John Byran, a friend of Henry Gudgell's master, who had incurred a knee injury during the Civil War.[2] If those facts are true, the date of the cane is probably between 1865 and 1867.

27

The Yale walking stick is the only known example of Henry Gudgell's talents in the field of woodcarving. The slender, tapering shaft has a handle carved in powerful spiral grooves. A slender serpent carved in relief is entwined around the bottom of the cane. Directly above the serpent's head is the full-length figure of a man; on the other side of the cane is a bent branch and leaf. A lizard and tortoise appear near the top of the shaft, and a series of carved bands—circular, diamond patterned and wide-fluted— may be seen directly below the handle. The Gudgell cane presents an interesting combination of abstract and realistic motifs. The entire walking stick was originally painted black, but a good deal of the pigment was worn away through its frequent use by the owner until his death in 1899.

The combination of motifs found on the Gudgell walking cane raises a number of questions as to the training and exposure of the carver. All of the figures on the cane are viewed as if seen from above and their spacing on the surface of the cane is regular and even. The small figure of the man with flexed knees is clad in Western clothes and correctly proportioned according to Western standards. However, the remaining motifs and their specific combination are undoubtedly African. The depiction of serpents and reptiles singly and in combination may be seen in numerous African examples, such as the Benin *Bronze Tube* in the University Museum, Philadelphia. Although documentary evidence does not allow a specific reconstruction of Gudgell's Kentucky childhood, it seems reasonable to suggest that he was at least familiar with the work of some Black American carver or carvers who were among the many slaves who had migrated to Kentucky from the coastal area of America in the late eighteenth century and executed works with a strongly African flavor.

The reasons supporting the creation of both African and Afro-American carved staffs extend beyond that of mere decoration. Their existence is closely related to the African belief in witchcraft, healing and conjuration, which was transferred to America. Some Black American communities of the deep South still believe in various forms of voodoo (voodum) and seek the services of a witchdoctor or root-doctor in favor of Anglo-American medicinal practices. Illnesses are sometimes described as witches in the form of familiar reptiles. A number of instances of similar beliefs are quoted in *Drums and Shadows*, compiled in the 1930s by the W.P.A.'s Georgia Writers Project:

> "There's a human round you what can make a hand to put any kind of insect in your body. He can kill an insect and grind it to powder and rub it on the skin of the person or give it to him to drink. When it enter the body it turn back into insect, sometime a lizard, a frog, or a snake."

> "Conjure is being practiced all the time. Frogs and lizards and such things is injected into people's bodies and the people fall ill and sometimes die."

> "I could feel the snake running all through me. If I had killed that snake, it sure would have been Flossie Hopkins."[3]

In a study, *Folk Beliefs of the Southern Negro*, Newbell N. Puckett cited an instance in which a woman was conjured, but went immediately to a "hoodoo doctor," who took a frog and a lizard out of her. He described the procedure:

> A woman thought she had lizards running up and down under her skin. A Negro hoodoo woman was called in . . . this woman had a lizard hidden in her sleeve, and, waiting for the frenzy to

facing page, left to right:

Bronze Tube, West Africa (Benin tribe), 19th century. Bronze, 15" high. The University Museum, Philadelphia.

Henry Gudgell, *Walking Stick*, c. 1863. Carved wood, 36¼" high. Yale University Art Gallery, New Haven.

William Rogers, *Walking Stick*, 1939. Wood, 33¼" high. Dr. and Mrs. William Bascom, Berkeley.

Jesse Aaron, *Totem*, 1970s. Wood and fiberglass, 70½ x 10 x 8". Donald N. Cavanaugh, Jr., Gainesville, Florida. Cat. no. 6.

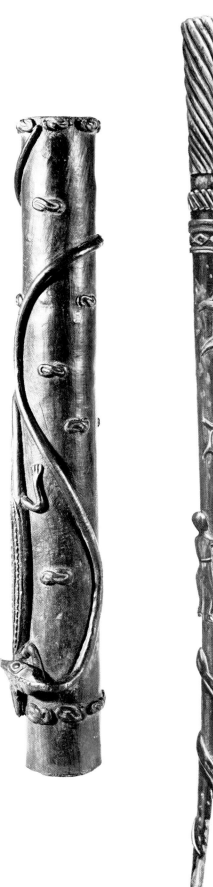
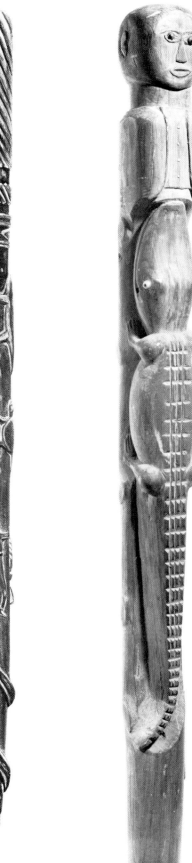
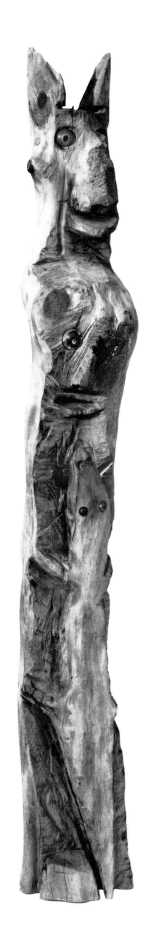

come out of the patient, she gently massaged her arm, pretending to work the lizard down the patient's arm to the fingertips. Then she gave a sudden fling and slung the lizard out of her sleeve and onto the floor. Curious onlookers cried and fled. The woman was from that moment cured.[4]

In many parts of Africa it is a traditional belief that witches travel in the form of animals—owls, bats, black cats, etc.—to bring death and disease to unfortunates. This is an interesting observation in relation to a testimony by George Boddison of Tin City, Georgia: "A person can take such a thing as a cat or dog or a lizard. They can kill this animal and they have some way to cause its spirit to be evil. But these (charms) that I wears keeps all these things from hurting me." Similar charms are still used by some Black Americans to ward off evil spirits, in the form of a rabbit's foot, four-leaf clover, a coin worn around the neck or leg or a horseshoe nailed above a doorway. The witches of African legend are most commonly seen in the form of reptiles in Southern American art.

The world of witches and enemies is very real in the minds of traditional West Africans and their Black American descendants in the Southern part of the United States. The designs which combine human and reptile motifs and the frequently occurring lizards, reptiles and alligators on Afro-Georgian canes are almost certainly related to the witchcraft beliefs of the owners and makers. A cane embellished with the proper motifs might be used to protect the owner by warding off evil spirits or even to inflict harm upon or neutralize those enemies who come in the form of snakes and lizards. At any rate there is a close and definite relationship between staffs found along the lower areas of the African Congo and their similar counterparts, the "conjuring sticks" of tidewater Georgia and South Carolina. As noted above, the Black American carver who influenced Henry Gudgell might well have come from Georgia because of the strong African survivals in the tidewater area of the state. *Drums and Shadows* revealed that in 1790 the Black population of the area was 70%, and slaves were being brought in illegally as late as 1854.

The career of a more contemporary Afro-Georgian carver, James Cooper, is well-documented. He was influenced by his grandfather, Pharoah Cooper, who carved objects in wood. James Cooper lived in Port Wentworth and earned his living primarily by selling lunches to refinery workers, cobbling shoes, and doing general repair work. However, James Cooper also carved walking sticks in his spare time and was affectionately known in his Black American community by the nickname of "Stick Daddy."[5] His walking sticks were embellished with a variety of motifs, including snakes, tortoises and alligators. His designs were usually carved in low relief on one side of the cane and stained. Another characteristic of Stick Daddy's style was his representation of reptiles, usually seen from above, with geometric incised designs revealing the white of the unstained wood.

Another master of the south coast of Georgia was William Rogers of Darien. Rogers engaged in the craft of woodcarving in addition to his career in cabinetmaking. During the 1930s Rogers carved a small wooden frog at Darien with a raised triangular head, beaded eyes and an open seamless mouth. The shoulders of the frog were powerfully rounded and the three-dimensional mass of its body well articulated. During the same period, Rogers carved a figurated walking stick now in a private collection in Berkeley, California. At the top of the staff the head and bust of a male human figure may be seen from a frontal position. Immediately below the human is the full-length figure of an alligator seen from above.

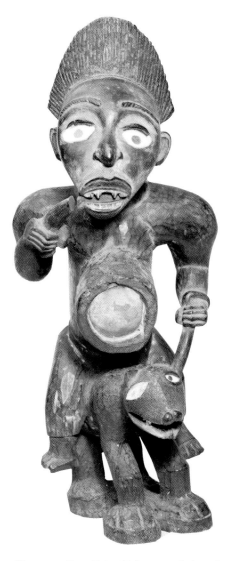

Figure on Dog, Zaire (Bakongo tribe), 19th century. Carved wood, 10″ high. Metropolitan Museum of Art, New York.

facing page:
William Dawson, *Gorilla*, 1977. Carved and painted wood, varnish, 10½ x 5½ x 2″. Roger Brown, Chicago, Cat. no. 87.

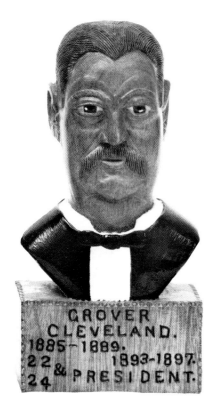

Ulysses Davis, *Grover Cleveland*, from *Forty Presidents* (39 busts, 1 presidential seal), 1970s. Mahogany and paint, approximately 8 x 4 x 2½" each. Ulysses Davis, Savannah. Cat. no. 68.

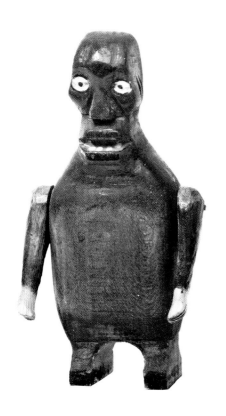

The African influences in the Rogers walking staff, as late as the 1930s, may be summarized in the choice of motifs (man and reptile), the use of several vantage points (man seen from frontal position, alligator from above), the love of bichromy (red cedar wood and black paint), and the embellishment of surfaces with colored beads. The African tradition of colored beadwork and the mixing of the main medium of sculpture with other materials are both well known in Nigeria, the Congo and especially in the beaded statuary of the Cameroon. It is common to find beaded eyes among African figures, but the beads frequently form the pupil of protruding carved eyes rather than the eye *per se*, as in the Afro-Georgian examples. In both subject matter and the use of insets for eyes, the works of William Rogers provide a link between African prototypes and contemporary carvers such as Ulysses Davis and Elijah Pierce.

Sculpture has also been used by Black Americans as a form of grave embellishment. In West Africa and Congo-Angola, it is a common practice to place household objects belonging to the deceased on the grave. Testimony collected in *Drums and Shadows* attests to the continuation of African practices in rural Georgia. An informant from Darien recalled, "Them dishes and bottles what put on the grave is for the spirit and ain't for nobody to touch them. That's for the spirit to feel at home." A Harris Neck resident said, "You put dishes and bottles and all the pretty pieces what they like on the grave. You always break these things before you put 'em down. You break them so that the chain will be broke. You see, the one person is dead and if you don't break the things, then the others in the family will die, too." In the Brownville section of Georgia, an informant stated, "They used to put the things a person used last on the grave. This was supposed to satisfy the spirit and keep it from following you back to the house."

One of the most dramatic examples of Afro-Georgian funerary art is the burial plot of the Bowens family at Sunbury, which was landscaped and decorated by Cyrus Bowens. The Bowens plot is mentioned in *Early Days of Coastal Georgia*, by Margaret Cate, and was also investigated by the W.P.A. Georgia Writers Project and Robert Farris Thompson. The small, fenced burial plot is located on the grounds of the Sunbury Baptist Church Cemetery in Liberty County, Georgia. The graves were created by Cyrus Bowens as oblong concrete slabs set in the earth, with a headstone at one end and a smaller footstone at the other. Iron poles were placed over a few of the graves for the purpose of supporting pots occasionally filled with flowers by surviving members of the family. In addition, Cyrus Bowens assembled some of the traditional Black American grave embellishments and implanted them in the concrete while it was still wet. For example, the grave of Aaron Bowens is marked by a headstone which is inset with the light of an automobile gleaming like a gigantic eye. The grave of Rachael Bowens bears a marker with an inscription and a representation of a human hand in whose palm a piece of mirror is embedded.

Finally, Cyrus Bowens carved wooden sculptures as the focus of the burial ground, providing some of the most unusual and dramatic examples of funerary art of that area. Bowens's sculptures consisted of a grouping of three pieces. The central design is extremely simple, basically a sphere on a cylinder. The features of a face are simply cut into the sphere to represent human eyes and a mouth, and a few inches below the head is the name Bowens. Originally, to the left of the central human figure stood a representation of a serpent, the base of which was an inverted fork with the handle supporting the form. The serpent was carved from a single

curved branch of tree and attached to the vertical support. The serpent's neck appears arched as if in an attack position. Flanking the right of the human figure was another piece of sculpture which rose over twelve feet into the air. Although the sculpture has been referred to as a bird, its powerful defining curve is more serpentine in nature. Regarding the significance of the human flanked by serpent imagery in these cemetary figures, the serpents could represent guardians to drive away evil spirits.

William Edmondson provides the only example of grave decoration in the present exhibition: he began by carving tombstones, and soon embellished them with animal figures. But grave sculpture represents a more significant aspect of Black folk art than this one example would suggest. Certainly, the spirit-warding purpose of much of the work in this exhibition links it to Black funerary art, both past and present. David Butler comes most immediately to mind, with his snipped tin creatures surrounding his house and covering his windows and doors. In its scale and environmental character, funerary sculpture also brings to mind the work of contemporary environmentalists such as Leslie Payne, Steven Sykes and, again, David Butler.

POTTERY: AFRO-GEORGIAN AND AFRO-CAROLINIAN FACE VESSELS

During the first half of the nineteenth century, Georgia and the Carolinas produced a tradition of pottery-making which is unique in the history of American ceramics. Slaves who were employed in plantation potteries fashioned a variety of small vessels in their spare time, for private use, which characteristically depict the features of the human face. That category of vessels is known by a number of terms including "plantation pottery," "voodoo pots," "grotesque jugs," "slave jugs," and even "monkey jugs." They are most appropriately described as Afro-Georgian and Afro-Carolinian face vessels. The stoneware vessels were made of local clay and glazed in a variety of colors ranging from light olive-gray to dark brown and black. The facial features of the vessels are frequently tormented; however, some examples are static, smiling and a few are suggestive of a voice raised in song. The eyes and teeth of the vessels were sometimes fashioned of kaolin (white clay) which provides a striking contrast in color and texture against the darker backgrounds.

A small group from among the many works produced at Miles' Mill Plantation in South Carolina comprise the finest-known examples of face vessels. Archives at the Charleston Museum support the theory that these were the creations of Black Americans. The majority of these vessels have prominent noses with pinched nostrils and a bridge which extends to meet the central section of prominently-arched eyebrows and diminutive ears. Large, widely spaced eyes with pierced pupils were fashioned of kaolin and set within deeply-rounded sockets from which they glow intensely. The clenched teeth of the open mouths of many of these vessels were also frequently fashioned of kaolin with the lower row of teeth much larger than the upper.

The similarities between certain Bakongo figural sculptures of Zaire and the finest Afro-Carolinian face vessels produced at Miles' Mill appear too close to be coincidental. These similarities are chiefly noticeable in the use of inserts of a lighter color for eyes and in certain facial expressions. It is entirely possible that some of the Miles' Mill potters were born in West Africa and were familiar with local tradition of figure sculpture or knew someone who practiced in that manner. Documentation attests to the fact that some 22,000 slaves from the Congo-Angola area were brought

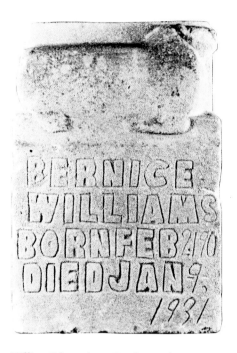

William Edmondson, *Tombstone for Bernice Williams*, c. 1931. Limestone, 17½ x 11¾ x 5½". Dr. and Mrs. Virgil S. LeQuire, Franklin, Tennessee. Cat. no. 105.

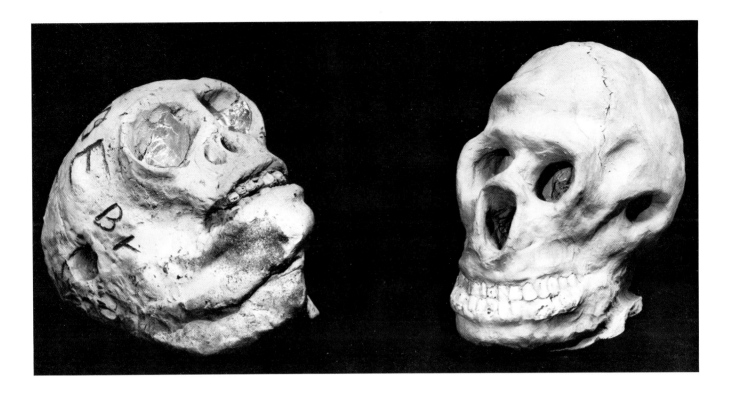

James Thomas, left: *Skull with Corn Teeth and Foil Eyes*, c. 1970. Unfired clay, corn kernels and tin foil, 7½ x 9 x 5". Center for the Study of Southern Culture, Oxford, Mississippi. Cat. no. 260; right: *Skull with Corn Teeth*, 1973. Unfired clay, floor wax and corn kernels, 8 x 5¼ x 8". Mississippi State Historical Museum, Jackson. Cat. no. 263.

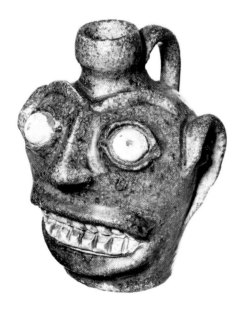

Face Vessel, 19th century. Fired clay, 5¾" high. National Museum of American History, Smithsonian Institution, Washington D.C.

to South Carolina during the eighteenth century. In fact the largest mass of African slaves in South Carolina during the eighteenth and nineteenth centuries were of Congo-Angolan origin.

A great deal of speculation has been advanced concerning the function of these unusual pieces, which are almost never dated. One theory is that the vessels were made to contain alcoholic spirits or were made in imitation of spirits to which a kinship to African art and religion may be traced. Since the sizes and shapes of the vessels are so variegated and some of the finest examples are only about four inches high, the notion of their use as containers seems illogical. A link between the vessels and religious spirits is not easy to dismiss when one considers the number of African traditions which survived in Georgia and the Carolinas for many years after the slaves were brought to that area. However, the diminutive vessels were produced in fairly large quantities and their obvious use in religious practices would have aroused suspicion on the part of the Anglo-American slave owners. Although it is well documented that the majority of face vessels were created in Georgia and South Carolina, they have been found as far north as upstate New York and as far west as Tennessee and Ohio. Generally speaking, they were found in the vicinity of the underground railroads which indicates that they were important enough to escaping slaves to be included among their prized possessions. They might have been regarded as good-luck pieces.

In a search for prototypes for Afro-Carolinian face vessels, English Toby Jugs necessarily come to mind. These are basically hollow china figures on low seats. They represent short, grinning men wearing deep-pocketed coats with large buttons, wide cuffs and a tricorn hat. The earliest examples are attributed to Ralph Wood (1716–72) of Burslem. But these are smoothly finished and represent naturalistic features which are in direct contrast to the finest works of the Afro-Carolinian tradition. The use of kaolin inserts to form eyes and teeth in the body of the pottery strongly recalls certain

African works instead. The use of mixed media in African figural sculpture—mirror insets in the eyes, buttons, cowrie shells, nails, brass studs and beads—is one of the most important traits of West African sculpture. This is a phenomenon that persists in much Black American sculpture today, and may provide the compositional basis for the use of eye inserts in face jugs.

QUILT MAKING

For many generations Black American women in the South have engaged in the art of making patch-work quilts. And it remains a common practice among rural Southern Black American women to hold "quilting bees" at which a group of women assemble around a frame and the three parts of a quilt (design top, cotton interlining and muslin backing) are "quilted," or joined, into a single cover. Quilt-making is not specifically an African tradition, as the warm climate of that continent does not necessitate heavy bed-covering. However it is possible that the tradition of patch-work quiltmaking is related to the African tradition of decorative textiles. As the designation "soul food" applies to certain delectable dishes which were originally created by innovative Black American slave cooks from the cast-off parts of the hog and scraps from the Big House kitchen, so the early slave seamstresses created works of art from discarded scraps of cloth. Decorative quilt art is not entirely a Black American phenomenon. Interesting and beautiful examples may be seen among the Amish and Pennsylvania Germans as well as others. However, the Anglo-American examples are often more formal and complex in design than the Southern Black American examples.

Black American quilt patterns are handed down from generation to generation, and it is not uncommon for women to possess samplers which illustrate some of the most frequently depicted examples. The patterns are basically geometric among which some of the most popular are "Sawtooth," "Single Chain," "Double Chain," "Pineapple," "Wedding Ring," "Rising Sun," "Triangles," and "Lone Star." Another popular pattern is the "Crazy Quilt" which combines scraps of materials of many sizes and colors in an informal arrangement with an absence of the geometric compartmentation which characterizes most examples.

Two unusual examples of Black American quilt art which depart from the typical geometric patterning are the so-called "Harriet Quilts" in the collection of the Smithsonian Institution and Boston Museum of Fine Arts. The quilts were fashioned during the 1880s by Harriet Powers, a Black American woman born a slave in 1837, who lived on the outskirts of Athens, Georgia. Fortunately, the Harriet Quilts are well-documented and a considerable amount of information about the designer is known.

Harriet Powers was the wife of a farmer and, following her emancipation, apparently engaged in quilt-making as a hobby. The Harriet quilt in the Smithsonian Institution was first referred to in 1886 when it was exhibited at a "Cotton Fair" in Athens, Georgia. This work is a vivid interpretation of Biblical scenes from the Old and New Testaments. The basic colors are very striking with a bright pink background and green strips outlining the compartments and border. The quilt is divided into eleven scenes beginning with the Garden of Eden and ending with the Nativity. When the Smithsonian quilt was purchased from Harriet Powers in 1890, she painstakingly explained its iconography to the purchaser, who recorded it at that time.[6] Without Harriet's own descriptions it would be difficult if not virtually impossible to interpret the scenes.

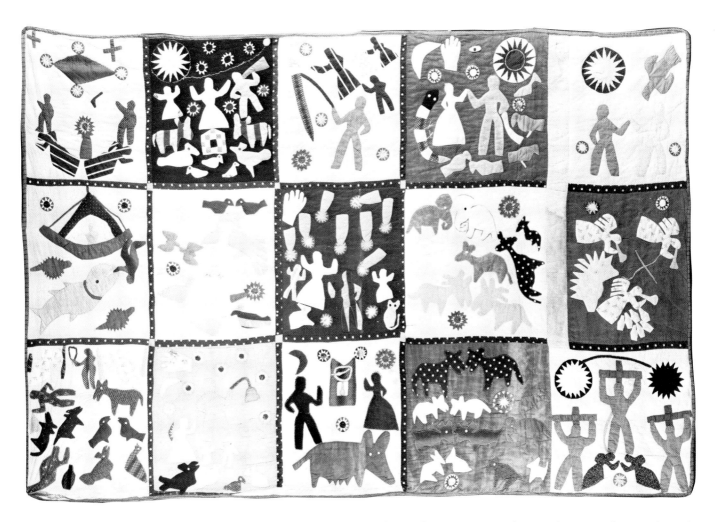

Harriet Powers, *Bible Quilt*, c. 1895. Cotton
fabric, 68 x 105". Museum of Fine Arts.
Boston, M. and M. Karolik Collection.

The first scene in the quilt represents Adam and Eve in the Garden of
Eden listening to the subtle whisper of a delightful candy-striped "serpent
which is beguiling Eve." The next scene continues the Paradise theme,
but Eve has conceived and given birth to Cain who appears in pantaloons
and has adopted a splendid Bird of Paradise as a pet. Other scenes represent
Satan "amidst the seven stars," Jacob's dream, Christ's Nativity, Baptism
and Crucifixion, and the "star that appeared in 1886 for the first time in
three-hundred years."

The Boston Museum quilt by Harriet Powers was completed several
years later than the Smithsonian example. It is larger and has a background
consisting of contrasting squares of colored calico, though the technique
of applique over a quilted background is identical in both of the quilts.
The scenes in Harriet Power's Boston Museum quilt are smaller, contain
more details and present a more complicated iconography than the
Smithsonian piece. The iconography of the Boston quilt was also pains-
takingly explained by Powers in 1898.[7] The quilt portrays a combination
of religious and astrological symbols, perhaps indicative of Powers's
concept of their synonymity. Along with familiar religious scenes such as
Job praying for his enemies, Jonah's plight and the Crucifixion are unusual
astrological representations. Powers was obviously referring to an eclipse
of the sun in the scene depicting the "dark day of May 19, 1780 when the
seven stars were seen at twelve noon. The cattle all went to bed, chickens
to roost and the trumpet was blown. The sun went off to a small spot and

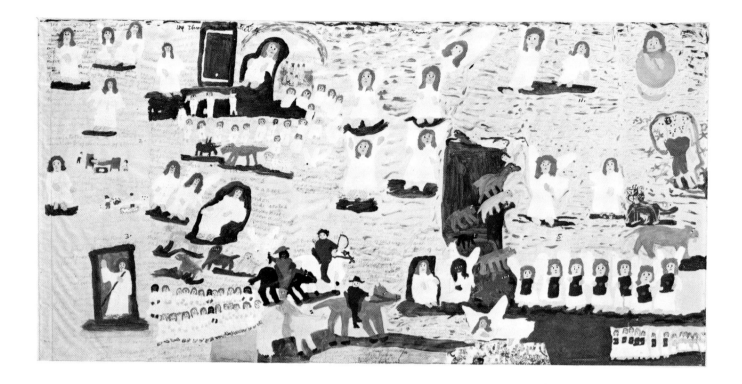

then to darkness." Another scene depicts an astrological occurrence, the "falling of the stars" on November 12, 1833. A scene particularly suggestive of mood depicts Cold Thursday, February 10, 1895 when a woman is seen frozen at prayer, another woman is frozen at a gateway, and a man is frozen at his jug of liquor. The Red Light Night of 1846 also appears, and a man is seen tolling a bell to notify the people of the wonder. The most unusual scene in the Boston Museum Harriet Quilt portrays Bob Johnson and Kate Bell of Virginia, "rich people who were taught nothing of God," and a large hog described by Harriet as "Betts," who ran five-hundred miles from Georgia to Virginia. Powers's combination of scenes and astrological occurrences may be interpreted as warnings to the sinful of the infinite power of God which is demonstrated to mortals through eclipses, falling stars, red light nights and extreme temperatures. The Harriet quilts are unique in the history of American art. The imagination of the designer, the composition of the scenes, the attractive color combinations, and the method of execution elevate the designs above the status of mere quilts to paintings in fabric.

As there are apparently no American prototypes for Harriet Powers's designs, one questions whether her style developed in total isolation. The iconography, the attempt to tell a complete story in each panel, the proportions of figures in the quilts are decidedly Western. However, the technique of appliqued designs to illustrate a story are closely related to similar practices in Dahomey. Dahomean court textiles display lively designs cut from brightly colored fabrics and appliqued to contrasting background. African examples disregard formal ground lines, as the Harriet examples, but are generally not compartmentalized, as the present examples are. It seems reasonable to suggest that some of Harriet Powers's relatives were brought to Georgia from an area in Africa where applique designs are common. Harriet Powers might have seen some local examples similar to Dahomean designs and derived her own.

Sister Gertrude Morgan, *Book of Revelation,* c. 1965–70. Paint on Windowshade, 4' x 6'. Herbert W. Hemphill, Jr., New York. Cat. no. 130.

36

Finally Harriet Powers's interest in celestial phenomena appeared to have been above average. It is possible that she considered herself a self-ordained prophetess or spiritual medium who spoke of God's powers through her quilt art. It is interesting to consider her in this light beside Sister Gertrude Morgan and James Hampton, both of whom also felt they had special visionary powers. It is hoped that additional works by this unusual quilt-artist will be discovered, as apparently there was no similar school of designers.

It is against this illustrious background that the works in the present exhibition were produced and should be viewed. A period of some four-hundred years has elapsed since the ancestors of these Black American folk artists were physically separated from the land, art and cultures of their origin. Prior to the Civil War, African influences were strongly manifest in slave-made artifacts in the deep South. Following the Emancipation Proclamation and the widespread migrations of free Blacks, many links in this stylistic chain were broken. However, one of the most remarkable facts about twentieth-century Black American folk art is that in spite of its apparent dissociation from Africa, certain of the motifs and design elements are undeniably African. The pre-Civil War links of the African-inspired stylistic chain, which was such a strong and vital force in slave folk art, were broken but not lost. For the artistic and cultural links were scattered like seeds on fertile soil in all parts of America. They quickly took root and thrive in various forms even today.

REGENIA A. PERRY
Professor of African and Afro-American Art History
Virginia Commonwealth University
Richmond

1. Archives of Abby Aldrich Rockefeller Folk Art Center, Williamsburg, Va.
2. Thompson, Robert Farris, "African Influences on the Art of the United States," paper published for symposium "Black Studies in the University," held at Yale University, New Haven, April, 1969, p. 128.
3. *Drums and Shadows*, Georgia Writer's Project of the Works Progress Administration, Athens: 1940, p. 10.
4. Puckett, Newbill N., *Folk Beliefs of the Southern Negro.* Chapel Hill: 1926, p. 303–304.
5. *Drums and Shadows*, p. 10.
6. Archives in Smithsonian Institution. National Museum of History and Technology, Washington, D.C.
7. Archives in Boston Museum of Fine Arts.

Spiritual Epics

The Voyage and the Vision in Black Folk Art

A deserted road disappears into a mountainous landscape in Joseph Yoakum's drawing of *Mt Thousand Lakes In Bryce Canyon National Park near Hanksville Utah*. A similar road appears in many of his landscapes: *Andes Mt. Range La Paz Bolivia; San Jaquan Valley of San Luis Obispo County; West Tip of Ohio Valley at Chariot Kentucky*. They are winding roads, occasionally interrupted by landscape features but always dwindling into the distance. Though they are empty, they are roads that Yoakum traveled often in his lifetime, perhaps physically but certainly in his spirit. He claimed he had visited every continent but Antarctica as a handyman with the circus, a valet to John Ringling, a hobo or a stowaway. He may rarely have left Chicago; there is little to document his wanderings. But the respective measures of fact and fantasy in Yoakum's account of his life are of little significance to the awesome quality of his work. What is important is the extent to which these voyages motivated him in his art. Thousands of his drawings record the landscapes of our world, but in the imagery of his imagination. They are all landscapes through which Yoakum believed he had traveled.[1]

Yoakum was once challenged on his representation of mountains in western Iowa. A visitor to his Southside Chicago storefront home remarked that, although he had grown up in Iowa, he had never seen mountains such as Yoakum's. "Well, that was because you never looked," Yoakum replied.[2] Elongated, flame-like shapes, his mountains are colored in shades of lavender and yellow in addition to his more customary green, grey and brown. Volcanic cones end in scallops, like enormous flowers; faces emerge from the linear patterns that represent rock ledges; and groves of trees grow in waving bands. Yet for Yoakum, these mountains existed. He never doubted the veracity of his vision, which accounts for the deliberate and unwavering character of his line. "The drawings are unfolded to me, a spiritual unfoldment," Yoakum recounted. "After I draw them, I have a spiritual remembrance and I know what is pictured."[3] Whether Yoakum had visited the landscapes or not, he had seen them in his spirit.

William Edmondson was inspired by a more specific revelation. A tombstone one day appeared in the sky before him, and the voice of God commanded him to carve.[4] As with Yoakum, the vision provided both the motivation to make art and the specific imagery. Edmondson quickly went beyond tombstones in his limestone carvings, to angels, brides, school-

teachers, horses and entirely imaginary creatures. "I see things in the sky," he reported. "You can't see them, but I can see them."[5] Like Yoakum, he insisted that what he had represented he had seen, whether physically or spiritually.

Edmondson and Yoakum are representative of numerous black folk artists in their reliance, even insistence, upon visions as the principal force behind the creation of their art. Visions recur as a theme in the countless variations in subject matter and style that characterize black folk art. For some of the artists, these visions might be more prosaically described as inspiration. For others, they have the fullness and irrevocability of the apocalypse and are the sole mission of their lives. For a small number—Yoakum seems to be the only example of overlap—the vision is transmuted into the romance of the voyage. But both the vision and the voyage are of the spirit; they are thereby indicative of a signal characteristic of black folk art. Although these predominantly elderly artists have lived much of their lives in a kind of physical and economic constraint, an alienation from the opportunities promised by our society to all, they nevertheless exhibit a spiritual resilience that enables them not merely to endure but

William Edmondson outside his workshop in Nashville, 1941.

to speak proudly and emphatically through their art. They are possessed by an irrepressible genius that compels them to create despite the absence of a substantial audience or the recognition and approval of the larger society.

At times, as in the case of Sister Gertrude Morgan, the work of these black folk artists is nearly overwhelmed by the sheer force of the maker's personality. Yet it is the spiritual power of this art that so often commands our attention and respect. The work varies from the crude to the very polished in execution, yet it is nearly always endowed with a phenomenal richness of spirit in both motivation and implication. This strength of spirit enables the artists to transcend the limitations of their lives, and confers upon their art a quality that transcends the ordinary. The voyage and the vision are primary among the expressions of their spirits: they are the metaphors of transcendence.

<p style="text-align:center">★ ★ ★</p>

Leslie Payne grew up near the Chesapeake Bay in Virginia's Northumberland County. He worked on the water as a fisherman and a crabber, at least part of his life with a Capt. G.H. McNeal out of Fleeton. Not surprisingly, the boats and fish so central to Payne's life appear as the subject of many of his painted wood and metal sculptures: folk artists, like many of their more schooled colleagues, turn to local imagery in a desire to express the specific character of a place. However, Payne's imagination wandered as well. He traveled a bit, as suggested by the ticket for a bus tour of New York City included in a commemorative bottle sculpture. He admired those who had achieved mobility and, most especially, flight. A series of works, including the bottle sculpture, pay tribute to Charles Lindbergh and his solo crossing of the Atlantic. *Sunrise Sunset* is one of these; it was originally installed in two parts in his yard near Reedville, Virginia. The first part consists of a small plane (37″ long) of the sort that Lindbergh flew, mounted on a post. It is made of wood covered with metal and has a single engine and propeller, plastic wheels and overhead wings supported by struts. The engine is elaborate and oversized, containing eight spark plugs with rubber wires connected to the propeller. Next to the plane stood a cut-out and painted sign board: over a representation of the Atlantic complete with waves and whitecaps the sun shines in red, yellow, blue and white rays; an arrow points to the ocean and bears the legend "cross Atlantic Ocean;" "Sunrise Sunset," the rest of the board announces, "Lindbergh Fly in 1927."

Payne dreamed of a flight for himself. Inspired originally by some World War bi-planes he had seen at an air show in Northumberland County in 1918, he began to make large-scale replicas of the planes of his youth. The recollections of Payne's visitors suggest that this activity took place primarily in the sixties and early seventies, though Payne repeatedly disassembled old planes to make new ones and so might have made several before this time. By the mid-seventies he had in his yard three or four of these model aircraft, each about fifteen feet long. They were fabricated of sheet metal with struts and wires to secure the wings, tail sections and landing gear; they were painted and decorated with flight decals and flags. Most were bi-planes, though there was also a replica of the "Spirit of St. Louis." One included a seventy-five horsepower engine that propelled the plane around the yard and on the adjacent highways.

Leslie Payne outside his machine shop at his home near Reedville, Virginia, c. 1973.

One of Leslie Payne's wood and metal aircraft, a 15' long replica of a bi-plane.

These aircraft were the vehicles for a series of fantasy journeys taken by Payne, sometimes in the company of neighborhood children; he would record these voyages in a log book.[6] One girl in particular, Pamela Annette Betts, participated in Payne's imaginative activities. Several Polaroid photographs from 1973 show her seated in a plane, in white gloves, flight cap and goggles, while in the background, Payne works on the plane's engine. In another, she sits behind a typewriter, perhaps preparing flight reports. Payne and his companions departed on these imaginary voyages from a grass yard that was kept clipped like a landing strip. To one side stood Payne's machine shops, which housed an extensive collection of tools. Payne, too, traveled in flight gear and overalls that bore a large decal reading "Old Airplane Builder Homemade."

The preparations for an earlier trip were recorded on a collage made by Payne and dated August 16, 1967. It reads in part: "two girls flying old model airplane year back in 1918 in First World War . . . they want to fly down to Langley Field Air Port gas up and oil up . . . want to a long flying to Geneva Switzerland New Mexico Newport News and back to Reedville . . ."[7] Taped to the back of the collage are Polaroids of Payne with his two travelers, Christine Gray and Darlene Hudnoll. In one, Gray and Payne work on the plane; in another, Hudnoll waves farewell from the cockpit. But apparently the flight plans went awry. "We girls not gone yet . . . mite run into fog (or) have rain," the collage concludes. "We get in my car and go way we wants to go."

Payne's fellow Virginian Walter Flax had similar dreams of a voyage. He too lived by the Chesapeake near the port towns of Yorktown, Norfolk and Newport News. His fascination was with boats; it began as a teenager during the First World War when he would ride his bicycle to the water to watch the battleships and freighters come and go from the Navy yards and docks. He hoped to go to sea with the Navy, but reported: "When that first war came, I wasn't smart enough. When that second war came, I was too game-legged."[8] A photograph from his youth restates the dream. It shows him posed in front of his small home dressed in a sailor's outfit.[9]

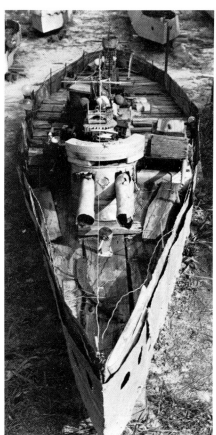

A single ship from Walter Flax's armada.

Walter Flax surrounded by his entire fleet of ships at his home near Yorktown, Virginia, c. 1975.

Flax's thwarted hopes expressed themselves in a project that consumed him for much of his later life. If the Navy wouldn't have him, he must have reasoned, he would become the master of his own fleet. So boat by boat he constructed an armada of ships that surrounded his house. Built of wood and scrap metal, the boats ranged in size from two or three to twenty-five feet. They included battleships, tugboats, submarines, steamships and cruisers. Cast-off buckets and gas cans with pipes attached formed guns, metal tubes represented smokestacks, and on one, a toy cash register suggested the bridge. Gauges, plastic electrical sockets, light bulbs and wooden ornaments completed the details. A refrigerator tipped on its back and filled with water served as a pond on which to sail the ships.

Flax was born sometime around the turn of the century and was raised by his grandmother. Though he resides now in a hospital, he lived alone for most of his life in a two-room frame house set by itself in a clearing in the pine woods that was accessible only by a footpath. He worked as a handyman, commuting to his jobs by bicycle. Along the way, he would gather the detritus that composed his sculptures. It is not known precisely when he began construction of his armada—his memory is not sharp—but a newspaper photograph from the forties shows that by then progress was already well underway.[10] Until very recently these ships were to be the only resolution of his hopes for a voyage: the Navy, learning of his miniature armada from newspaper accounts, took him for his first real cruise.

Aircraft also captured Flax's imagination. He fabricated two crude wooden planes, one about two feet long, the other about five, and mounted them on posts near his house. Both were bi-planes—though not as elaborate as Payne's—made from logs, floorboards and plywood. And in the yard of Steve Ashby's abandoned home near Delaplane, Virginia, the ruins of yet another plane can still be found. Fashioned of a six-foot wooden post that formed the body of the aircraft, it had plastic-covered wings and bicycle wheels. It was connected by extension cord to the electrical system in the house so that its running lights could be illuminated. Although this plane was incidental to most of Ashby's work, which focused on remarkably inventive small and life-sized human figures, animals and whirligigs, it was the largest piece he ever made and stood very near the road.

For those born early in the century that witnessed the birth of flight, such a fascination with planes is perhaps not inexplicable. Yet considered together with the elaborate fantasies constructed by Payne and Flax and perhaps Yoakum as well, they take on a significance well beyond mere curiosity. To a considerable degree, the lives of all these men were educationally, economically and hence physically circumscribed; even Yoakum, if he had traveled as widely and lived as freely as he claimed, had not done so for many, many decades by the time he was depicting his journeys. Payne's flights and Flax's cruises seem responses to these physical constraints. Their aircraft and ships are emblems of opportunities missed, places unseen and dreams unrealized. Yet neither man, if we can trust their photographic portraits, felt unfulfilled. Indeed, the image they project is one of confidence and self-command. Whatever limitations they perceived in their lives, whatever opportunities they felt were denied them, they must have found compensation in their artwork. The spiritual voyages of these artists must have been a powerful medium of deliverance.

★　　★　　★

Something akin to this desire to escape the physical constraints of life seems to inspire visionary art as well. The urge for deliverance is the same in both the voyage and the vision. But while the former is limited to the temporal, the latter is more frequently spiritual. Occasionally, the vision reinterprets history or reveals the supernatural. But most often, it promises redemption, describing a more perfect world.

Such was the nature of James Hampton's vision. He had numerous revelations of a distinctly religious character; they began when he was twenty-two and living in Washington, D.C. "This is true," he wrote, "that the great Moses the giver of the tenth commandment appeared in Washington, D.C., April 11, 1931." Fifteen years later, he received another vision. "This is true that on October 2, 1946, the great Virgin Mary and the Star of Bethlehem appeared over the nation's capital." In 1949, "This is true that Adam the first man God created appeared in person on January 20, 1949. This was on the day of President Truman's inauguration." And finally, "This design is proof of the Virgin Mary descending into Heaven, November 2, 1950. It is also spoken of by Pope Pius XII."[11] The Pope had in fact declared the Assumption of the Virgin to be part of church dogma that same day.

These visions are witness to a profoundly religious personality. They also explain the passion and determination with which Hampton dedicated himself to his life's work: the creation of his monumental *Throne of the Third Heaven of the Nations Millenium General Assembly*. Returning

James Hampton in the 1950s with an early version of his monumental *Throne*.

home each night around midnight from his job as a janitor for the General Services Administration, he would work in solitude on this project for the next five or six hours. Incomplete at his death in 1964, it had been initiated at least by 1950 when he rented the garage in which the work was executed. One component, however, bears the inscription "Made on Guam, April 14, 1945" (Hampton served in the Army and was stationed for a time on Guam). So it is conceivable that Hampton worked on the *Throne* for some twenty years.

Hampton scoured his neighborhood for materials for his *Throne*. Chairs and tables came from used furniture shops and were sometimes pulled home in a toy wagon; bits of discarded foil, cardboard and light bulbs were gathered in a sack. In his garage, these materials were used to create an environment of objects: a winged throne, pulpits, offertories, winged vases and stands, wall plaques and crowns. Foil was built up layer upon layer over the furniture and foil-covered bulbs and shapes of cut-out cardboard decorated the objects. The entire assemblage celebrated Hampton's apocalyptic vision. It is a representation of God enthroned in the heaven of heavens at the Millenium of the nations, presumably surrounded by the Saints and the Apostles and confronting the multitudes.

Hampton christened himself St. James and may have considered himself a prophet as well. He wrote in a mysterious script on tablets that may have been meant to suggest those on which the Ten Commandments were written. It has been speculated that this script alludes to God's instructions to St. John when the Second Coming was revealed to him: he was to record all he saw in a cryptic language.[12] It may also refer to the practice

The prayer room at Sister Gertrude Morgan's Everlasting Gospel Revelation Mission in New Orleans, 1973.

of speaking in tongues when possessed by the Holy Spirit. In either case, it seems clear that Hampton believed the future had been revealed to him and that he was preparing for his salvation even as he warned others to make ready.

Sister Gertrude Morgan also had a mission, literally and figuratively. She described her home as such: The Everlasting Gospel Revelation Mission. And it was her purpose to "become that Lamb through which the Lord speaks,"[13] by preaching from her home and on the street. She painted to illustrate her sermons and her vision of the New Jerusalem. Her image of the Promised Land is of a tall grid like an apartment house with numerous cheerful faces looking out; surrounding this structure is usually a group of angels, their faces framed by white wings. Sister Gertrude herself generally appears in these compositions, dressed as a bride and standing next to her groom, Jesus, at the threshold of the New Jerusalem.

One drawing, *A Poem of My Calling* (1972), tells in great detail of her motivating visions. "My heavenly father called me in 1934 on the 30th day of December . . . the strong powerful words he said was so touching to me . . . I'll make thee as a signet for I have chosen thee go ye into yonders world and sing with a loud voice for you are a chosen Vessel of mine to call men women boys and girls . . . " Inspired by this divine message, she left her home in the vicinity of Columbus, Georgia, July 1938, settling in New Orleans in February 1939. There, she worked with a fundamentalist sect and helped establish an orphanage, dressing in the

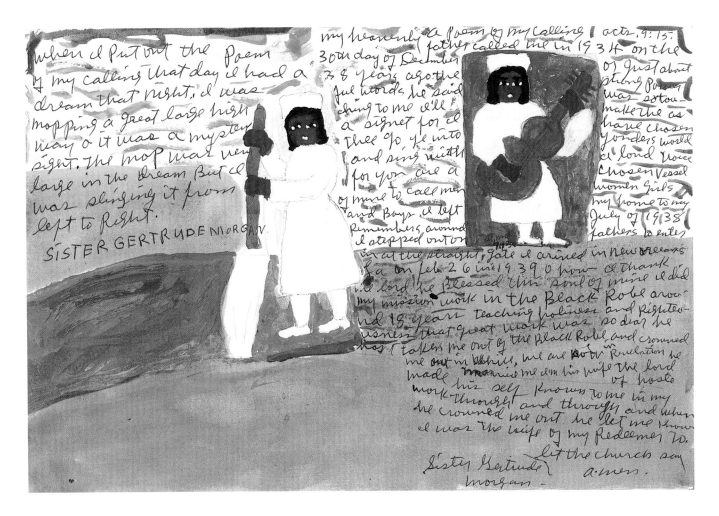

Sister Gertrude Morgan, *A Poem of My Calling*, 1972. Ink and acrylic on paper, 9¾ x 15". Susann E. Craig, Chicago. Cat. no. 155.

black robes of her denomination. In 1957, she received another vision. "I did my mission work in the Black Robe around 18 years teaching holiness and righteousness that great work was so dear he has taken me out of the Black Robe and crowned me out in white we are now in Revelation he married me I'm his wife the Lord of Hosts . . . " The drawing shows her with a mop, presumably "keeping house for Dada God and Dada Jesus," as she wrote on another work.

Other artists have worked from visions. An Elijah Pierce carving depicts an incident in which he was struck dead by God and reborn with new devotion. Jesse Aaron heard a divine voice telling him to carve. But Pierce's subject matter is about equally divided between the sacred and the profane, and Aaron's is virtually all secular. Indeed, Aaron's work is based much more in the traditional forms of Afro-American carvers: his large Totems with their reptile forms and human faces are monumental variations on nineteenth-century canes. Neither Pierce nor Aaron were nearly as singleminded in their religious inspiration as Hampton or Morgan.

As Pierce and Aaron illustrate, visions do not necessarily result in exclusively sacred subject matter, nor do they necessarily all have a sacred origin. The life of the spirit has other manifestations. Although the subject matter depicted by Sam Doyle of St. Helena Island, South Carolina, is only rarely sacred, it is replete with spiritual references. *Dr. Buz* represents the island's voodoo doctor, tuned in via a conch shell to his unseen source of

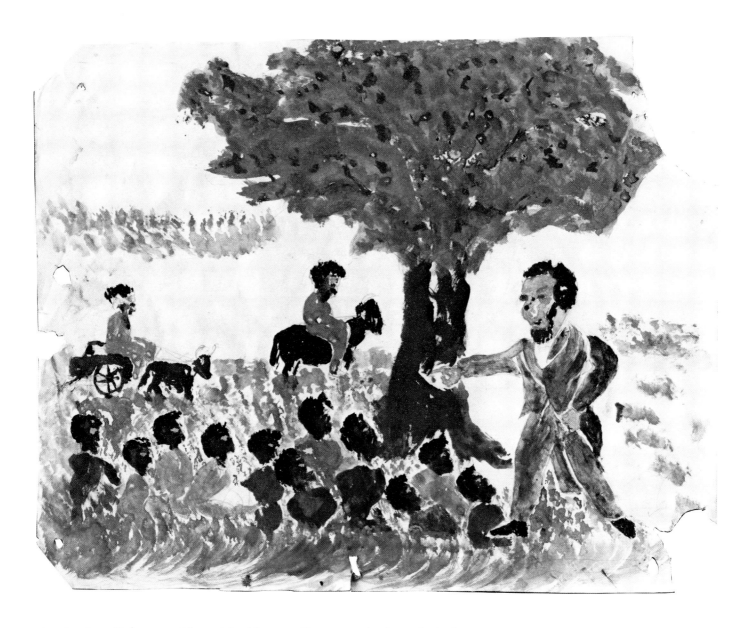

inspiration. *Fisherman Chased by Monster* illustrates the legend of a boy who was frightened to death by the appearance of a supernatural creature. These legends have the substance of truth for Doyle: he insists that the Dr. Buz of his youth "really worked" and that he or his fellow islanders have seen the spirits he represents.

A distinction between that which can be deductively proved and that which is known to be spiritually true also characterizes Doyle's representations of historical incidents. One of his watercolors is *Lincoln Preaching to the Slaves*. According to Doyle, Lincoln made a secret appearance on St. Helena early in the Civil War and spoke to the slaves under a tree at a place called Indian Hill. He promised them the island if they would support the Union cause. It is not known if Lincoln ever visited St. Helena; yet Doyle's work probably does allude to an historical occurrence. The coastal islands were among the first regions of the South to be occupied by the Union army and the first black regiment was raised there under the command of Thomas Wentworth Higginson. When Lincoln signed the Emancipation Proclamation, it therefore took immediate effect on the

Sam Doyle, *Lincoln Preaching to the Slaves,* 1970s. Watercolor and pencil on paper, 13 1/16 x 17 1/16". Private Collection. Cat. no. 95.

48

islands in a way that it did not elsewhere in the South. Large celebrations by newly freed slaves were held on the islands in January 1863; it is probably one of these that Doyle depicts.[14] While Lincoln was not in attendance, his proxy in the person of Higginson may well have been, and doubtless his presence was felt by the celebrants. Lincoln's appearance in Doyle's watercolor is probably based on legends that were handed down to him; the work reflects spiritual truth rather than historical fact. Even in the case of history, then, that which is apprehended spiritually is that which is of real significance.

Doyle's representations of the supernatural—as in *Fisherman Chased by Monster*—find a parallel in the works of others, notably Nellie Mae Rowe and David Butler. Rowe's drawing of a *Sailor* shows him as he confronts a mannequin that looks like something one would encounter only in a dream; in her drawing *Rocking Chair*, plants metamorphose into gnome-like figures. She has also represented creatures that she believes will evolve from present-day animals, as in *Something that Hasn't Been Born Yet*. Butler doesn't so much represent spirits as attempt to ward them off. His yard sculptures can be seen as efforts to fill his environment with benevolent forces, while the window awnings—which sometimes incorporate Christian images—are to block out malevolent ones. This can be inferred from Butler's prescription for protecting one's house from evil spirits. Shake salt into a sieve, he recommends, and hang it over a keyhole. Spirits passing through the sieve will then be burned by the salt. James Thomas also talks of spirits, particularly in reference to his skulls, and one assumes a similar vision of the supernatural motivates Mose Tolliver in much of his nearly hallucinatory work.

Whether dream-like, as with Yoakum, religious, as in the case of Hampton and Morgan, historical, as in the case of Doyle, or supernatural, as with Butler, Rowe and others, visions account for the genesis of much black folk art, but they do not account for all of it. As was true of Leslie Payne, spiritual motivation can exist side by side with a desire to make visible the specific characteristics of a place. The result in Payne's case is a group of works that describe both spiritual travel and the physical experiences of the fisherman. George White's narrative works also depict place, whether it is The Old Hills of Kentucky or the cowboys and Indians of the old West. Memory accounts for some other works. In the case of Bill Traylor, it was individual memory: his recollections of farm animals, coon hunting and drinking bouts provided the basis for the remarkable creative bloom of his later years. It is as if, in his age and his solitude, he felt overwhelmed by his memories and sought to exorcise them by giving them visible form. For Ulysses Davis, history joins individual memory: his carvings include portrait busts of all the Presidents. And as noted in the case of Jesse Aaron, his inspiration, at least in part, may have been in Afro-American traditions. Finally, it is possible that much of this work is produced to provide amusement, whether for children, as perhaps in George Williams's *Devil on Wheels*, or for adults, as in Steve Ashby's wildly humorous depictions of a woman copulating with a spotted mule, or a man clutching his erect penis in the company of a woman with exposed breasts.

Yet visionary works share certain characteristics with those generated by either memory or a sense of place. Sam Doyle's depictions of the supernatural legends of St. Helena are as rooted in the character of his environment as are Leslie Payne's fishing boats or George White's cowboys. There is a certain kind of heightened knowledge that comes from a long-

term association with a given locale, which expresses itself in both visionary and more specifically depictive works. And there is a sense of security that comes from a life-long identification with a community that seems to provide some motivation for many artists. Steve Ashby would take his wooden assemblages to the local store to show them off; James Thomas gives his to neighbors in Leland, Mississippi. Indeed, it seems certain that some works are created as an expression of community, that they are made to order and in the company of friends.

It is perhaps not mere coincidence, then, that most of the artists in this exhibition are from the South, where black communities are of longer standing, and that few of the artists have ever ventured far from these communities. As noted above, physical constraint is more a function of economic factors than choice; yet it is a significant determinant in this art. If one compares the work of those few artists who have spent most of their lives in the North—Yoakum, William Dawson, Inez Nathaniel-Walker and Pierce—with that of the Southern artists, one finds that, with the exception of Pierce, the work of the former seems far more dissociated from its immediate surroundings than does that of the latter. Yoakum's dream landscapes, Nathaniel-Walker's figures in mysterious social situations and Dawson's enigmatic totems of heads and houses seem far less of a place than the works of White, Rowe, Doyle or even Gertrude Morgan. Her visionary works seem the result of a close association with a complex and particularly black Gospel tradition.

<p style="text-align:center">★ ★ ★</p>

If we believe at all in the promise of our society, we shall soon see the end of much that generates this art. As educational opportunities are equalized and society becomes more mobile and homogeneous, the visions of many of these artists may disappear. The legends of St. Helena, for example, are bound to become less vivid as its population disperses and is replaced. Religion and history particular to blacks—especially slavery—will remain, but one wonders if they will continue to have the same potency for people absorbed into a mainstream culture. Certainly, the lack of preciousness with which much of this art is created will become a thing of the past, as the distinctions between art and other forms of activity are more widely taught and recognized. It is no surprise that so many of these artists are elderly, nor that they seem to have so few genuine successors.

What we perhaps have witnessed in the remarkable efflorescence of black folk art in the fifty years between 1930 and 1980—and even more particularly in the twenty years between 1960 and 1980—is the sudden maturation of a material culture even as the conditions essential to its existence seem to be disappearing. As demonstrated by Ms. Perry elsewhere in this publication, twentieth-century black folk art is not without precedent. Yet it is unparalleled in other centuries in terms of sheer quantity and variety; it is certainly equivalent to the preceding accomplishments in terms of quality as well. It may be that there is simply more interest in the visible culture of blacks now than in the past and that more of their accomplishments survive thereby. But it seems also that as conditions gradually improved for blacks in this century, particularly in the late fifties and sixties, blacks must have felt more confident about expressing themselves artistically and pursuing their artistic destinies. Whereas in the nineteenth century one perceives what Sherman Lee has described as "the ritual of survival through art"[15]—the struggle by blacks

to maintain even a slight sense of cultural identity in the face of a hostile society and through art somehow to alleviate the oppressive conditions of their lives—by the late twentieth, one sees this notion transformed into the assertion of cultural richness and racial pride through art. We have seen this happen through music, through dance and sports; it is a function of our own myopia that we have not heretofore recognized this assertion through art.

The metaphors of the voyage and the vision have been central to the achievements of self-taught black artists. Implicit in both is a resolute optimism that seems a distinguishing feature of black folk art. The voyage represents both a desire for deliverance—from the physical limitations of life—and an affirmation of belief that the world is full of majesty and mystery and worthy of scrutiny. It is a voyage from and a voyage to, a poignant yet proud expression of hope for temporal salvation. The vision, too, promises redemption and deliverance and is similarly without self-pity. Rarely, it reinterprets the past, as in Doyle's evocation of Lincoln's presence at a celebration of Emancipation. Occasionally, it reveals the supernatural and the fear and power therein. But predominantly, the vision is of the future; Yoakum's road is an emblem for it. Often, it is religious in its derivation, as in Pierce and Aaron, and in its physical expression, as in Hampton and Morgan. Even when wholly religious, it is seldom punitive or moralistic, but based on the hope of the salvation and even apotheosis of the maker in another, more perfect world.

JOHN BEARDSLEY

1. In *The Banquet Years* (New York: Harcourt Brace, 1958), Roger Shattuck discusses several themes in late nineteenth and early twentieth-century French art, among them the voyage. It is developed here because of its particular pertinence to black American folk art.

2. Reported in Whitney Halstead's unpublished manuscript *Joseph Yoakum*, p. 33, in the collection of the Department of Prints and Drawings, the Art Institute of Chicago.

3. Quoted in Norman Mark, "My Drawings are a Spiritual Unfoldment," *Chicago Daily News/Panorama* (November 11, 1967).

4. Recounted in Edmund Fuller, *Visions in Stone* (Pittsburgh: University of Pittsburgh Press, 1973):8.

5. Quoted in Fuller, p. 12.

6. Seen by Patricia Olsen of Richmond, though for the moment it cannot be found.

7. This collage is in the collection of Patricia Olsen.

8. Quoted in Elinor Horwitz, *Contemporary American Folk Artists* (Philadelphia and New York: J. B. Lippincott, 1975): 116.

9. Shown in "Fifty Ships in My Front Yard," a ten minute videotape produced by Steve Frank and shown on *P.M. Magazine*, WJZ TV, Baltimore, 1981.

10. Ibid.

11. These visions were recorded by Hampton on labels attached to his *Throne* and in the notebooks that accompany the piece. They are published in Lynda Hartigan, *The Throne of the Third Heaven of the Nations Millenium General Assembly* (Montgomery: Montgomery Museum of Fine Arts, 1977): 7.

12. Hartigan, p. 17.

13. Quoted in "Retired Street Preacher Gaining Fame as Naive Artist," *Sunday Advocate* (Baton Rouge, July 2, 1972):3F.

14. I am indebted to Peter Wood, Durham, North Carolina, for this reading of Doyle's drawing.

15. In John Vlach, *The Afro-American Tradition in Decorative Arts* (Cleveland: Cleveland Museum of Art: 1978): viii.

The Artists

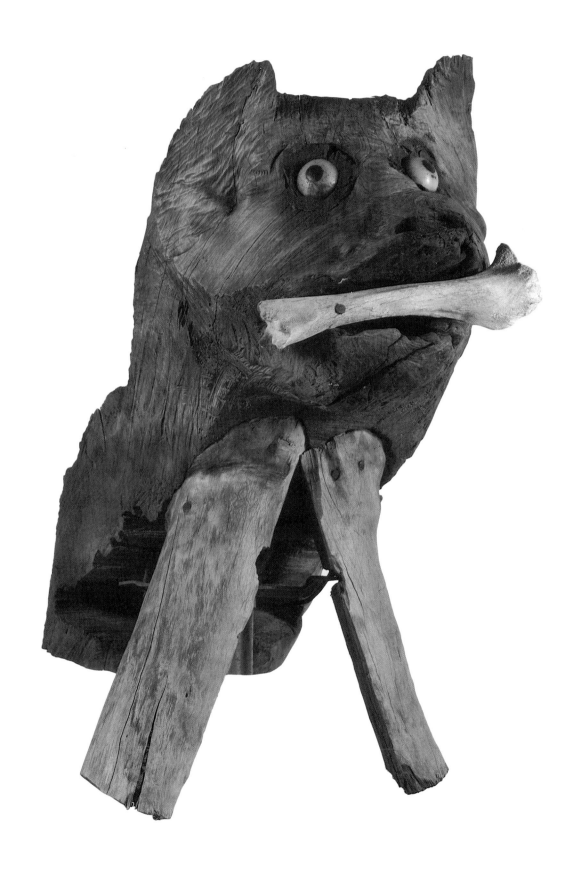

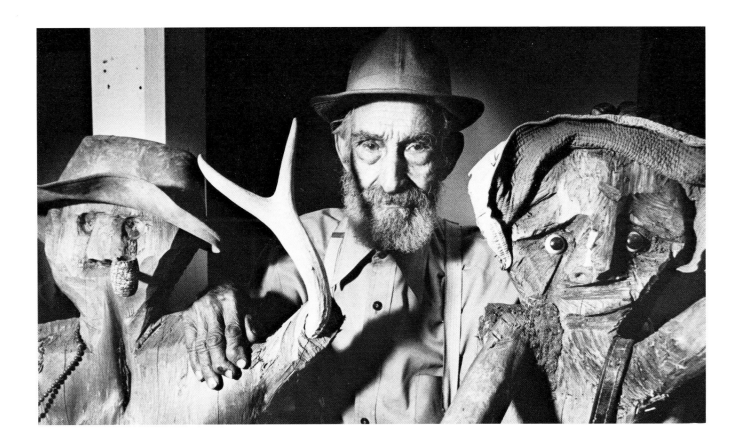

Jesse Aaron

Born 1887, Lake City, Florida
Died 1979, Gainesville, Florida

facing page:
Bulldog, 1969. Cedar, fiberglass and bone, 25½ x 12½ x 26". Stuart and Mary Purser Collection, Gainesville, Florida. Cat. no. 1.

Jesse Aaron began making sculpture only late in life. He was over seventy when his wife temporarily lost her sight because of cataracts: he was consequently forced to quit his job as a chef to stay home and take care of her. He opened a nursery on his three acres in Gainesville, selling flowers and vegetables. An operation restored his wife's sight in 1968, but Aaron had to sell the nursery to pay the medical expenses. He had never been without work and prayed that God would reveal an occupation for him. "In 1968 three o'clock in the morning, July the fifth," Aaron reported, "the Spirit woke me up and said 'Carve Wood' one time. I got up three o'clock in the morning, got me a box of oak wood and went to work on it. The next day or two I finished it."[1]

So began Aaron's energetic career as a sculptor, which lasted until his death in 1979 at age 92. He frequently cut and hauled his own wood for his carvings, preferring cedar or cypress for their insect-resistant qualities. He would choose a piece that suggested human or animal forms and draw them out of the wood. "God put the faces in the wood," Aaron insisted. "Don't bring me a piece of wood and ask me to carve something out of it. 'Cause I won't. Don't tell me what you want, it might not be there, you understand?"[2] Aaron may well have felt that his representations were of

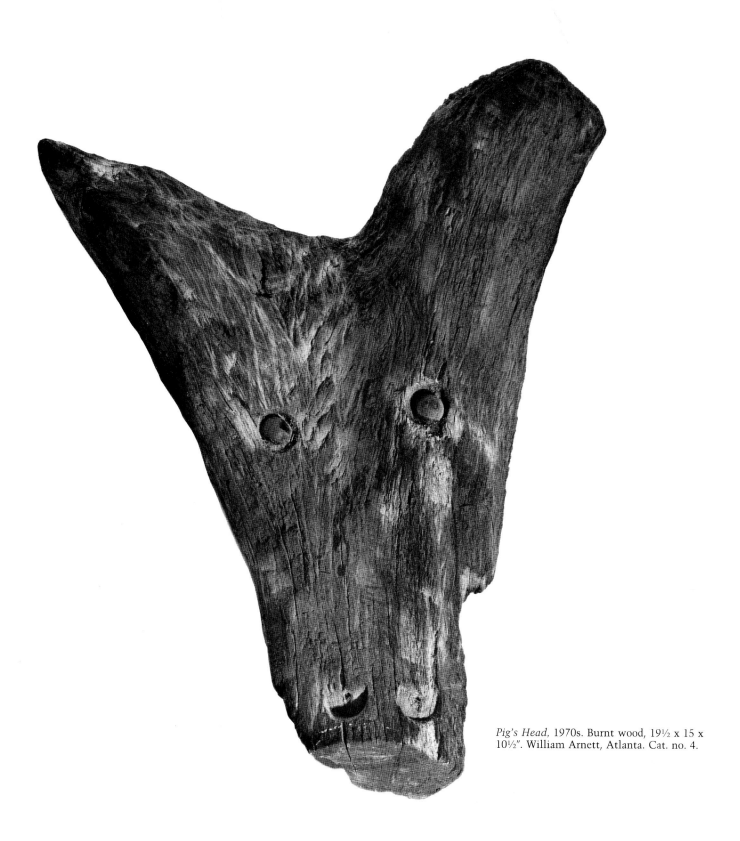

Pig's Head, 1970s. Burnt wood, 19½ x 15 x 10½". William Arnett, Atlanta. Cat. no. 4.

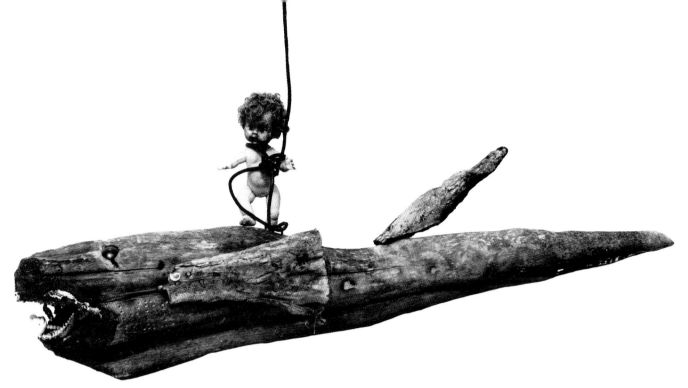

Shark, 1970s. Wood, plastic and shark's teeth, 14 x 52 x 10″. William Arnett, Atlanta. Cat. no. 5.

spirits that inhabited the logs: he frequently told stories about ghosts and dead creatures that came back to life.[3]

Aaron worked by roughing out his carvings with a chain saw and finishing them with chisels, knives and drills. Eyes that he made of cast polyester resin were added to some of the works; others are adorned with found objects such as hats, purses or antlers. None are painted or stained, though Aaron burned a few of them to alter their surface color and texture.

Part black and part Seminole Indian, Aaron was the oldest of eleven children. He left school in the first grade to help support his siblings, working as a farm hand. In his early twenties, he apprenticed as a baker and ran several bake shops before moving to Miami and working on a tomato farm for several years. He was married in 1912, returned briefly to Lake City, and then settled permanently in Gainesville. There he worked as a cook for the Hotel Thomas (1933–37), a hospital, university fraternities and, for a time, the Seaboard Railway.

Aaron's work has been exhibited previously at the University Gallery, University of Florida at Gainesville (1970), the Junior Museum, Tallahassee (1976), and the Florida School of the Arts, Palatka (1980). In 1975, Aaron received a Visual Artists Fellowship from the National Endowment for the Arts.

1. The story of Aaron's revelation was recounted by Stuart Purser of Gainesville. The quote is drawn from a slightly different story by Donald Van Horn, "The Vision of Jesse Aaron," *Southern Folklore Quarterly* 42 (1978), pp. 258–60.
2. Quoted in Van Horn, p. 267.
3. Several stories are related in Van Horn, pp. 260–265

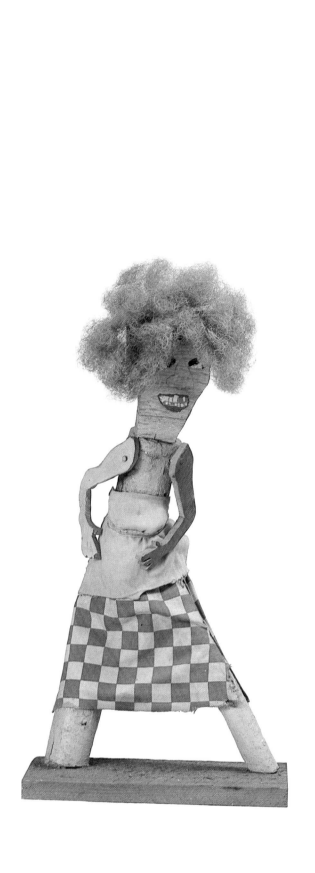
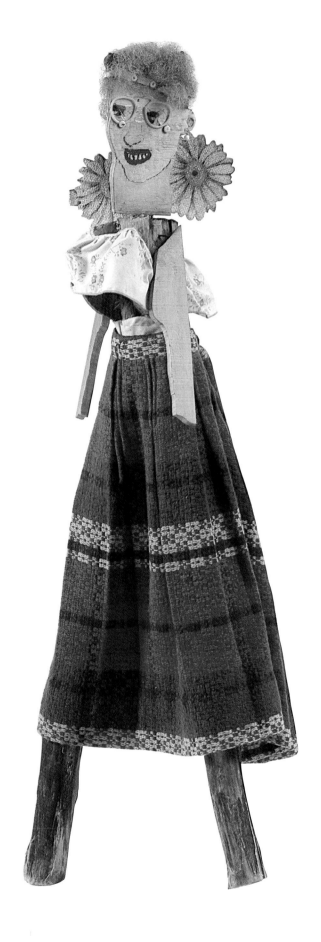

Steve Ashby

Born 1904, Delaplane, Virginia[1]
Died 1980, Delaplane, Virginia

Steve Ashby lived his entire life in the northern end of Virginia's Fauquier County, in and around the village of Delaplane. He was the second of twelve children born to farm workers John Henry and Edith Ashby. In all probability, his ancestors had lived around Delaplane for many generations. A white landowner, Thomas Ashby, received a grant for 320 acres near Delaplane in 1742; Steve Ashby's family may have been descended from his slaves. Ashby's sister Dora Ashby Butler recalls that their father's parents had been slaves of the McCarty family, also of Delaplane. In any event, Ashby's association with his Fauquier County environment was one of long standing. "I remember when my brother Alan and I cut corn for Colonel Mosby's horses," he joked, referring to the Civil War raider.[2]

Ashby worked most of his life as a farm hand, except for a period as a waiter in a Marshall, Virginia, hotel. When in his twenties, he married a woman considerably older than he; they adopted one child, a boy. His wife Eliza worked as a domestic. In the forties, they settled in a converted one room schoolhouse outside of Delaplane, where they lived for the rest of their lives, and Ashby began work as a gardener for Mrs. Ben McCarty. He continued in this job until his retirement in the early sixties.

According to Dora Butler, Ashby had made small carvings throughout his life. But with his retirement and the death of his wife in the early sixties, this activity intensified. He began making small figures cut out of plywood, first by hand and later with an electric saw. He often painted them and would attach photographs, hair, clothes and various other found objects. At the same time, he made a group of nearly life-sized figures from tree trunks and branches. These, too, had painted or collaged faces, often cut from plywood. Ashby kept a supply of magazines and mail order catalogues, as well as paint and assorted objects, in a shed behind his house; he selected from this cache in perfecting his assemblage-like figures. He would arrange them in his yard and dress them with different clothes as the spirit moved him; the women often wore his wife's clothing and jewelry. He was proud of the fact that the figures were anatomically complete under their costumes: "He's all man" or "She's all woman," he would proclaim.[3]

Ashby's subjects ranged from the locally-inspired to the pornographic. Many of them reflect the agrarian character of Fauquier County—the *Man with a Scythe* or the *Cow Being Milked*—and its preoccupation with

Facing page, left:
Pregnant Woman, 1970s. Painted wood and mixed media, 25 x 13 x 8". Herbert W. Hemphill, Jr., New York. Cat. no. 16.

right:
Standing Woman in Red Striped Skirt, 1970s. Painted wood, cloth and metal, 46½ x 15 x 7". Phyllis Kind Gallery, New York and Chicago. Cat. no. 18.

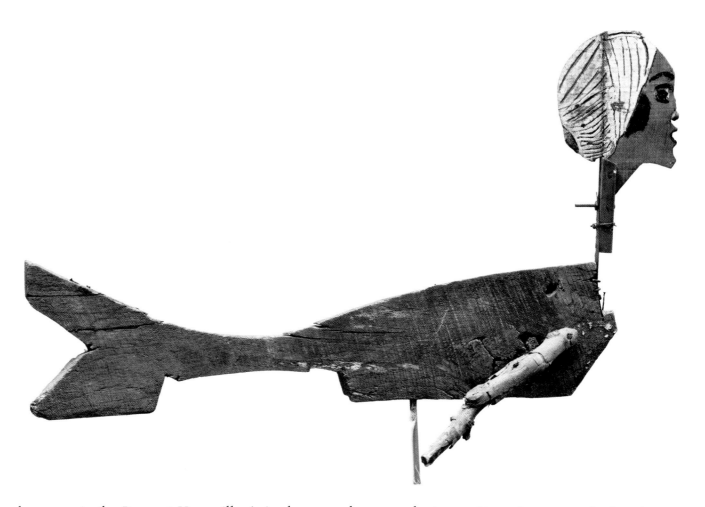

Mermaid, c. 1965. Wood and metal, 21 x 35 x 15". Ken and Donna Fadeley, Birmingham, Michigan. Cat. no. 8.

horses, as in the *Races at Upperville.* Animals are nearly as prevalent as human figures. Some of the pieces are kinetic, responding as the wind activates propeller blades. One shows a couple dancing; others are frankly bawdy (*Woman and Mule*), and Ashby was careful to keep these hidden, particularly from his women visitors. Washerwomen, fishermen and bicyclists also appear in his sculpture. Ashby attributed his inspiration for this remarkable variety of subjects to images revealed in dreams. "I wake up with an idea that won't let me get back to sleep," he told Michael Hall. "So I get up and make that idea."[4] He was supremely confident of himself and of his ability to realize these ideas. "I knew I could do it," he told a local reporter. "I kept thinking about it. I dreamed about it. I just had to do it."[5]

Ashby's work was included in the exhibition "Six Naives" at the Akron Art Institute, 1973.

1. Ashby's sister Erlene Williams gives his birthdate as July 3, 1904; elsewhere it is given as July 2, 1904. (Charles Rosenak, "A Visit with Steve Ashby," *The Clarion,* Winter 1981, p. 63), and 1907 (*Six Naives,* Akron Art Institute, 1973).

2. Recalled by Ken Fadeley, Birmingham, Michigan.

3. Recalled by John McCarty, Delaplane, Virginia.

4. Quoted in *Six Naives,* unpaginated.

5. Quoted in Jim Birchfield, "Folk Art or Inspired Toys?", *Piedmont Virginian* April 18, 1973, pp. 2, 4.

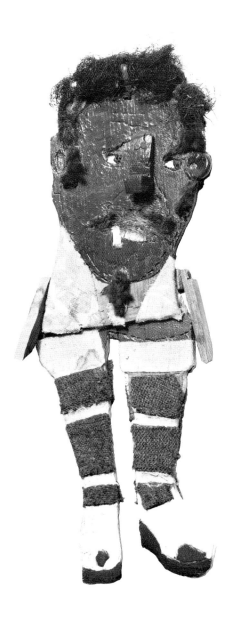

Figure (Self-Portrait), 1974. Painted wood and mixed media, 15 x 6 x 1¼". Elinor L. Horwitz, Chevy Chase, Maryland. Cat. no. 25.

Man with Scythe, c. 1978. Wood, paint, cloth and metal, 66 x 27 x 27". Chuck and Jan Rosenak, Bethesda, Maryland. Cat. no. 33.

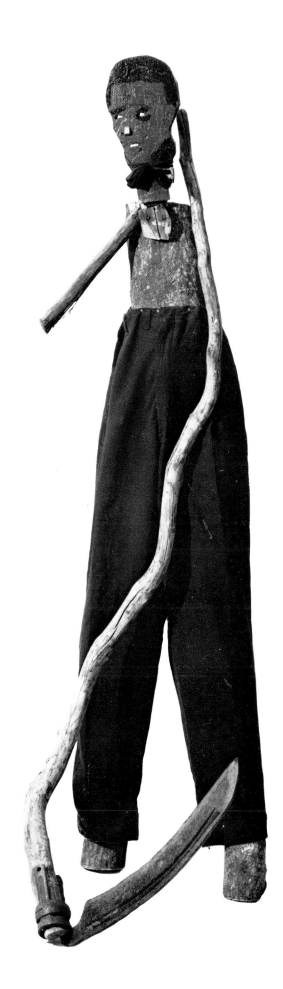

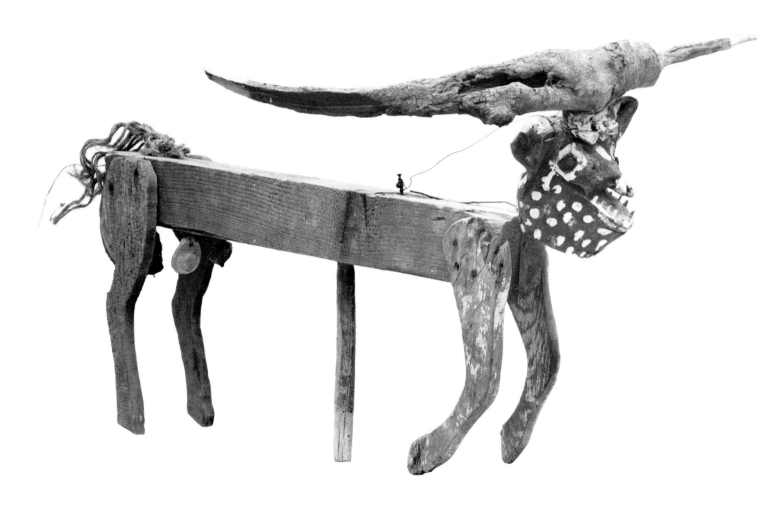

Goat, 1970s. Wood, paint and mixed media, 21 x 34 x 28″. John Freimarck, Mechanicsville, Virginia. Cat. no. 13.

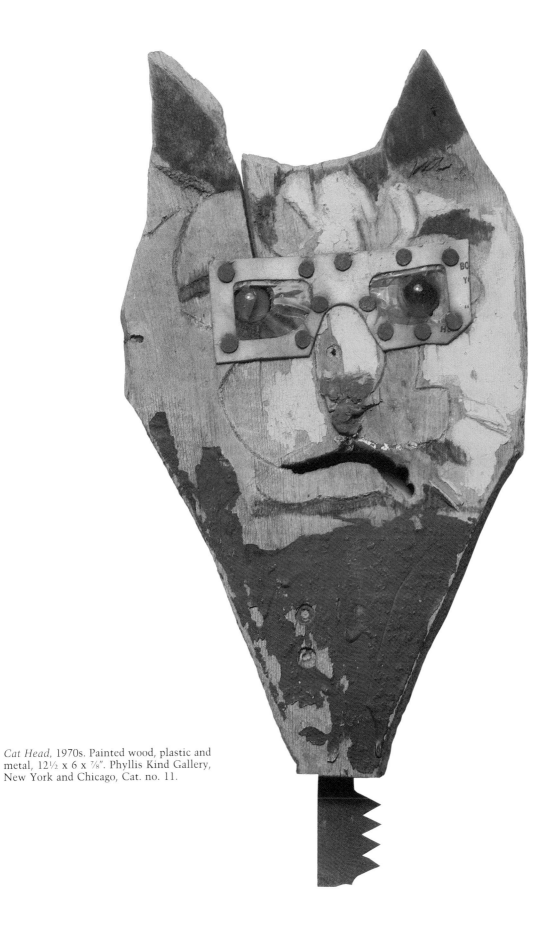

Cat Head, 1970s. Painted wood, plastic and metal, 12½ x 6 x ⅞". Phyllis Kind Gallery, New York and Chicago, Cat. no. 11.

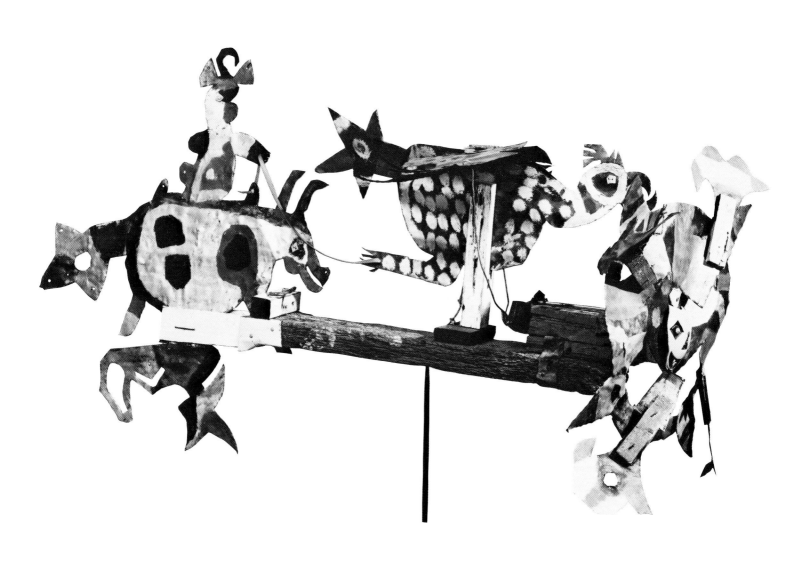

64

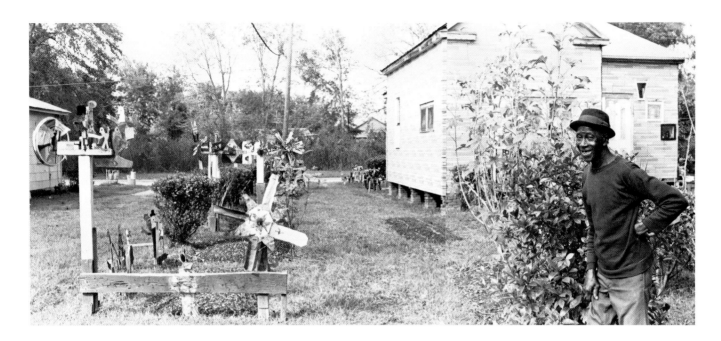

David Butler

Born 1898, Saint Mary Parish, Louisiana
Lives in Patterson, Louisiana

David Butler works in a tradition closely related to the environmental or "roadside" art of such better known figures as Simon Rodia of Watts or James Hampton of Washington, D.C. He has created a rich outdoor environment around his small house in Patterson, Louisiana, a pageant-like garden filled with colorful metal cut-outs in the form of real and fantastical animals, elaborate whirligigs, trains, Biblical scenes and Santa and his reindeer. He has even made a work of art out of his bicycle, which is covered with painted metal embellishments. What distinguishes Butler from the truly monomaniacal environmental artists is the flexibility of his environment: aside from the perforated-metal decorative window coverings which are permanently fixed to the house, the objects filling his surroundings are portable, impermanent, continually disappearing and being replaced. Above all, each of them has a fully developed aesthetic integrity as an individual sculpture. Butler's impulse seems to be to encapsulate himself within a densely additive environment, almost as if to ward off unfriendly spirits. Yet he is easily able to part with his exorcising emblems; he thinks as does any sculptor in terms of complete, autonomous objects.

Butler, like many artists of his untutored kind, came into the most productive phase of his artistic life at a relatively late age, and, like Mose Tolliver, through a physical disablement. Sometime when he was in his forties, he was forced into retirement by a work-related accident and began thereafter working full-time in his present medium of "snipped-tin," or cut and folded and painted metal sculptures.

Butler apparently began drawing even as a boy in his native town of Good Hope, Louisiana. (He now lives in nearby Patterson.) He was the

65

first of eight children of a carpenter, Edward Butler, and his religious-missionary wife, who worked for her community and was well-known throughout Saint Mary Parish. David's early life was dominated by the obligations of his household: he played a large role in the care of his five younger brothers and two sisters and apparently assisted his parents in other ways as well. According to New Orleans Museum curator William Fagaly, he carved in spare moments, drawing subjects "familiar to his environment—people picking cotton or fishing, shrimp boats, sugar cane fields—and whittling wooden boats and animals." Fagaly goes on to say that "His adult life was spent working in sawmills in the area performing a variety of jobs such as cutting grass, building roads, shipping lumber on railroad cars, or working on a drag line."[1] Butler was married for a number of years; his wife died in the late 1960s.

Today, David Butler is somewhat infirm, but he remains astonishingly active as an artist. Indeed, meeting this frail 83 year old man, one wonders how he summons the strength to fabricate his hand-cut and shaped and painted assemblages, which are generally mounted on substantial wooden stakes or pedestals driven into the ground. He is well-known in his community and especially liked by the local children. His aesthetic is both distinctive and unerring: his innate sense of shape and his palette—generally tending to red, white, black, silver and blue, with some pieces combining orange, green, black and white—are consistently interesting and sophisticated. He is devoutly religious and sometimes draws on religious imagery in his work—for instance, the Nativity scene is always on view at the Christmas season. He is also exceedingly superstitious. But his work is most often characterized not by piety or fear, but by whimsy and fantasy: he says he usually receives his ideas fully formed in dreams. Flying elephants, "cockatrices" or sea monsters coexist with more simply conceived roosters, lizards, fish, dogs and alligators. The more ambitious pieces incorporate windmill elements or other moving parts attached to each other with wire.

Butler seems to be viewed slightly askance by some of his neighbors, perhaps cast in the role of "village eccentric." The power and originality of his work seem not to be automatically understood by the simple people who form his social background. Yet *he* clearly senses his own specialness and his own importance in his milieu. He continues tenaciously to develop as an artist and craftsman, and he maintains an unselfish openness to those few neighborhood children or "outsider" sophisticates who do thoroughly appreciate the beauty and originality of his unselfconscious achievement.

David Butler's work has been shown once before, at the New Orleans Museum of Art (1976).

1. Wm. Fagaly, *David Butler*, exhibition catalogue, New Orleans Museum of Art, February 13–March 21, 1976.

Butler has surrounded his house with his snipped tin creations, and even made window awnings of them.

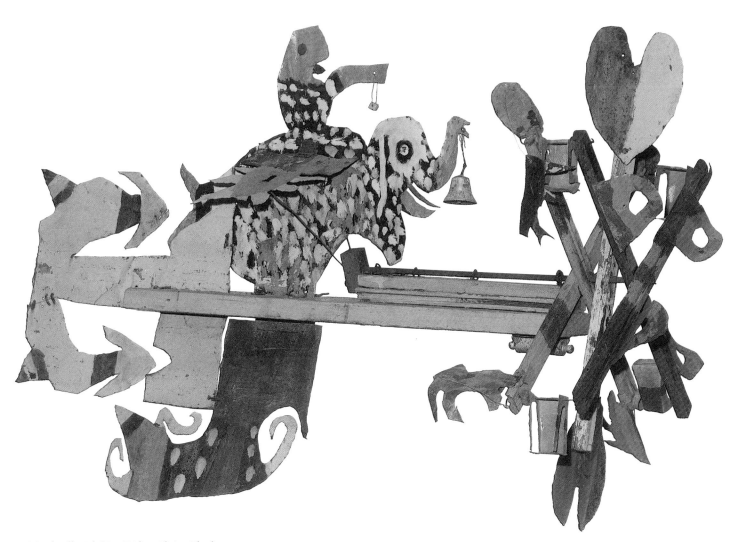

Windmill with Man Riding Flying Elephant,
1975. Painted tin, wood and plastic, 30 x 47
x 29". New Orleans Museum of Art, Gift of
the Artist. Cat. no. 38.

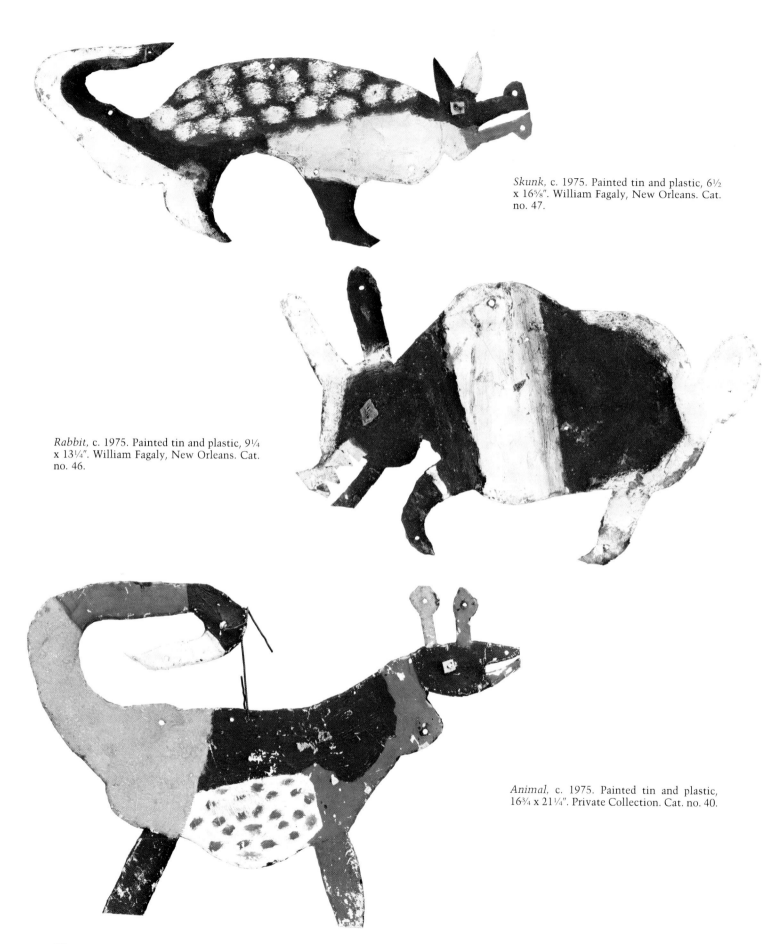

Skunk, c. 1975. Painted tin and plastic, 6½ x 16⅝". William Fagaly, New Orleans. Cat. no. 47.

Rabbit, c. 1975. Painted tin and plastic, 9¼ x 13¼". William Fagaly, New Orleans. Cat. no. 46.

Animal, c. 1975. Painted tin and plastic, 16¾ x 21¼". Private Collection. Cat. no. 40.

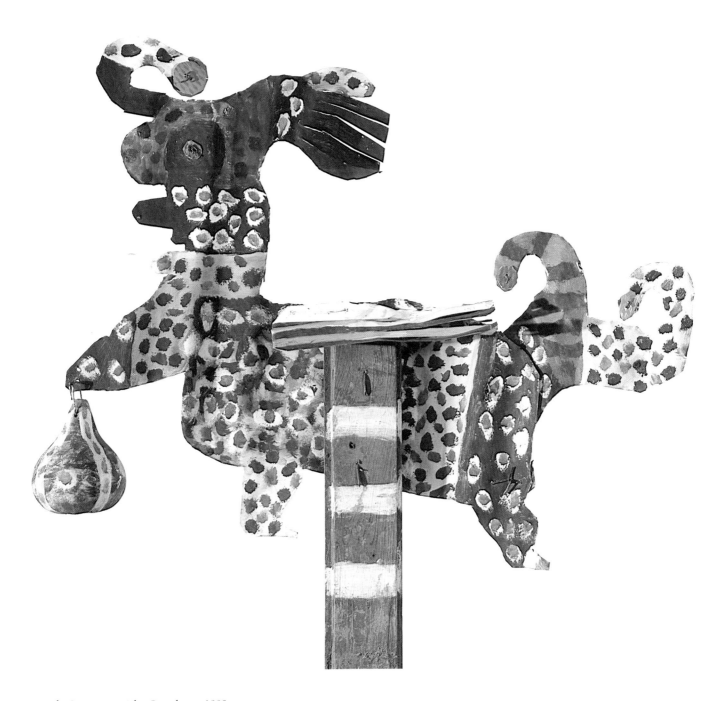

Winged Creature with Gourd, c. 1980.
Painted tin, plastic and gourd mounted on
wooden post, 40 x 31½ x 7¾". Private Col-
lection. Cat. no. 56.

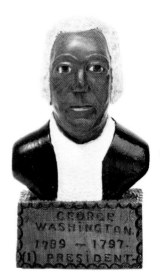

GEORGE
WASHINGTON.
1789 — 1797.
(1) PRESIDENT.

ANDREW
JACKSON.
1829(7TH)1837
PRESIDENT.

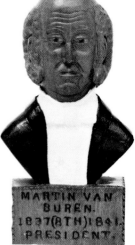

MARTIN VAN
BUREN.
1837(8TH)1841.
PRESIDENT.

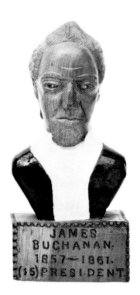

JAMES
BUCHANAN.
1857 — 1861.
(15) PRESIDENT

THEODORE
ROOSEVELT.
1901 — 1909.
26.PRESIDENT.

WILLIAM-H-TAFT.
1909 — 1913.
27-PRESIDENT.

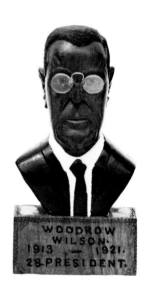

WOODROW
WILSON.
1913 — 1921.
28-PRESIDENT.

CALVIN
COOLIDGE.
1923 — 1929.
30-PRESIDENT.

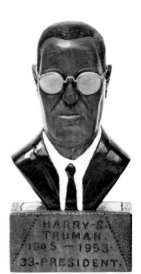

HARRY-S-
TRUMAN.
1945 — 1953.
33-PRESIDENT.

LYNDON-B.
JOHNSON
1963 — 1969.
36-PRESIDENT

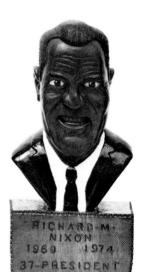

RICHARD-M-
NIXON
1969 — 1974.
37-PRESIDENT

RONALD-REAGAN.
1980 —
40-PRESIDENT.

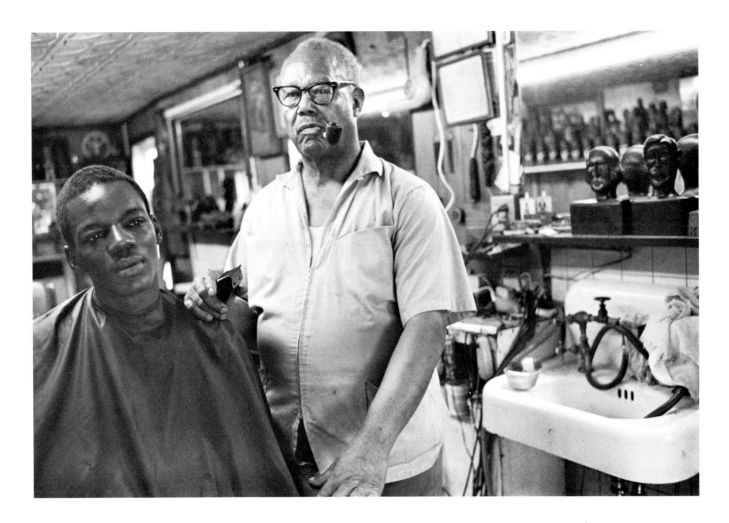

Ulysses Davis

Born 1914, Fitzgerald, Georgia
Lives in Savannah

Ulysses Davis is a barber and a woodcarver and has been both since his early youth; in this, he is like Elijah Pierce. He is the second oldest of eleven children born to Malachi and Mary Etta Davis of Fitzgerald, a small community in south-central Georgia.[1] His father was a blacksmith. Davis gave his first haircut at the age of ten: "His name was Jesse Stanley. He had two pennies. Got my father's tools and I told him that I would cut his hair for the two cents, but when I got through, I didn't get but the penny. I've cut hair many days for a nickel."[2] Davis built his present shop in the early fifties behind his house in Savannah; to help him, he has trained one of his sons in his carefully practiced profession.

Davis left school in the tenth grade to help support his younger brother and sisters, taking a job as an office helper for the railroad. The man for whom he worked moved to Savannah and sent for him; Davis joined him there in 1942 and has lived in Savannah ever since. He was laid off in the early fifties and turned again at that time to barbering.

Davis's shop—"Ulysses Barber Shop"—is decorated outside with floral carvings. The screen door, trim and window frames are incised with rose and tulip designs. These are stamped into the wood with dies made by Davis from automobile bushings: he learned metalworking from his father. Inside the shop, shelf and counter spaces are covered with woodcarvings— they stand two or three deep on some of the shelves. A few are framed reliefs, made in Fitzgerald in the late thirties and brought to Savannah. These include two farm scenes, *Boy Milking Cow* and *Farmhouse with Airplanes*, and two religious carvings, a *Crucifix* and *Samson and the Lion*. Again recalling the work of Elijah Pierce, these reliefs are painted and some decorated with glitter. Davis also uses rhinestones: "Twinklets fascinate me and I keep them. By fiddling around I find some use for them. I call pieces of junk like rhinestones from broken necklaces, sequins that came off an old evening gown my wife tired of wearing, twinklets because they twinkle—sparkle. I use some of this twinkling junk for eyes, for decoration on some of my carvings. I think that in using them I make my art more attractive to some people who see my work."[3]

Davis has also carved reliefs of the astrological symbols. But by far the larger number of his carvings are free-standing. Many are fantastical creatures, variations on both human and animal forms. Others, such as the *Lizard*, are subjects that appear in the work of numerous black American carvers. Davis has also created several free-standing Crucifixions. The most imposing was made in 1946 and stands over forty inches high (*Jesus on the Cross*, Kiah Museum). Carved from a single piece of cedar, the body was first roughed out with a hatchet, the face sketched out with a pencil and then carved, and the body carved and sanded. The body was then nailed to the cross and the nailheads brightened with silver paint. The crown of thorns was made from a piece of mahogany with toothpick inserts.

Davis carved a full figure of Abraham Lincoln in 1944, and busts of Lincoln and Washington at about the same time. To these was added in 1968 a bust of Martin Luther King carved on the occasion of the civil rights leader's assassination. Davis is not unique in his depiction of these subjects, but he is alone among contemporary folk carvers in his recent production of a series of busts of the forty presidents.[4] Though individually small—each is eight inches high and four inches wide—these busts as a group are monumental in effect. They seem uniform at first, all but one being made from mahogany (Buchanan is pecan). But gradually, the individual characterizations emerge: the different men are depicted in the clothing of their respective eras and have the hair, glasses and even facial expressions that we associate with each of them. These works are masterpieces of portraiture.

Davis's work was included in "Missing Pieces: Georgia Folk Art, 1770–1976," which showed at the Atlanta Historical Society (1976–77) and subsequently toured to the Telfair Academy of Arts and Sciences, Savannah; the Columbus (Georgia) Museum of Arts and Crafts; and the Library of Congress, Washington, D.C.

facing page:
Farmhouse with Airplanes, 1943. Carved and painted relief, 13 x 15⅝". Ulysses Davis, Savannah. Cat. no. 63.

1. Biographical information on Ulysses Davis was gathered by Virginia Kiah of Savannah and published in "Ulysses Davis, Savannah Folk Sculptor," *Southern Folklore Quarterly* 42 (1978): 271–85. Mrs Kiah first discovered Davis in 1953.

2. Quoted in Anna Wadsworth, ed., *Missing Pieces: Georgia Folk Art, 1770–1976* (Atlanta: Georgia Council on the Arts and Humanities, 1976):65.

3. Kiah, p. 277.

4. Though there have been forty presidents, there are only thirty-nine carvings since Grover Cleveland served two non-consecutive terms.

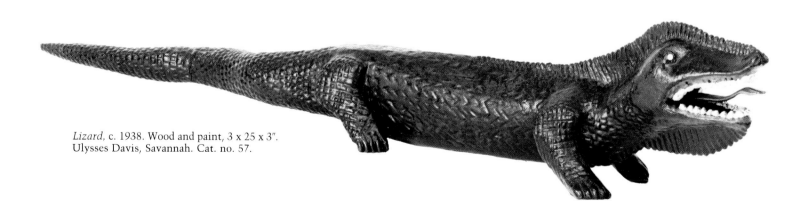

Lizard, c. 1938. Wood and paint, 3 x 25 x 3″.
Ulysses Davis, Savannah. Cat. no. 57.

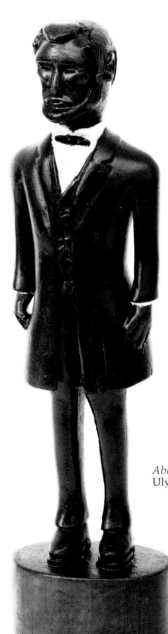

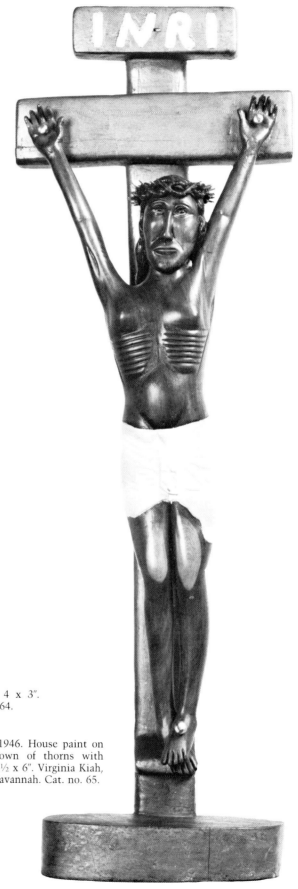

Abe Lincoln, 1944. Wood, 15 x 4 x 3″.
Ulysses Davis, Savannah. Cat. no. 64.

Jesus on the Cross, 1946. House paint on
cedar, mahogany crown of thorns with
toothpicks, 40½ x 13½ x 6″. Virginia Kiah,
The Kiah Museum, Savannah. Cat. no. 65.

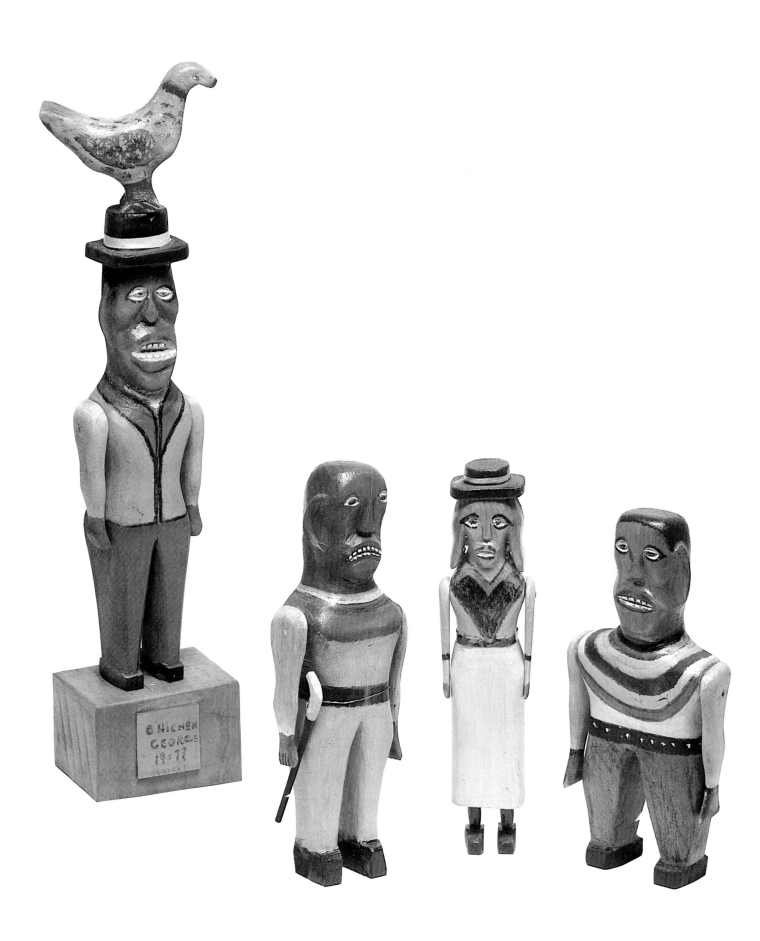

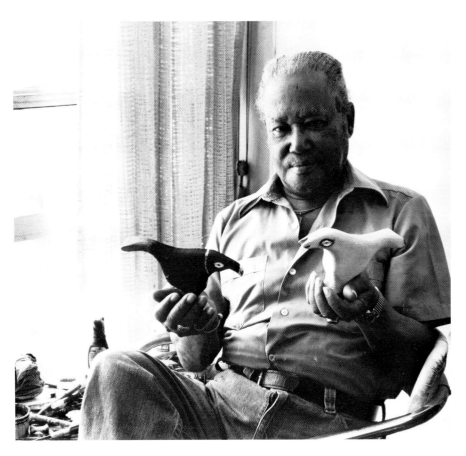

William Dawson

Born 1901, Huntsville, Alabama
Lives in Chicago

facing page, left to right:
Chicken George, 1977. Carved and painted wood, varnish, 18 x 4½ x 3". Roger Brown, Chicago. Cat. no. 86.

Man with Rifle, 1976. Carved and painted wood, varnish, 10¼ x 3½ x 2". Roger Brown, Chicago. Cat. no. 84.

Woman in White Skirt, 1970s. Carved and painted wood, varnish, 10 x 2 x 2". Susann E. Craig, Chicago. Cat. no. 80.

Man in Striped Shirt, 1970s. Carved and painted wood, varnish, 9¼ x 4½ x 1½". Susann E. Craig, Chicago. Cat. no. 76.

Although born in Alabama, Dawson has spent most of his life in Chicago. He was raised on a farm, moving to Chicago in 1923 with his wife Osceola, also of Huntsville, whom he married that year. He was soon thereafter employed by E. E. Aron, a produce distributor, rising to the position of manager of their operations at South Water Market during his thirty-five year tenure with the firm. Dawson then worked as a security guard and at other temporary jobs until retiring altogether in the mid-sixties.[1]

Following his retirement, Dawson enrolled in adult education classes in ceramics and painting, but soon gravitated toward sculpture. He has focused on sculpture until recently, when he began to paint again. The repertory of his sculptural subjects is drawn from a wide variety of sources: the Bible (*Joseph in his Blue Robe*), current events (*Idi Amin Walking His Pet Pig*) and television (*Chicken George*, a character from Alex Haley's *Roots*). Characters from folk tales account for some of the subjects, such as the gorilla and the monkey, which appears as a single image or in groups in a "monkey tree." Some of the depictions seem more purely imaginative—even surreal—as in the fanciful combination of faces and buildings on totems or the preacher emerging from the top of an apartment building in *Dream House*.

Idi Amin Walking His Pet Pig, 1977. Carved and painted wood, found objects and string, 13½ x 5½ x 2½". Chuck and Jan Rosenak, Bethesda, Maryland. Cat. no. 88.

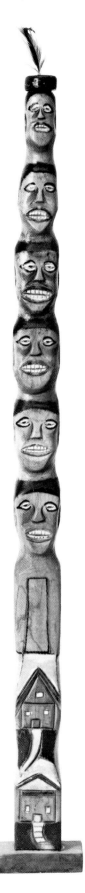

Dawson tends to limit his subjects and work dozens of variations on a given theme—totem poles with faces one atop the other; frontal symmetrical figures; quirky house-like structures; generalized animals. His sculptures are to this extent literally toy-like, archtypical in form and subject, works springing as much from the craftsman's instinct as from a creatively improvisatory approach. It is in their simple straightforwardness and peculiarly raw and unsentimental character that Dawson's works transcend the ordinary.

Dawson's human and animal figures are carved and painted, then finished with varnish and sometimes glitter. Animal bones, stones and shells provide additional decoration. The human figures generally have movable arms attached with nails. The totems are carved from single pieces of wood; in the case of some of the early ones, they are made from furniture legs. As with Inez Nathaniel-Walker, the eyes are the dominating image in the figures and totems. Wide and round, they are painted a brilliant white against the darker color of the face. A rare exception to this preference for representational subjects is a bell-shaped carving decorated with painted triangles. It has a door at the bottom and is surmounted by a small face.

Dawson's work received its first exposure in the mid-seventies in a small solo exhibition in the Lincoln Park Branch of the Chicago Public Library. It was subsequently included in group shows at the Phyllis Kind Gallery and the Hyde Park Art Center, both in Chicago. In 1978, it was included in "Contemporary American Folk and Naive Art" at the School of the Art Institute of Chicago, and in 1979, in "Outsider Art in Chicago" at Chicago's Museum of Contemporary Art.

1. Much of this biographical information was gathered and provided by David Kargl of Chicago.

Totem (with two houses and six heads), 1976. Carved and painted wood, varnish and feather, 36½ x 3½ x 2½". Susann E. Craig, Chicago. Cat. no. 85.

Dream House, 1970s. Carved and painted wood, varnish and glitter, 16 x 8 x 8". Roger Brown, Chicago. Cat. no. 73.

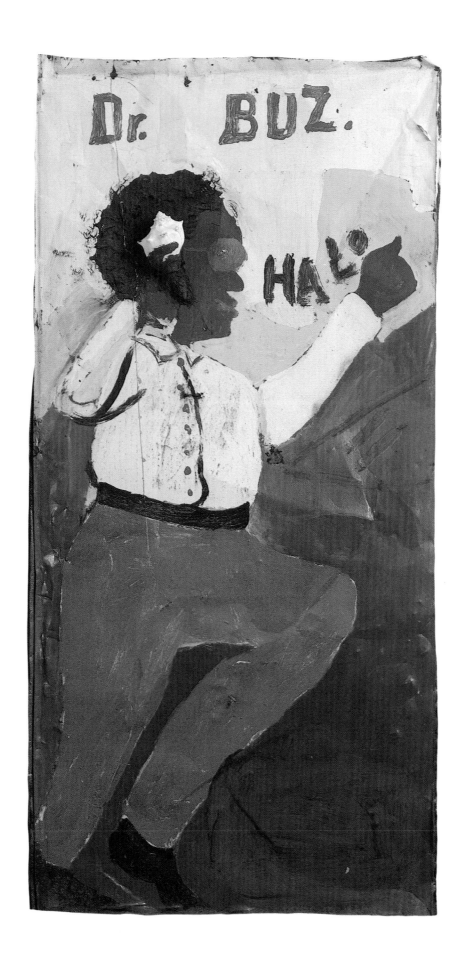

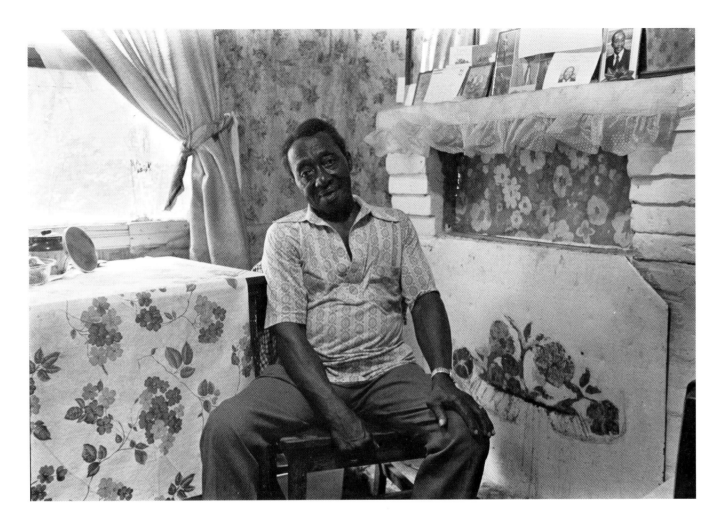

Sam Doyle

Born 1906, near Frogmore, South Carolina
Lives near Frogmore[1]

In the early decades of the twentieth century, when Sam Doyle was growing up on St. Helena Island near Beaufort, South Carolina, the island was physically and culturally remote from the nearby mainland. St. Helena was traditionally a black island; even during slavery its white owners were frequently absent. During Doyle's youth it was still occupied and farmed almost exclusively by blacks. Many had been slaves on the island and passed along to those of Doyle's generation stories of slavery time, of the plantations, slave masters and natural and supernatural occurrences of their lives. Many were Gullahs, imparting a melodic, Caribbean-sounding dialect including some West African words and pronunciations that is still in evidence on St. Helena today.[2]

 Though St. Helena is now linked by bridge to the mainland and about equally populated by blacks and whites, the lore of his forebearers and the incidents of his own youth are still vivid in Doyle's paintings and drawings. One drawing depicts the "whooping boy," the ghost of a slave allegedly

facing page:
Dr. Buz, c. 1980. Enamel paint and tar on metal (with conch shell), 57 x 27". Private Collection. Cat. no. 102.

81

beheaded and buried to protect a treasure, a ghost that Doyle reports haunted St. Helena every seven years until the advent of the automobile. Another shows Abraham Lincoln on a visit to St. Helena, preaching to the slaves. Many of the paintings, executed in enamel paint on sheet metal, depict the islanders of Doyle's own life: Dr. Buzzard, the island's richest black and a voodoo doctor, who received his inspiration by listening in a conch shell; WeWe, also known as Le Bit, the smallest woman on the island; Miss Full Back ("I named her that because of her shape," Doyle explains); Rev. Cathit ("you catch it from him on Sunday"): and Try Me ("that's what she said: 'try me'").

Many of these paintings are displayed under the large oak trees of Doyle's yard, leaning against an abandoned cafe once operated by his wife. They face the road, inviting people to stop. At Christmas, the paintings of local figures are shown alongside a multi-panel depiction of the Nativity and the Three Wise Men. These are painted in a more subdued style than most of Doyle's work; it is as though Doyle feels that his raw, emotive style is appropriate to his secular subjects, but that the Nativity paintings require a more polished one. Doyle has also made a number of archtypical wood sculptures of the familiar animal shapes of this genre—the turtle, the snake and the alligator.

Doyle grew up in the Wallace community on St. Helena, which was comprised mostly of the descendants of freed slaves of a plantation owner named Wallace. He was one of nine children born to his farm-worker parents. He attended through the ninth grade the nearby Penn School, a private vocational and agricultural school run by northern whites for the island's black children. There he studied literature as well as carpentry and was singled out for his drawing ability. The sister of one of his teachers, an artist in New York, invited him to come north and study art. But circumstances determined otherwise. "I had to go to work," Doyle explains simply. He dropped out of school and took a job as a clerk in a Frogmore store, then as a porter in a wholesale store in Beaufort for twenty years between about 1930 and 1950. He was married in 1932 and settled in about 1940 in his present house, a two-story wooden cottage that he helped to build. His wife and three children eventually moved to New York, but Doyle preferred to "stay in the sticks," as he says. He worked in a laundry at the Parris Island Marine Corps base for sixteen years, retiring in the late sixties. Though he still works part time as a grounds keeper at the ruins of Frogmore's "Chapel of Ease," an eighteenth century church, he considers painting his principal profession. The enthusiasm of his youth is now finding its full expression.

Doyle's work is being shown for the first time.

1. Bonnie and David Montgomery of Jefferson, New York, were instrumental in leading us to Sam Doyle.

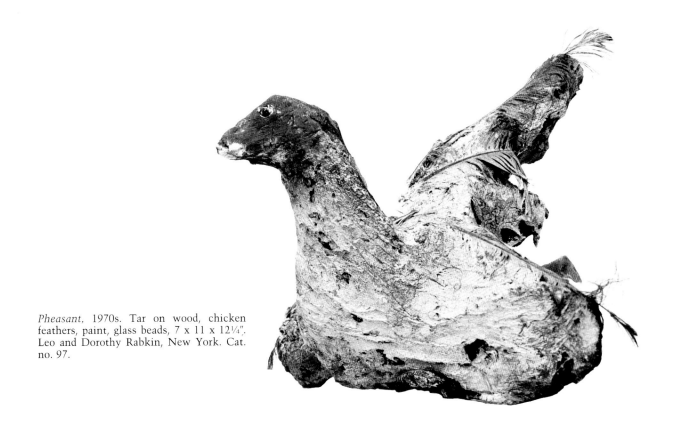

Pheasant, 1970s. Tar on wood, chicken feathers, paint, glass beads, 7 x 11 x 12¼". Leo and Dorothy Rabkin, New York. Cat. no. 97.

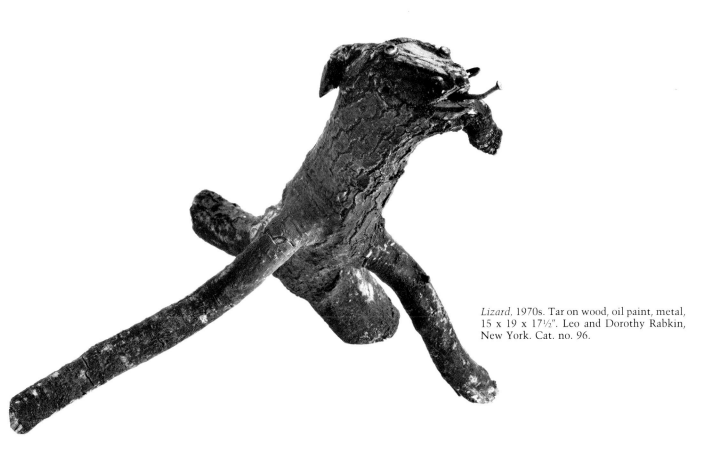

Lizard, 1970s. Tar on wood, oil paint, metal, 15 x 19 x 17½". Leo and Dorothy Rabkin, New York. Cat. no. 96.

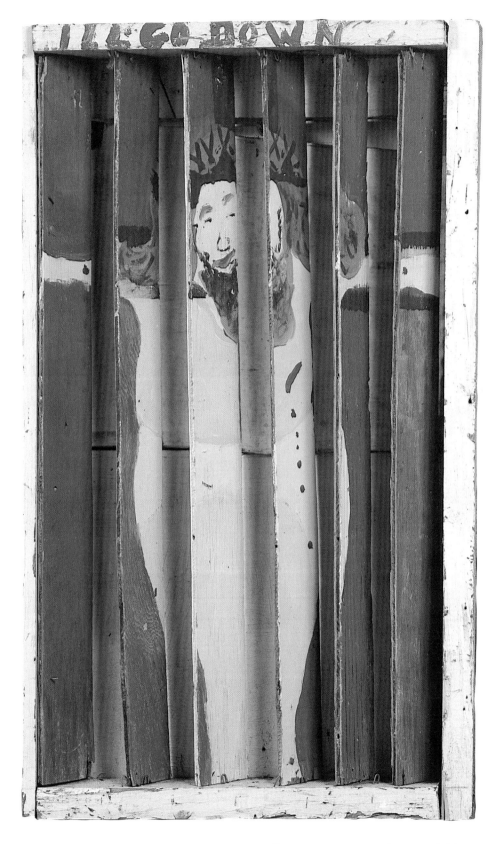

I'll Go Down, 1970s. Oil on wood, fabric and metal, 41½ x 25 x 5". Leo and Dorothy Rabkin, New York. Cat. no. 94.

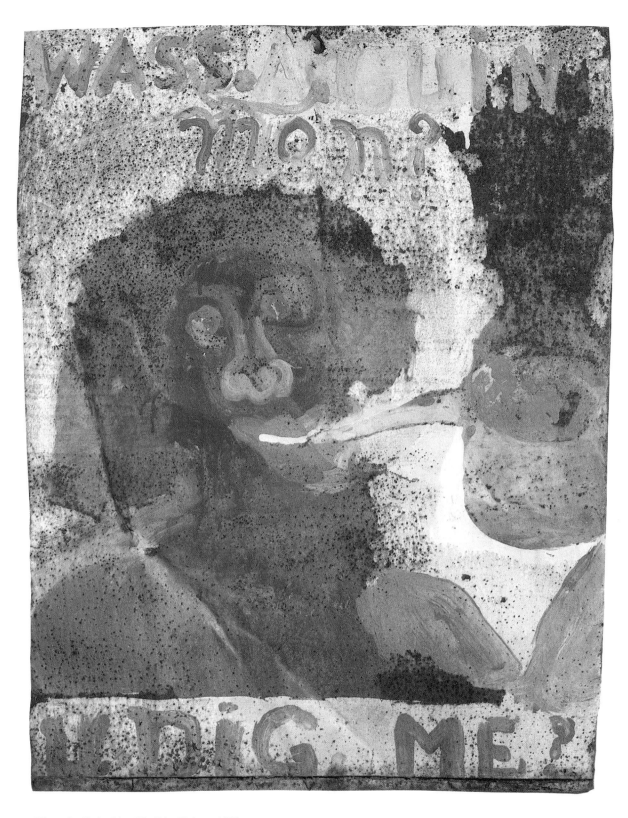

Wass A. Guin Mon/U. Dig Me?, c. 1980.
Enamel paint on metal, 28 x 22¾". Private
Collection. Cat. no. 104.

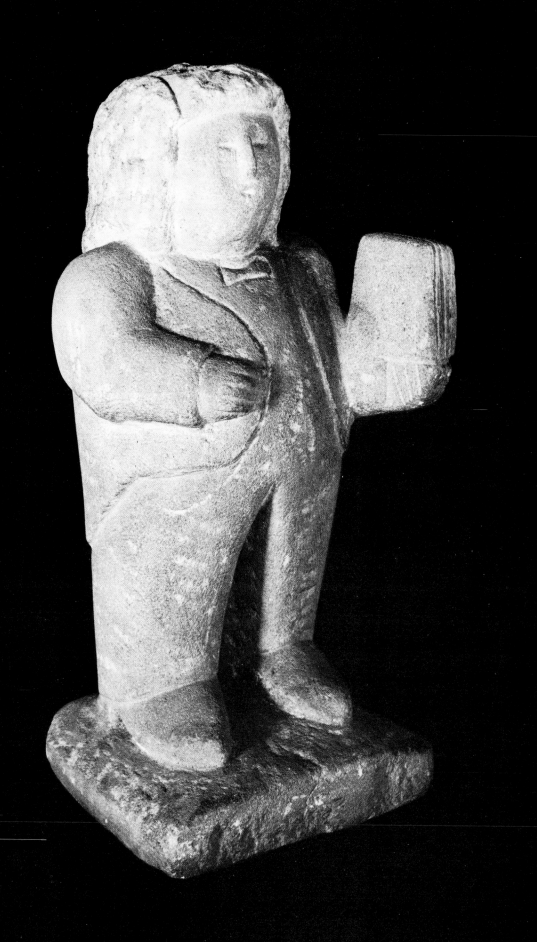

86

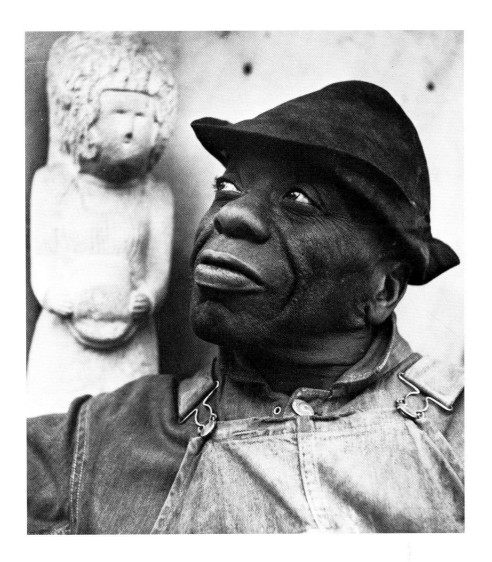

William Edmondson

Born c. 1870, Davidson County, Tennessee[1]
Died 1951, Nashville

More than any other painter or sculptor in this exhibition, William Edmondson has achieved recognition as an American artist, not only as a black or a folk artist. This can be explained in part by his exhibition at the Museum of Modern Art in 1937. Organized by Dorothy Miller and including twelve examples of his work, it was instigated by the photographer Louise Dahl-Wolfe, who had been introduced to Edmondson by friends in Nashville. She photographed the sculptor and his work and, through contacts at the Modern, encouraged them to show the sculpture. It was to be the Modern's first solo exhibition of the work of a black artist. But one wonders if the subsequent more general interest in Edmondson's work did not result as much from the remarkably "modern" character of the work as from the Museum's exhibition. Indeed, one imagines that the Modern's exhibition itself was a consequence of just this modernity. For

87

despite the rather ingenuous personality that is suggested by the photographs of Dahl-Wolfe and Edward Weston, Edmondson was carving in a manner much like his more sophisticated contemporaries. The generalized forms, the tendency toward abstraction, the rigid, almost hieratic poses suggest parallels to the work of William Zorach, John B. Flannagan and Elie Nadelman. In his charming depiction of animals, Edmondson particularly brings to mind the similar stone carvings of Flannagan.

"Jesus has planted the seed of carving in me," Edmondson told a *Time* magazine reporter in 1937.[2] He insisted that he could not help carving, that he was directed to work by God. Though he reported that he received numerous visions in his lifetime, a very specific one inspired his carving: "I was out in the driveway with some old pieces of stone when I heard a voice telling me to pick up my tools and start to work on a tombstone. I looked up in the sky and right there in the noon daylight He hung a tombstone out for me to make."[3] Edmondson began his work by carving memorials, many embellished by doves or sheep (*Tombstone for Bernice Williams*). These were commissioned by blacks in the congregation of Edmondson's church and used in their cemetery. But it was not long before he began to carve animals and human figures, angels and crucifixions. "God was telling me to cut figures," Edmondson explained. "First He told me to make tombstones, then he told me to cut the figures."[4]

Edmondson worked exclusively in limestone, which was inexpensive and available locally in great quantities. He apparently fashioned his own chisels and files in different sizes for rough and finished carving. A Weston photograph shows him in his carving outfit: a full-length apron, goggles and a hat. Above the shed in which he worked, he had hung a sign that read "Tombstones for sale/garden ornaments/stone work/Wm. Edmondson." Few of his carvings fit these designations, however. There are several memorials, as noted, and a few bird baths. But most of the works are functionless and seem to be intended only as art. There is no other way to account for the enigmatic *Noah's Ark*, for example—neither tombstone nor ornament—nor for the charming range of human characterizations: school teachers and preachers, couples and brides. By whatever inspiration, Edmondson must have conceived of himself as an artist, despite his denial: "I'm just doing the Lord's work. I didn't know I was no artist till them folks come told me I was."[5]

Edmondson was born near Nashville in the Hillsboro Road section of Davidson County, Tennessee. His parents, George and Jane, were slaves of the Edmondson and Compton families. William was one of six children. His exact birthdate is unknown, as it was recorded in a family Bible that was lost in a fire. His early occupations are also largely unknown, though it is believed he worked as a laborer and porter. After 1908, his activities are better documented. From that year until 1931, he was a janitor at the Women's Hospital (later the Baptist Hospital) in Nashville. After the hospital closed in 1931 and he lost his job, he received his inspiration to carve. He was twice employed by the sculpture division of the W.P.A. between 1939 and 1941.

In addition to the show at the Modern, exhibitions of Edmondson's work include those at the Nashville Art Gallery (1941); the Nashville Artist Guild (1951); the Willard Gallery, New York (1964 and 1971); Tennessee Fine Arts Center at Cheekwood, Nashville (1964); the Montclair (New Jersey) Art Museum (1975); and the Tennessee State Museum, Nashville (1981; circulated 1981–1982 by the Southern Arts Federation).

facing page:
Speaking Owl, c. 1937. Limestone, 22½ x 18 x 7½". Estelle E. Friedman, Washington, D.C. Cat. no. 122.

1. Jym Knight, New York, received this date from members of Edmondson's family. Much of the rest of the biographical data used here was compiled by him.
2. Quoted in *Will Edmondson's Mirkels* (Nashville: Tennessee Fine Arts Center at Cheekwood, 1964): 1.
3. Quoted in Edmund Fuller, *Visions in Stone* (Pittsburgh: University of Pittsburgh Press, 1973): 8.
4. *Mirkels*, p. 3.
5. Fuller, p. 22

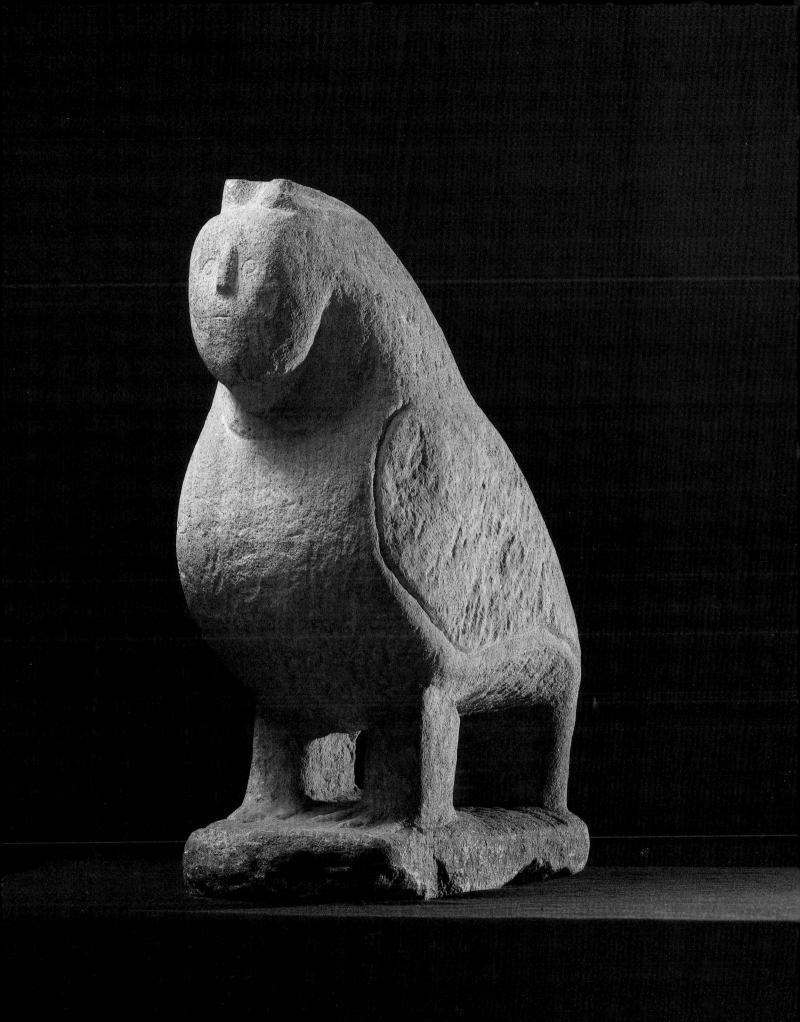

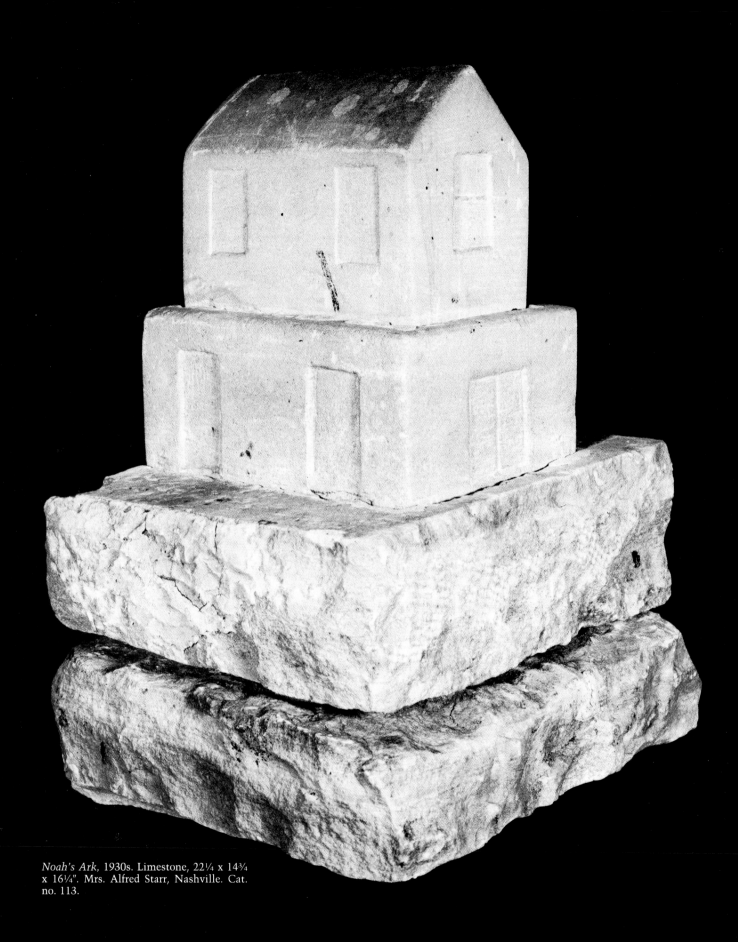

Noah's Ark, 1930s. Limestone, 22¼ x 14¾ x 16¼". Mrs. Alfred Starr, Nashville. Cat. no. 113.

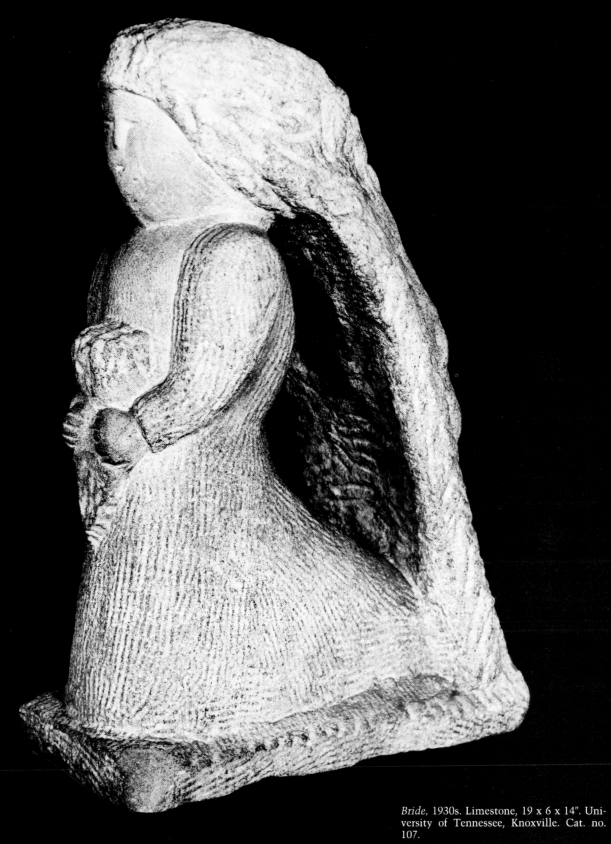

Bride, 1930s. Limestone, 19 x 6 x 14″. University of Tennessee, Knoxville. Cat. no. 107.

92

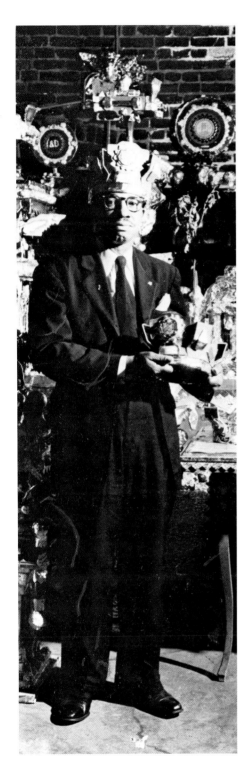

facing page:
Hampton's *Throne* as seen through the doorway of his rented garage in Northwest Washington, D.C., c. 1955.

James Hampton

Born 1909, Elloree, South Carolina[1]
Died 1964, Washington, D.C.

James Hampton is an anomaly among contemporary black folk artists. While some others, such as Sam Doyle, David Butler and Nellie Mae Rowe, display their creations outside and invite the attention of passers-by, Hampton was a reclusive man who kept his creation in a locked garage in an alley in Northwest Washington, D.C. Many have a sense of themselves as artists—Elijah Pierce and Jesse Aaron, for example, both opened small museums devoted to their work. But Hampton seems to have considered himself a prophet instead. He was St. James, Pastor of a church of his own creation and "Director of Special Projects for the State of Eternity." And, while many others are motivated by visions, few are as specific and as powerful as Hampton's. Only Sister Gertrude Morgan, who envisioned herself the "Bride of Christ," to be wed for all eternity to the Savior at the Second Coming, could match the complexity and the intensity of Hampton's motivating force.

Hampton's "Special Project" was a work he entitled *The Throne of the Third Heaven of the Nations Millenium General Assembly.* Made principally of old furniture and found objects covered in gold and silver foil and purple kraft paper, it is an assemblage of one hundred and eighty objects that celebrate and forewarn of the Second Coming. As set up in his rented garage and now permanently installed at the National Museum of American Art in Washington, D.C., Hampton's work is dominated by a central throne made of an elaborately decorated arm chair with a red velvet seat. This is set in the rear center of a platform; in front of it stands a pulpit and before that an altar. This is the axis of symmetry for Hampton's entire creation. On either side are arranged a subsidiary pulpit, six chairs, an offertory table, winged vases and stands (referring to Jesus, the Virgin, Moses, Adam and Eve), wall plaques and crowns. Labels on the works reveal that, on the left, the pieces refer to Jesus, the New Testament and Grace; on the right, they refer to Moses, the Old Testament and the Law. Wall plaques on the left bear the names of the Apostles, on the right, the Prophets.

The image of God enthroned pervades Christian iconography. But Hampton probably based his *Throne* on the vision of God in the Book of Revelation, apparently his favorite part of the Bible.[2] As revealed to St. John the Divine, Revelation tells of the Second Coming and the Last Judgement. In it God appears enthroned and surrounded by shining angels. This image accounts not only for the throne itself in Hampton's work, but probably for the foil-covered wing shapes that recur throughout it. The Third Heaven in the title of the work refers to the Biblical abode of God. As described in Genesis, Matthew and II Corinthians, the first heaven is

the region of the clouds, the second is of the planets and the third of God. This last is the heavens of heavens. The Nations Millenium alludes to the day of judgement for all nations, which will be called together at a General Assembly. The Throne thus envisions the appearance of God before the multitudes and surrounded by Jesus, Mary, Moses, Adam and Eve, the Prophets, the Apostles and a host of angels. In this its iconography is much like the portal sculpture on Romanesque and Gothic cathedrals, but abstracted. Hampton's vision of the Millenium is uniquely unpopulated, without representations of the human figure.

Hampton seems also to have intended his *Throne* as a monument to Jesus.[3] This is suggested by a plaque on one of the stands, which reads "October 20 1946 Jesus 10 Commandments Rev. A. J. Tyler A Monument to Jesus." In a loose-leaf binder kept with *The Throne*, Hampton made a similar notation: "No. 2 St. James Rev. A. J. Tyler A Monument Jesus October 7, 1947 Revelation." Reverend Tyler was a pastor at the Mt. Airy Baptist Church in Northwest Washington until his death in 1936. He was a popular minister, noted for saying that in a city of monuments he wanted his church to be a "monument to Jesus." An electric sign bearing that legend still hangs over the door of Mt. Airy. There is no evidence that Hampton knew or was preached to by Tyler. Hampton was not a member of his church or any other; he believed that the existence of only one true God invalidated the formation of different denominations.[4] Yet Tyler's message was of great importance to Hampton: he often described himself as the Pastor of the "Tyler Baptist Church" and may indeed have hoped one day to use his *Throne* for services or didactic purposes.[5]

Hampton's monument to Jesus and the Throne of God was probably motivated by visions of a religious nature, which are recorded in his writings and on the objects themselves. He believed that each night as he worked God visited him in his garage and directed the fabrication of *The Throne*. Like his admired St. John, Hampton may also have considered himself a prophet of the apocalypse.[6] In a notebook he titled *The Book of the 7 Dispensation by St. James*, he wrote in an indecipherable script and added the word revelation to each page. This may relate to God's instructions to St. John, who was told to record in cryptic language all that had been revealed to him about the Second Coming.

Hampton was born in a rural town in South Carolina in 1909. In 1928, at the age of nineteen, he moved to Washington, D. C., joining his elder brother Lee. It is not known what his occupation was until 1939, when he began working as a cook in local cafes. He was drafted in 1942 and served in the army as a noncombatant, working at carpentry and maintaining airstrips. Honorably discharged in 1945, he returned to Washington and took a job a year later as a janitor for the General Services Administration. He held this job until he died. In 1950, he rented the garage in which his *Throne* was found after his death. It is not known precisely when work began on this remarkable project, but it is presumed to be around this date.

Hampton's *Throne* was acquired by the National Collection of Fine Arts (now the National Museum of American Art) shortly after his death. Outside of its permanent home in Washington, it has been shown at the Abby Aldrich Rockefeller Folk Art Center, Williamsburg (1972); the Walker Art Center, Minneapolis (in their exhibition "Naives and Visionaries," 1974); the Whitney Museum of American Art, New York (in "Two Hundred Years of American Sculpture," 1976); the Museum of Fine Arts, Boston (1976); and the Montgomery Museum of Fine Arts (1977).

Diagnosis of Ten Commandment: a wall plaque that is among the one hundred eighty objects that compose *The Throne*.

1. We are indebted to Lynda Hartigan, Assistant Curator of Twentieth Century Painting and Sculpture at the National Museum of American Art, Washington, D. C., for her thorough research into both Hampton's life and the iconography of *The Throne*.

2. Lynda Hartigan, *The Throne of the Third Heaven of the Nations Millenium General Assembly* (Montgomery: Montgomery Museum of Fine Arts, 1977). p. 16. Of her several writings on *The Throne*, this is the most recent and hence most comprehensive.

3. Hartigan, p. 14.

4. Hartigan, p. 15.

5. Hartigan, p. 18.

6. Hartigan, p. 17.

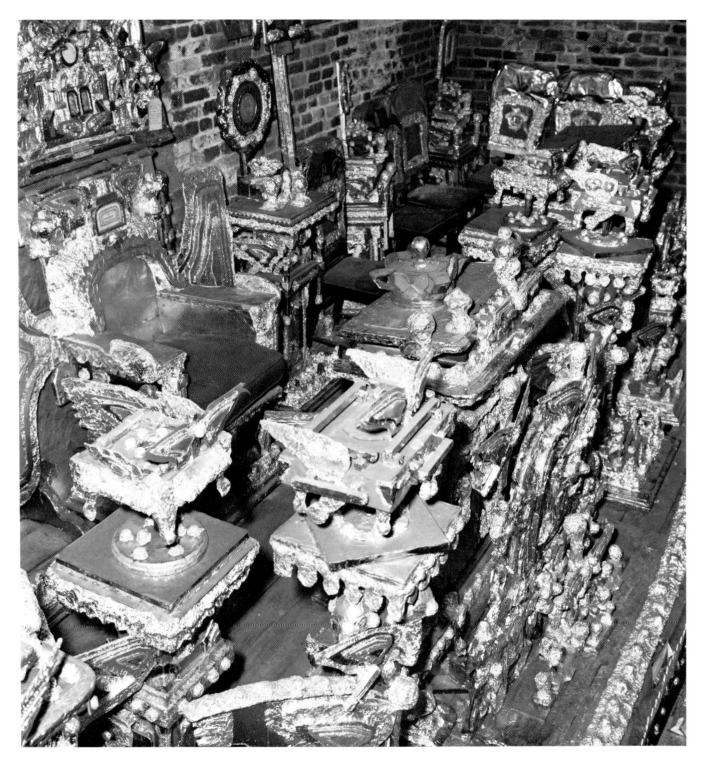

The Throne as originally installed in Hampton's work space, c. 1955.

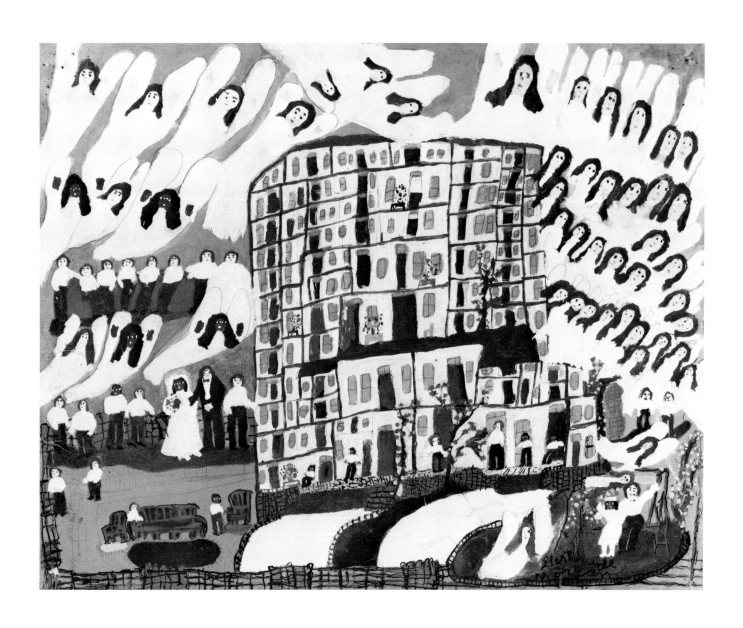

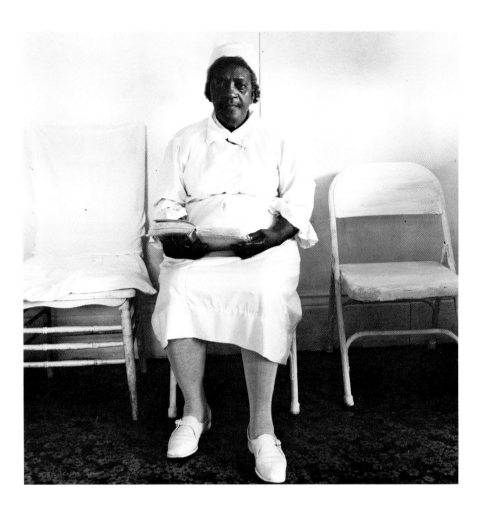

Sister Gertrude Morgan

Born 1900, Lafayette, Alabama[1]
Died 1980, New Orleans, Louisiana

facing page:
New Jerusalem, c. 1965–75. Pen, pencil and acrylic on cardboard, 22 x 28¹⁄₁₆″. Alan Jaffe, New Orleans. Cat. no. 150.

It was through visiting Sister Gertrude Morgan in 1974 in her small white frame house in St. Bernard Parish, in New Orleans' Ninth Ward, that an important aspect of the aesthetic of self-taught black artists began to become evident. Sister Gertrude was a powerfully gifted person, not just as a painter but as a preacher and singer, a woman whose faith in God and determination to help others were forcefully sensed just by her presence. It seemed somehow perfectly unextraordinary to discover that her front lawn was covered with four-leaf clovers.

Gertrude Morgan's life seems to have followed a series of progressions from one to another phase in both her religious and artistic callings. Her childhood was spent in Lafayette, Alabama; she was an active member there of Dr. J. B. Miller's Baptist church. In 1937, when she was 37, a voice said to her, "Go and preach, tell it to the world." She went in 1939 to New Orleans, where she began a period of intensive missionary work, beginning as a street preacher. She started an orphanage with two other women, Mother Margaret Parker and Sister Cora Williams, raising money through

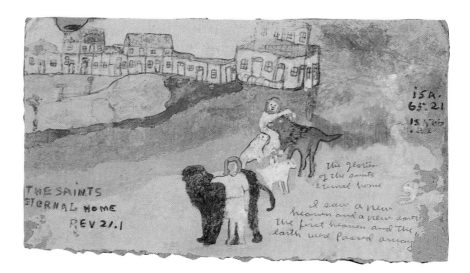

The Saints Eternal Home, c. 1965–75. Pen, pencil and watercolor on cardboard, 8½ x 15½". Alan Jaffe, New Orleans. Cat. no. 159.

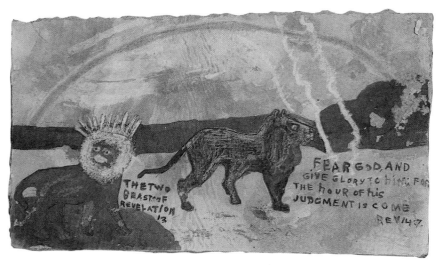

The Two Beasts of Revelation, c. 1965–75. Pen, pencil, pastel and watercolor on cardboard, 8⅜ x 15¼". Alan Jaffe, New Orleans. Cat. no. 166.

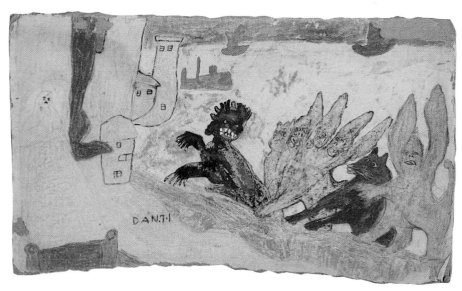

Book of Daniel 7.1, c. 1965–70. Pencil, pastel and watercolor on paper, 9 x 16⅛". Alan Jaffe, New Orleans. Cat. no. 129.

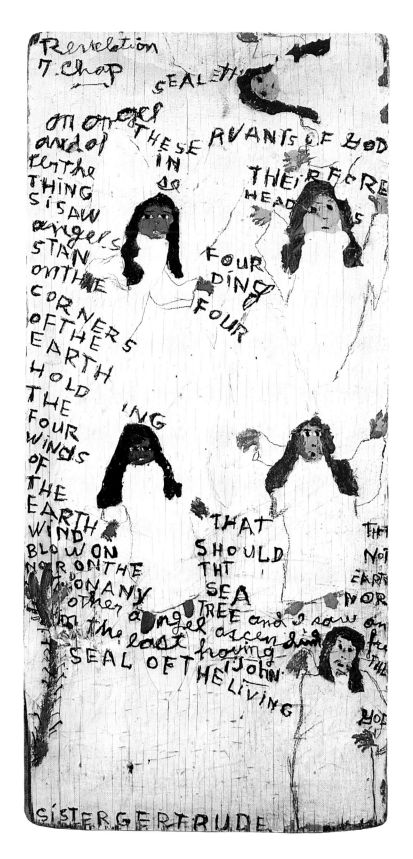

Revelation 7. Chap. c. 1965–75. Acrylic on wood, 32½ x 15⅜". Alan Jaffe, New Orleans. Cat. no. 157.

collections. These women founded and built a chapel and child care center in Gentilly. The so-called "sanctified" fundamentalist sect which Sister Gertrude joined in her early New Orleans missionary career emphasized music and dancing as the primary means of communication with God. This habit of rhythmic expression was to influence Sister Gertrude's art in all its manifestations. She played guitar, piano and tambourines and sang in a deep chant-like voice.

The Gentilly orphanage was destroyed by Hurricane Betsy in 1965; after that time, Sister Gertrude increased her painting activity, which had begun in 1956, and continued her gospel singing and preaching from her new house. As a street missionary, Gertrude Morgan had worn the traditional black habit of her sect. But around 1957, she received divine word that she was to become the bride of Christ, and began to wear all white garments. Gradually her entire environment—house and furniture, including piano, chairs, tables—were painted or upholstered in white. Her environment was always punctuated with her many elaborately painted objects—the megaphones she spoke into, her guitar case, hand fans, window shades and fireplace screens.

Sister Gertrude was a prodigiously talented painter, whose subtlety and variety of composition and technique make her among the most complex and sophisticated artists in the present exhibition. Her imagery is often richly apocalyptic. Repeated subjects are the Flood, "The Fire Next Time," the vision of the New Jerusalem as prophesied in the New Testament Book of Revelations, Paradise after the Second Coming. One of her repeated chants, "Jesus is My Airplane," is illustrated literally in several paintings, with Gertrude and Jesus together in an airplane. The celebratory nature of her themes is echoed in the exuberant palette, whose punctuating use of black and especially chalk white, creates a sense of almost wild vibrancy and compositional intricacy. Gertrude's unerring instincts for how color can be used to condition the psychological tone of her paintings is especially obvious in the contrasting color combinations she employs when depicting images of the devil—monsters, demons, the devil himself on horseback—and those depicting salvation and the Good. Gertrude painted many autobiographical scenes as well as religious ones, depicting herself in both kinds of work. She seemed innately to understand the power of clear primary colors to imply simplicity, optimism, openness— and the evocativeness of non-primaries, violet and brown, in depicting the forces of darkness. Sister Gertrude's writings and her gospel lyrics often deal with the presence of evil and the need to resist it. "It's sin I been working against, that's why I started the Everlasting Gospel Revelation Mission, to whup up on sin. Satan, he is so mighty. O he's a mighty demon. It's like he's taken his tail and pulled down a third of the stars of Heaven. That's what he's doing today. Got his old talking tongue, lying tongue, hooked tail!—Amen!—to pull people's minds and health and strength and their ways and actions and their interests—Amen—from

This sign hung outside Sister Gertrude's home in New Orleans.

Fans, c. 1975. Acrylic on cardboard, approximately 13 x 13" each. Regenia Perry, Richmond. Cat. nos. 141, 142.

Vision of Death, c. 1965–75. Ink and acrylic on paper, 7½ x 8″. Alan Jaffe, New Orleans. Cat. no. 167.

God. Let the church say Amen. Satan is always just below your feet, looking for his chance, and you got to say, 'Get back! You low-down crawling devil. Get back! You biting thing!'

> God warned Noah bout the rainbow sign
> Said no more water but the fire next time."[2]

Sister Gertrude's work was widely exhibited in her lifetime. Selected exhibitions include those at the Borenstein Gallery, New Orleans (1970); Louisiana Arts and Science Center, Baton Rouge (1972); Union Gallery, Louisiana State University, Baton Rouge (1972); Anderson Galleries, Virginia Commonwealth University, Richmond (1972); and the New Orleans Jazz and Heritage Fair (1974). She was included in "Dimensions in Black" at the La Jolla (California) Museum of Contemporary Art (1970) and "Louisiana Folk Paintings" at the Museum of American Folk Art, New York (1973).

1. William Fagaly of the New Orleans Museum of Art recalls receiving this information from Sister Gertrude. However, Herbert Hemphill remembers being shown by her a photograph of her childhood home, which he believes was in Columbus, Georgia. Perhaps she moved there early in life.

2. Quoted in Guy Mendes, "The Gospel According to Sister Gertrude Morgan" (unpublished manuscript, Versailles, Kentucky, 1974): 3–4.

Christ Coming in His Glory, c. 1965–70.
Crayon and acrylic on cardboard, 6 x 9¼".
Alan Jaffe, New Orleans. Cat. no. 134.

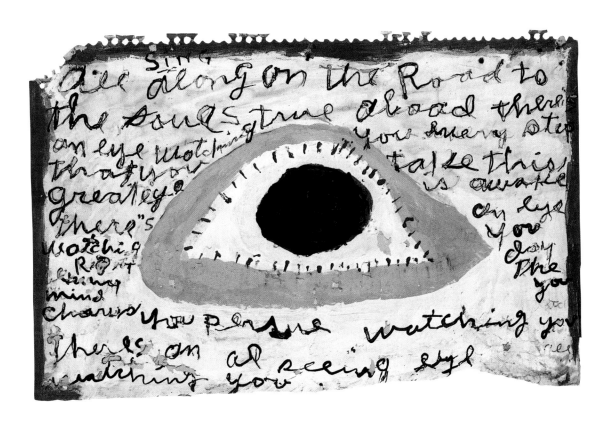

There Is An Eye Watching You, c. 1965–75.
Pen and gouache on paper, 6¹³⁄₁₆ x 11″. Alan
Jaffe, New Orleans. Cat. no. 165.

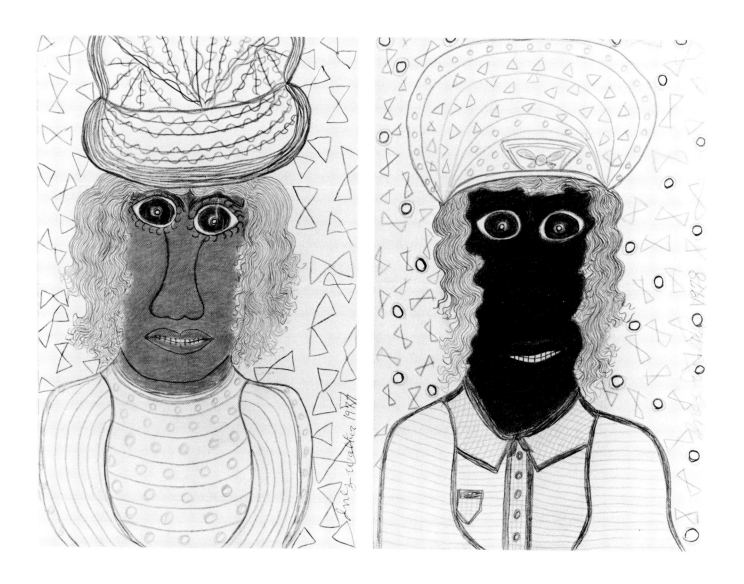

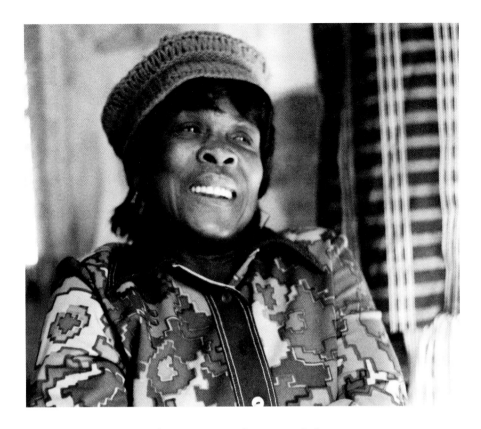

Inez Nathaniel-Walker

Born 1911, Sumter, South Carolina
Lives in New York

Describing the process by which she works, Nathaniel-Walker said, "I just sit down and go to drawing. You know—the more I draw, the better I get. I don't look at nothing to draw by. Just make 'em myself. I can't look at nobody and draw. Now that's one thing I wished I could do. But I can't. I just draw by my own mission, you know. I just sit down and start to drawing."

Nathaniel-Walker made this statement to Michael Hall, who confirmed it by observation. "She began with the face and hair at the top of a page and continued marking and doodling down through the neck and collar area and finished out with the upper body until she ran out of paper at the bottom of the page. She worked directly and almost never went back to anything or erased any line. The line seemed to have a life of its own, and she followed it and directed it at the same time. The completed drawing emerged as a curious kind of record or souvenir of a moment of concentration in a continuous and prodigious production."[1]

Nathaniel-Walker began to draw while an inmate of the Bedford Hills Correctional Facility in New York in the early seventies. She drew, she said, to protect herself from the "bad girls."[2] The first works were generally small and relatively simple in composition, most depicting only a single head. Gradually, they became larger and more elaborate, with multiple figures, patterned backgrounds and, frequently, floral decorations. The

facing page, left:
Orange Face with Hat, 1977. Crayon and colored pencil on paper, 18 x 11¾". Webb and Parsons, New Canaan, Connecticut. Cat. no. 183.

right:
Brown Face with Hat, 1978. Crayon and colored pencil on paper, 18 x 11¾". Webb and Parsons, New Canaan, Connecticut. Cat. no. 184.

patterns were originally geometric, but eventually broke loose into floating lozenges or iris-shapes. Colored pencil, usually in pastel shades, gave way to crayon in bright hues of red and orange. The figures were often depicted in apparent social situations, drinking and toasting, or smoking while reclining on couches. They were always shown either in profile or full face, with the eyes remaining frontal. Regardless of how ornate the background or how brightly-colored the faces or figures, it is the eyes that are always the focal point of Nathaniel-Walker's compositions. Heavily outlined, wide and staring, they convey at once fear and desperation, wisdom and power.

Nathaniel-Walker's subject matter and technique remained consistent throughout thousands of drawings. They were first seen by a teacher in the prison English class, who showed them to a local folk art dealer. Subsequently, the dealer received from Nathaniel-Walker dozens of sketch books full of drawings and numerous single sheets of a larger size. Nathaniel-Walker's work continued at this pace even after her release from prison in late 1972.

Born in South Carolina, Nathaniel-Walker came North around 1930, seeking an alternative to farm work. "Got tired of working so hard on the farm, weeding and hoeing. The muck would eat you up."[3] Her mother had died when she was two; her father, Wallace Stedman, was killed when she was twelve or thirteen. She was taken in by a cousin and married in her early teens. By the time she settled in Philadelphia in the thirties, she had four children. There, she worked for a time in a pickle plant until she lost her job in a strike. In 1949, she moved to Port Byron, New York, and took a job in an apple processing plant.

Nathaniel-Walker was convicted of "criminally negligent homicide" of a man who apparently mistreated her. "Some of these men folks is pitiful," she observed.[4] She served a short sentence, entering Bedford Hills in 1971 and returning to live in Port Byron by early 1973. Inez Nathaniel was married again in 1975; the surname Nathaniel was gradually dropped from the signature on her drawings and replaced by her new name, Walker. She is now separated and lives in upstate New York.

Nathaniel-Walker's drawings were first shown at the Webb-Parsons Gallery, Bedford, New York (1972, 74) and in the exhibition "Six Naives" at the Akron Art Institute (1973). They were included in "Transmitters: The Isolate Artist in America" at the Philadelphia College of Art (1981).

facing page:
Two Figures (red and brown), 1976. Crayon and colored pencil on paper, 29¾ x 41⁷⁄₁₆". Webb and Parsons, New Canaan, Connecticut. Cat. no. 180.

1. Nathaniel–Walker is quoted in *Six Naives* (Akron: Akron Art Institute, 1973), unpaginated. Michael Hall is quoted in *Transmitters: The Isolate Artist in America* (Philadelphia: Philadelphia College of Art, 1981), p. 33.

2. Recalled by Pat Parsons of the Webb and Parsons Gallery, New Canaan, Connecticut.

3. Quoted in "Self-Taught Artist Discovered in Prison" (unsigned), *Correctional Services News* (Albany, August 1978), p. 8.

4. "Self-Taught Artist," p. 8.

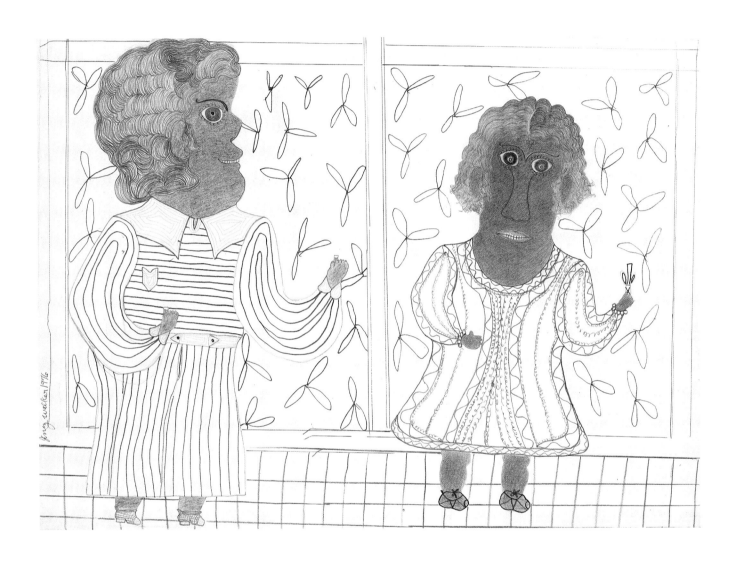

107

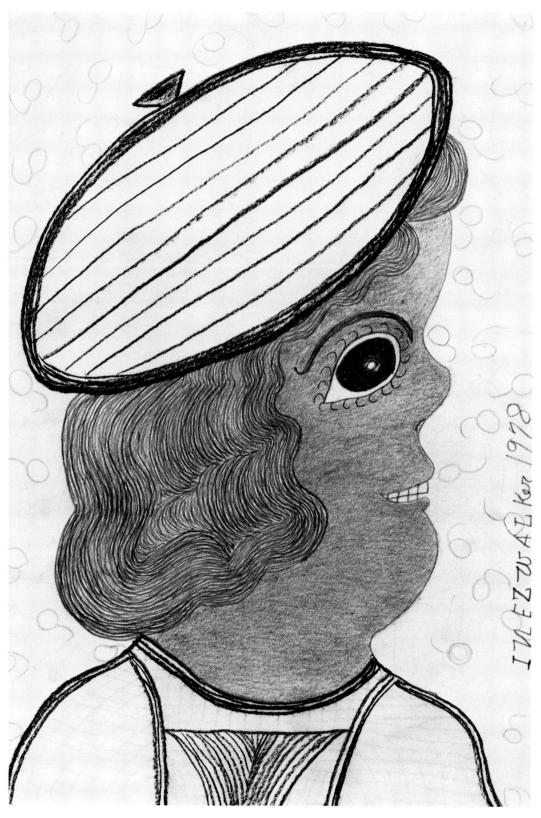

Woman with Beret, 1978. Pencil, colored pencil and crayon on paper, 17½ x 11½". Estelle E. Friedman, Washington, D.C. Cat. no. 188.

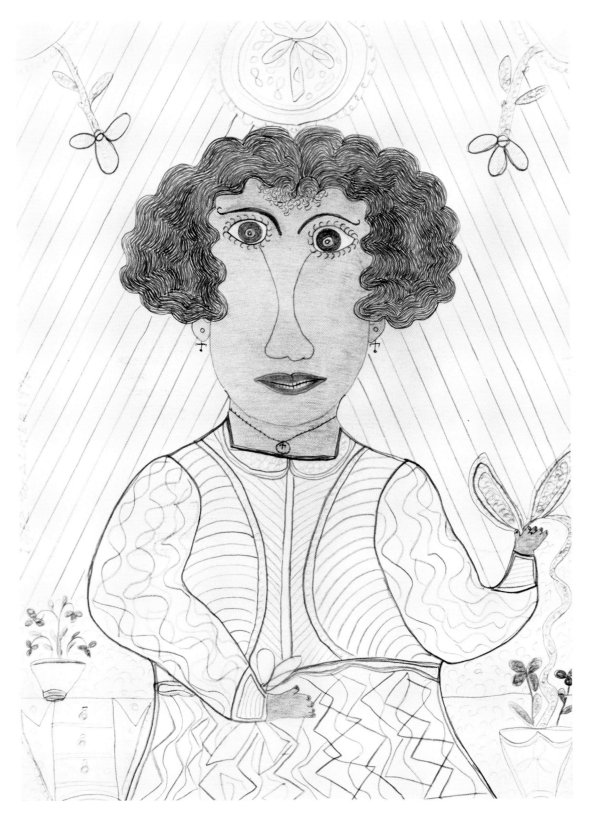

Single Woman in Green, 1976. Crayon and colored pencil on paper, 29½ x 21½". Amelia Parsons, Bedford Hills, New York. Cat no. 179.

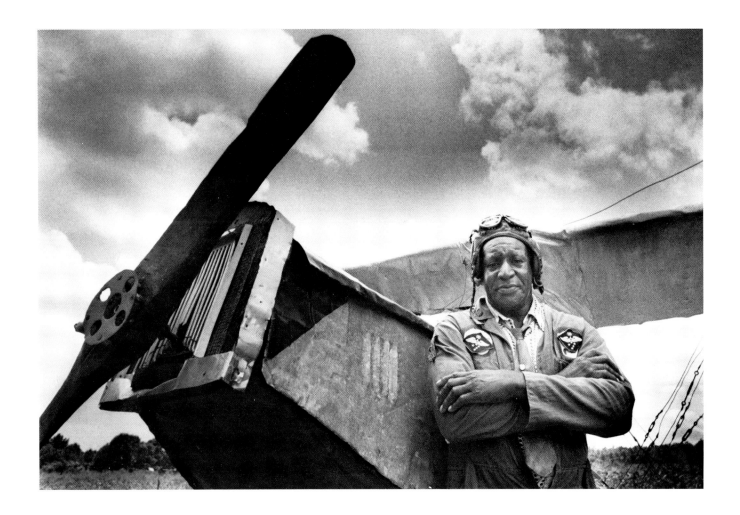

Leslie Payne

Born c. 1907, Fairport, Virginia[1]
Died 1981, Kilmarnock, Virginia

facing page, above:
G. H. McNeal in Year 1929, 1970s. Painted wood and mixed media, 33½ x 52 x 10". Herbert W. Hemphill, Jr., New York. Cat. no. 191.

below:
Fish, 1970s. Painted wood and metal, 13 x 45¼ x 7½". George Schoelkopf, New York. Cat. no. 189.

Leslie Payne's presence in the spring of 1918 at an air show in Virginia's Northumberland County was to be of singular importance to him for the rest of his life. It was there that his infatuation with airplanes began. Payne was born in Virginia in an area on the Chesapeake Bay known as the Northern Neck, a long spit of land between the Potomac and Rappahannock Rivers that includes Northumberland County. He attended County schools through the fourth grade; he later became a fisherman and crabber. He also worked for a time on the menhaden fleets for the McNeal-Dodson Co. out of Fleeton. Too young for World War I, he tried to enlist in World War II but failed to qualify. These three experiences—of the air show, the water and the military—were to become the major themes of the remarkable artistic achievements of Payne's later years.

It is thought that Payne lived in New Jersey for a time and worked in a junk yard there. He also settled in Baltimore. But by 1947, he was back on the Northern Neck, working as a handyman and living in a small frame

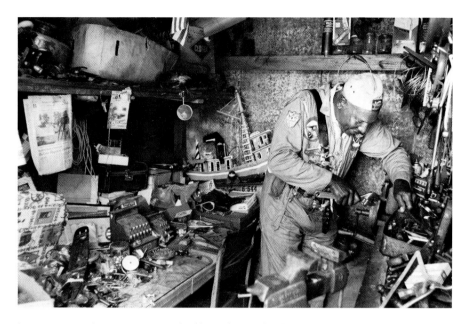

Payne in his machine shop.

house at Lillian, near Reedville. There, he began to fabricate airplanes. These were not small models, but twelve to sixteen foot metal replicas of such planes as the Spirit of St. Louis and a World War I bi-plane of the sort he would have seen at the air show. By the early seventies, he had three or four of these aircraft outside his house. One of these was equipped with a 75 horsepower engine. It is said that Payne actually tried to fly it, but when it failed to lift off, he drove it on the highways until chased off by the local sheriff.[2] The absence of literal flight did not discourage Payne, however. He took instead a series of imaginary journeys in his planes, entering the flights in a log book. He and a neighborhood girl, Pamela Annette Betts, are shown in Polaroid photographs in flight caps and goggles, ready for their journeys.

Lindbergh was a hero of Payne's, as suggested by his replica of the Spirit of St. Louis. *Sunrise Sunset* celebrates Lindbergh's flight over the Atlantic, as does a small bottle sculpture with commemorative objects contained within. Simultaneous with these works, Payne also made a number of painted wood and metal sculptures pertaining to his experience as a waterman. Several are fishing boats bearing the legend "G. H. McNeal," who was Payne's employer when he was a fisherman. At least one of these was once part of a large tableau about fishing on the Chesapeake. This work may also have included the large bright blue *Fish*. *Two Soldiers* and *Hitler* commemorate World Wars I and II respectively, and reflect an interest in warfare. They were intended as patriotic images—a demonic Hitler is shown with bombs and a swastika pierced by daggers. The *New York Lady* is similarly patriotic, based on Payne's recollection of the Statue of Liberty, which he saw on a bus trip to New York. It is made of cut and painted metal, decorated with glittering plastic reflectors. Indeed, so was Payne—he had rhinestones embedded in his teeth.

Payne was unusual among folk sculptors in executing preparatory studies for his works. The large planes were based on plans drawn from books and photographs. Preparatory drawings exist for *Hitler*, two of the G. H. McNeal boats and one of the small planes. Payne's sculptural oeuvre is also known to include a minstrel show, a whirligig of a man in a top hat and a Model T Ford, all made from cut and painted metal.

Payne's work is being shown for the first time.

Sunrise, Sunset (with airplane), 1974. Painted wood, metal and mixed media, 10'4" x 5'3" x 8" (sign), 24 x 37 x 41" (airplane). John Freimarck, Mechanicsville, Virginia. Cat. no. 196.

1. September 20, 1907 is the birthdate Payne gave to Patricia Olsen, a Richmond writer who is the source of most of our biographical information on him. The program for his funeral gives his birthdate as October 1906.
2. Recalled by Jeff Camp of Tappahannock, Virginia.

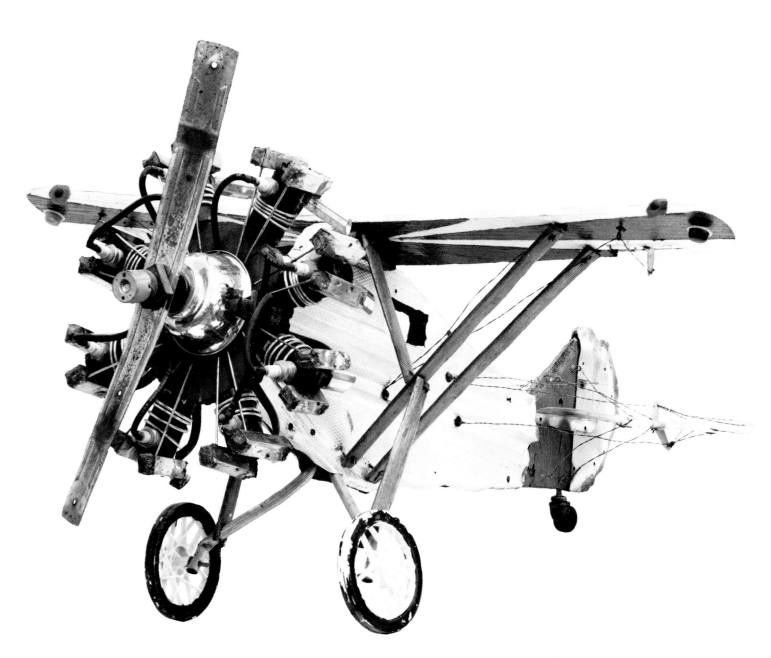

Detail of the airplane from *Sunrise, Sunset*.

113

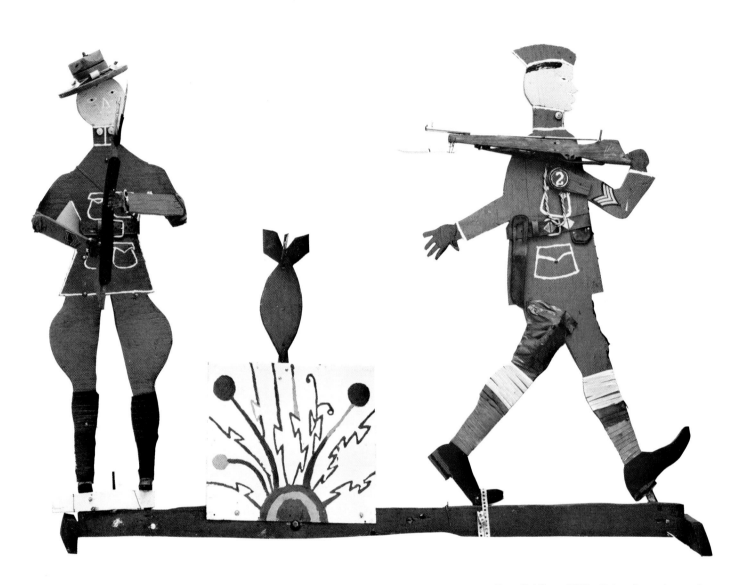

Two Soldiers, 1970s. Painted wood, metal, knives, 71½ × 83 × 15¼". Phyllis Kind Gallery, New York and Chicago, Cat. no. 197.

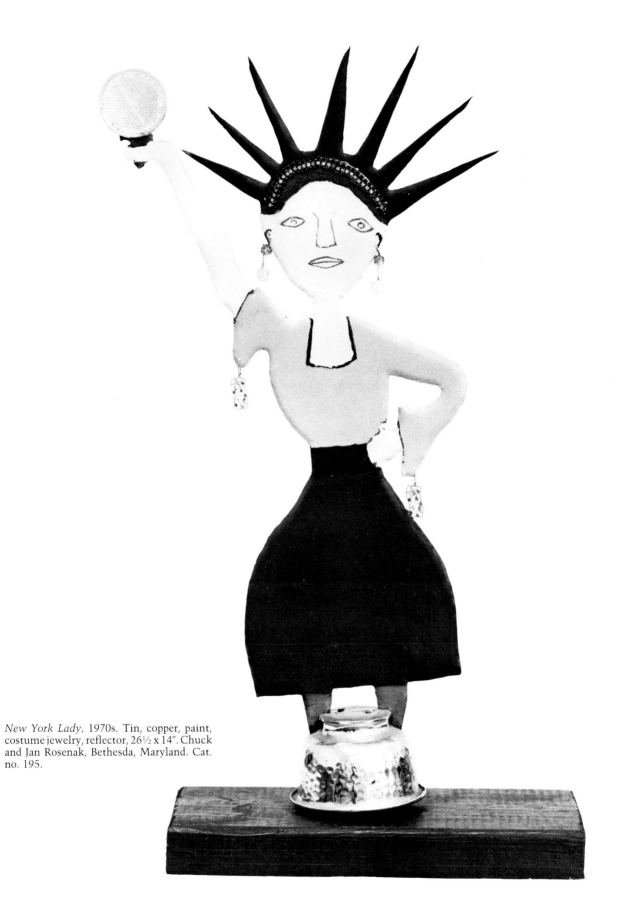

New York Lady, 1970s. Tin, copper, paint,
costume jewelry, reflector, 26½ x 14″. Chuck
and Jan Rosenak, Bethesda, Maryland. Cat.
no. 195.

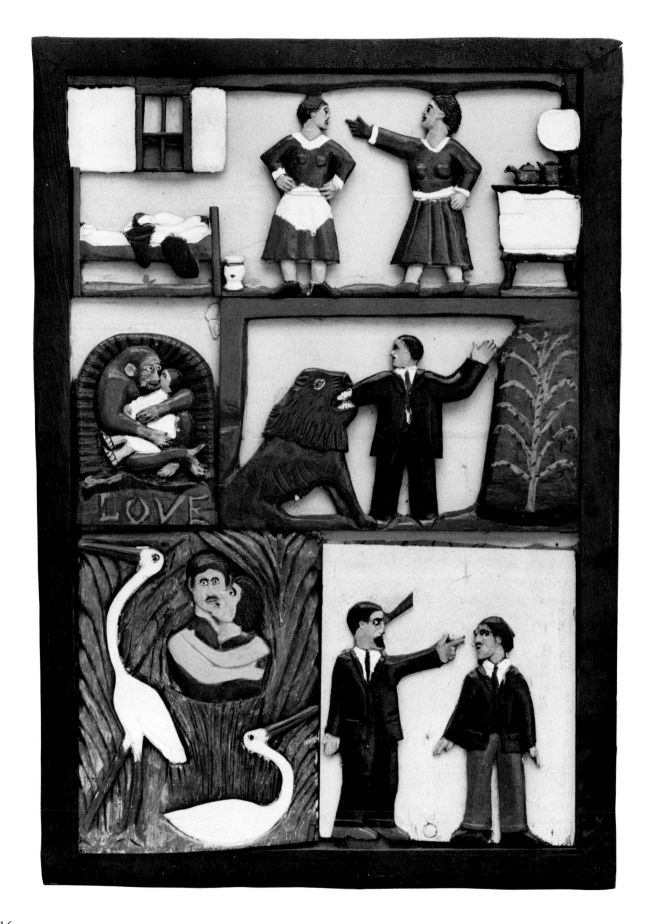

116

Elijah Pierce

Born 1892, near Baldwyn, Mississippi
Lives in Columbus, Ohio

Elijah Pierce has had two principal professions in his lifetime, those of the barber and the preacher, but his life-long vocation has been woodcarving. He was given his first job as a barber at age sixteen, when an elderly white barber in Baldwyn hired him as an assistant. When the man died, Pierce continued to manage the shop—this lasted until the death of Pierce's first wife after a year of marriage in about 1916. Not long thereafter, Pierce says, he began a period of wandering. He worked on bridge gangs for the railroad and obtained passes which took him to places such as Memphis and St. Louis. He also rode the rails as a stowaway. It was a time of fast living, as Pierce tells it, when he dressed well, played the piano and liked to dance.

By the early twenties, Pierce had found his way to Danville, Illinois, where he was again working as a barber. There, in about 1924, he met the woman who was to become his second wife. He resisted marriage, and she left him to return to her family in Columbus. He followed her there, telling her "I'm just on my way to visit my sister in Youngstown." They were married his first day in Columbus and Pierce has lived there ever since.

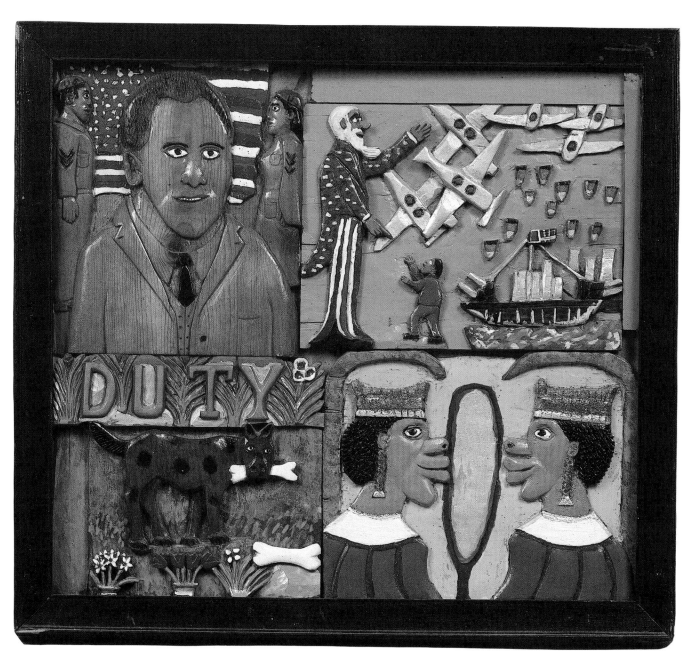

Pearl Harbor and the African Queen, 1941. Carved and painted wood, 23¾ x 26¾". The Hall Collection of American Folk and Isolate Art, Bloomfield Hills, Michigan. Cat. no. 204.

facing page:
Crucifixion, 1940. Carved and painted wood on painted wood panel, 47 x 30½". The Elijah Pierce Art Gallery, Columbus. Cat. no. 203.

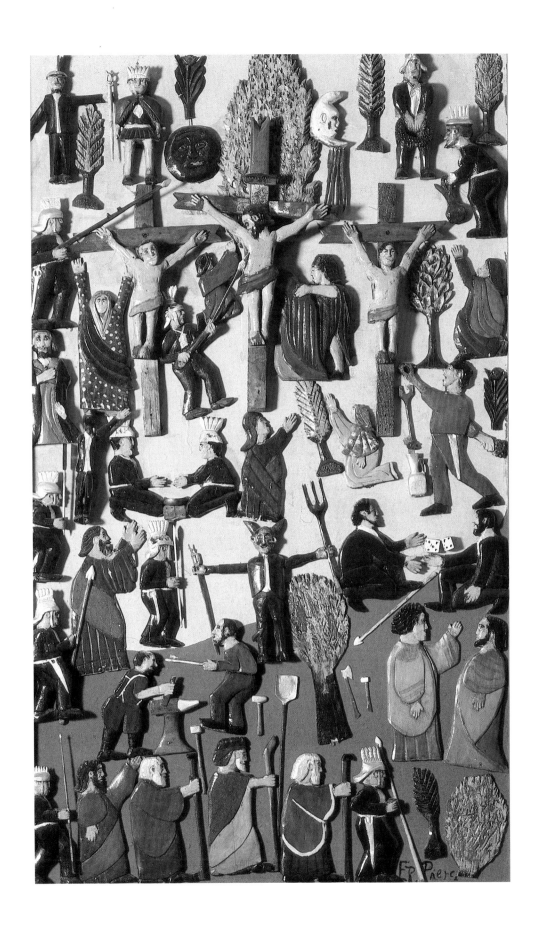

He worked for thirty years for other barbers, but in 1954 built his own shop. His second wife died in the mid-fifties; he is now married to his third wife, Estelle.

Pierce realized early in life that he was called to preach, but says he resisted it for many years. By 1920, however, he had embraced this role and that year he was awarded a preacher's license by the Mt. Zion Baptist Church in Baldwyn. Though his preaching sometimes took the conventional form, it also found expression in many of his woodcarvings. "My carvings look nice," he told a reporter in 1979, "but if they don't have a story behind them, what's the use of them? Every piece of work I carve is a message, a sermon."[1]

One of these messages concerns his own rebirth. He recalls an evening while he was still living at home in Baldwyn when he was reading the Bible. Across from him, his mother was looking at a new Sears, Roebuck catalogue. "I reached across the Bible to look at the catalogue," Pierce recounts. "The good Lord laid his hand on my head and I fell out of my chair .. I heard a voice say, 'I told you to read the Bible and you disobeyed me, so I'm just showing you my power.' The house was full of people ... They said I was dead. I didn't feel any pain. I just went out like the sun going behind a cloud. Then I came back. Since then, I'm afraid of the Lord."[2] This incident is memorialized in a carving titled *Obey God and Live.* Pierce has depicted numerous other religious subjects, particularly Biblical stories. These include Noah's Ark, Jonah, The Story of Job, Elijah, and The Three Wise Men. "A preacher hardly gets us in the pulpit without preaching some picture I got carved," he proclaimed to a writer in 1975.[3]

The religious aspect of Pierce's work reached an apogee with two works, the monumental *Crucifixion* and *The Book of Wood.* The former was carved in numerous small, individual pieces in 1933 and only later mounted in its present form. *The Book of Wood* was completed over about a six month period in 1932. It includes 33 separate scenes from the life of Christ ("one each for the years of His life"), mounted on seven sheets of cardboard bound together by string. In his younger days, Pierce would pack a selection of these carvings into his car and travel throughout the Midwest with them, using them to illustrate the sermons he gave at county fairs, schools and churches. A photograph from those days shows Pierce and his wife in ecclesiastical robes, holding microphones and standing in front of his carvings.

Pierce's work also has its secular aspect. Indeed, the first carving he recalls making as an adult was a small elephant for his wife. Pierce has done hundreds of animals since: some are depictive—alligators, tigers, horses, dinosaurs; others are fantastical or fabled. An example of the last, the *Monkey Family,* is in several scenes: in one, the monkeys bathe their young in the spray of an elephant's trunk; in another, the young lean over, preparing to swat a fly off their sleeping mother's head. These are the crafty, capable animals that appear in folk tales of the "signifying monkey." Pierce has also depicted sports figures (including *Louis vs. Braddock*) and politicians (*Nixon Being Chased by Inflation*).

Others of the works are autobiographical. Pierce was born on a farm in northeastern Mississippi; his father was an ex-slave who was nearly sixty when Pierce was born. The experiences of his father's life were depicted in works titled *Slavery Time; Picking Cotton* in this exhibition is a variation on this theme. Pierce disliked farming, as revealed by the unhappy figures in *Picking Cotton,* and early in life sought alternative employment. It was this that led to barbering.

Leroy Brown, 1970s. Carved and painted wood, glitter and rhinestones, 19¾ x 10¼". Phyllis Kind Gallery, New York and Chicago. Cat. no. 219.

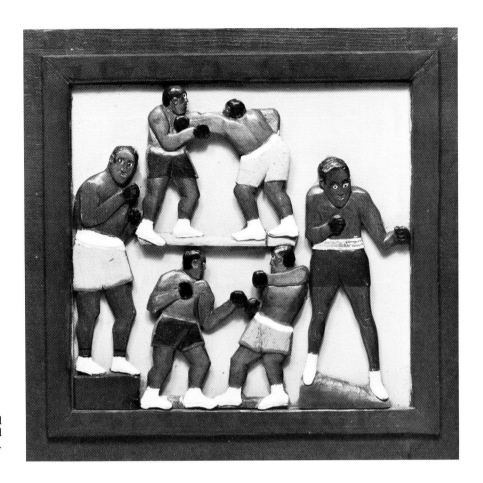

Louis vs. Braddock, c. 1950. Carved and painted wood, 21½ x 23". Jeffrey Wolf and Jeany Nisenholz-Wolf, New York. Cat. no. 208.

"I didn't even know I was an artist 'til they told me," Pierce said in 1976.[4] Now, however, Pierce and his wife have transformed his barber shop into the Elijah Pierce Art Gallery. They receive visitors from the local community and from the rest of the nation and abroad; Pierce has been the subject of several films and national magazine articles and has a considerable audience in the art public. He is revered in his own community both as an artist and as an orator. His work was first shown in an art context in the early seventies in solo exhibitions at the Hopkins Hall Gallery, Ohio State University, Columbus (1971); The Krannert Art Museum, University of Illinois, Urbana (1971); the Bernard Danenberg Galleries, New York (1972); the Pennsylvania Academy of the Fine Arts, Philadelphia (1972); the Columbus Gallery of Fine Arts (1973); and the Phyllis Kind Gallery, New York (1976). More recently, it was included in "Transmitters: The Isolate Artist in America" at the Philadelphia College of Art (1981). In 1973, Pierce received First Prize at the International Meeting of Naive Art in Zagreb, Yugoslavia.

1. Quoted in Gaylen Moore, "The Vision of Elijah," *The New York Times Magazine* (August 26, 1979), p. 30.

2. Moore, p. 30.

3. Quoted in Elinor Horwitz, *Contemporary American Folk Artists* (New York: J.B. Lippincott Co., 1975), p. 88.

4. Quoted in Michael Kernan, "Piercing, Wondrous Woodcarvings," *The Washington Post* (March 21, 1976), p. G1.

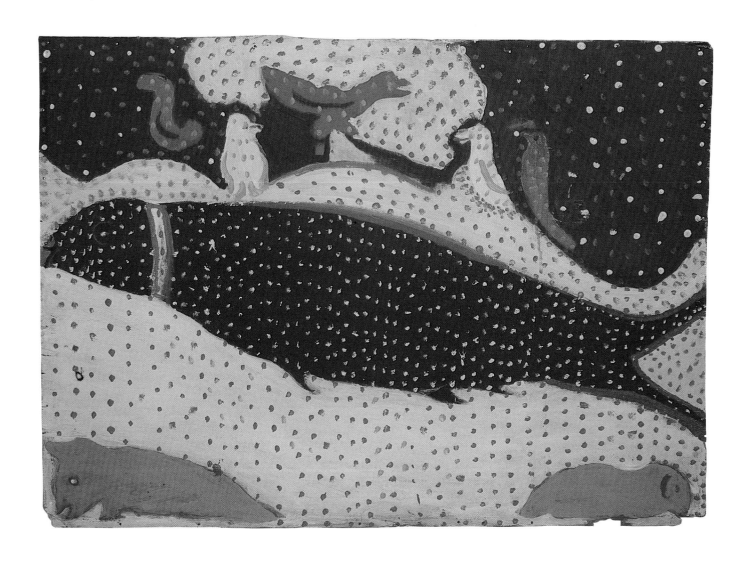

Nellie Mae Rowe

Born 1900, Fayette County, Georgia
Lives in Vinings, Georgia

Nellie Mae Rowe is the master of several media. She began to draw early in life, while at the same time learning from her mother how to make quilts and dolls. In the mid-sixties, her creativity flourished: it is now protean and prolific. She has executed numerous drawings in crayon or

facing page:
Black Fish, 1981. Acrylic on wood, 26½ x 37". Alexander Gallery, Atlanta. Cat. no. 245.

Fish on Spools, 1980. Acrylic on wood, 7½ x 25 x 1½". Alexander Gallery, Atlanta. Cat. no. 238.

felt-tip pen; she has painted in oils; she has made sculptures in wood and chewing gum; and she has continued to produce dolls. She has done all this with an energy and enthusiasm that keeps her constantly busy. "Sometimes I even get behind on the washing," she admits.

Memory and imagination are both central to her work. "I do as my mind tells me to do," she explains. "Sometimes when I'm drawing, I don't know what it's going to be, but I just keep on going."[1] The images that crowd her drawings reflect these two sources. *Molly* is a portrait of the mule that pulled the plow at her sharecropper parents' home. She appears in front of a checker-board background containing numerous smaller representations of faces, animals and vegetation. A doll dressed in orange, with glasses and a wig, is Rowe's *Self-Portrait as a Child.* The drawing *Something That Hasn't Been Born Yet* suggests a more fanciful inspiration. This is a hump-backed creature with a checkered coat, black mane and long tail, an animal that Rowe explains will come into existence sometime in the future. It floats in front of a background as dense and colorful as that of *Molly,* but is as dominated by curves as *Molly* is by squares. But it is in the drawings less dominated by a central image that Rowe's compositional sophistication reaches its apogee. The elements of *Rocking Chair* are built up on the page in layers; shapes overlap and merge. Plant forms sprout feet and heads; small figures dance; animal shapes appear throughout. The rocking chair itself sits serenely empty, surrounded by details Matisse-like in the richness of their color and pattern.

Rowe's earliest-surviving drawings were executed in a far more simple fashion. One of these works shows the faint outline of a fish in ink on graph paper. Color was soon added to fill in the outline, while the background remained empty. Then it too began to fill up, with plant shapes and ghost-like faces, until Rowe achieved her present style of all-over decoration.

Rowe's sculpture shows some of the same characteristics as the drawing. It is densely painted in bright colors on front and back surfaces. One large fish shape cut from board contains the painted images of a face and another fish. Rowe also works in chewing gum, which she accumulates in a coffee can until she has enough to fashion it into a head or an animal. She then hardens it in the refrigerator and paints it. One such head seems almost like a voodoo image: it has a different face on each side and is decorated with glittering costume jewelry. It is a piece that demonstrates the fascination of ugliness.

Rowe was born in rural Fayette County, Georgia. Her father was a blacksmith and a farmer. She disliked the intensive labor of unmechanized

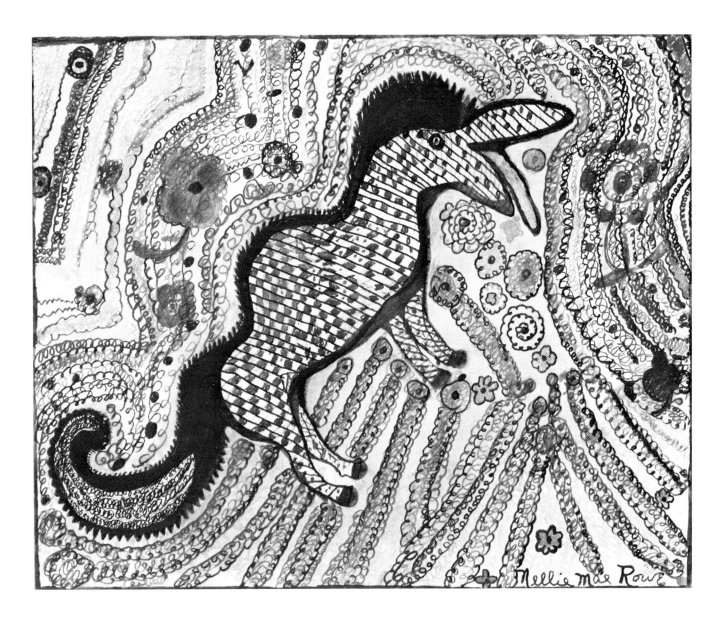

Something That Hasn't Been Born Yet, 1979. Ink and pencil on paper, 15 x 20". Alexander Gallery, Atlanta. Cat. no. 236.

farming and moved to Atlanta as an adult, working as a domestic. Married twice, her first husband died in 1936, the second in 1948. She has lived just across the Chattahoochee River from northwest Atlanta for over forty years, in a one-story cottage built by her second husband. It is filled with her dolls and drawings, together with memorabilia from her long life. A sign on the door proclaims "My House is Clean Enough to be Healthy and Dirty Enough to be Happy." The yard is decorated with hanging objects, including chimes, paintings on metal and plastic flowers. Until they were stolen, several of her dolls sat outdoors, gazing down the road and attracting passersby.

Rowe's work was included in "Missing Pieces: Georgia Folk Art, 1770–1976," an exhibition at the Atlanta Historical Society in 1976–77 that was also shown at the Telfair Academy of Arts and Sciences, Savannah; the Columbus (Georgia) Museum of Arts and Crafts; and the Library of Congress, Washington, D.C. It has also been featured in solo exhibitions at the Alexander Gallery, Atlanta (1978, 81) and the Parsons-Dreyfuss Gallery, New York (1979).

1. Quoted in Michael Haggerty, "Art and Soul," *Atlanta Weekly* (June 29, 1980), p. 18.

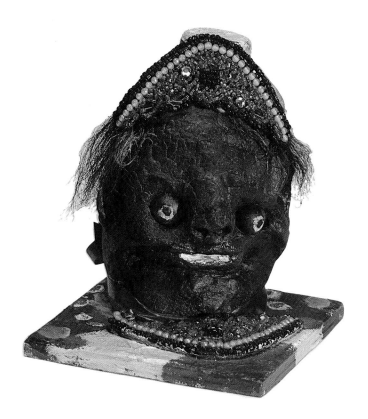
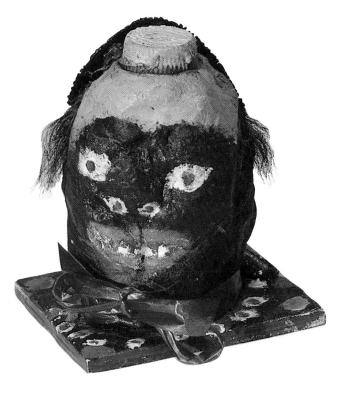

Two-Faced Head (recto and verso), 1980. Painted gum and mixed media, 5½ x 4¼ x 4¼". Judith Alexander, Atlanta. Cat. no. 242.

Purple Pig, c. 1975. Wood, chewing gum and watercolor, 7½ x 6 x 8½". Chuck and Jan Rosenak, Bethesda, Maryland. Cat. no. 231.

Pig on Expressway, 1980. Crayon on paper,
18 x 23″. Alexander Gallery, Atlanta. Cat.
no. 239.

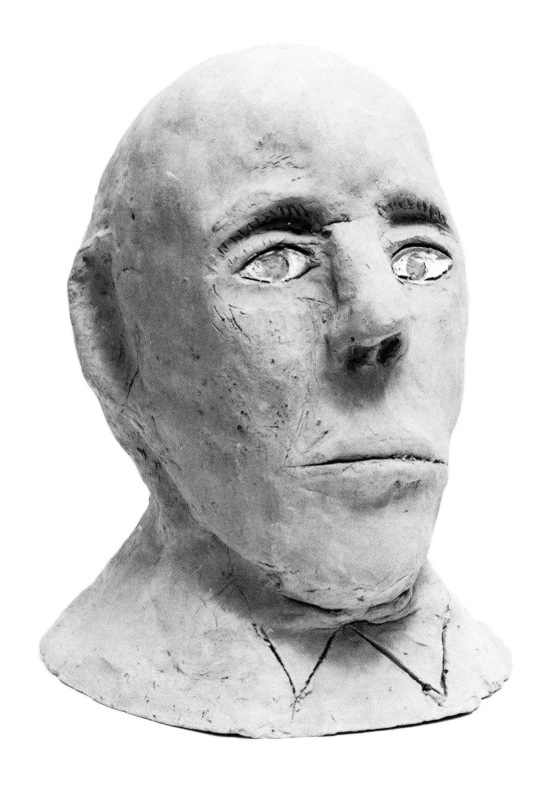

128

James 'Son Ford' Thomas

Born 1926, Yazoo City, Mississippi
Lives in Leland, Mississippi

James Thomas is an unusual figure in the present group of artists, being a creative prodigy both as sculptor and as musician. He demonstrated his extraordinary natural talent for sculpture and guitar-playing from childhood on. He recalls, as a child living with his grandparents in Eden, Mississippi (his siblings stayed with their parents), that he didn't have many friends: "I never did fool with too many boys because I was always busy. Just anything would run across my mind, I'd do it. I was always around the house making fish nets, or molding clay, or something."[1] Thomas has continued to mold clay, progressing from the toy clay and wood tractors of his youth (thus the nickname "Son Ford") to the skulls and animals of his adult artistic activity. He has also developed prodigiously as a blues musician, picking, singing and composing some of the most sophisticated and original music currently being played in the tradition of the Delta Blues.

Thomas has been close to and importantly influenced by several Blues musicians, particularly B. B. King, Elmore James, Robert Johnson and Sonny Boy Williamson. But his visual style and image repertory were created out of his own imagination and daily experience. He does not accumulate and form environments out of his sculptures; they are more like ritualistic, transitory objects of exorcism or placation. He relates, "This is all done by head, not by no book or no picture. I have never went to no school to do this. No teacher has ever taught me nothing about it. My Uncle Joe was the first person that showed me . . . I'd sit up by the fireplace at night and make things until I got sleepy. I got where I could make mules, and rabbits, and squirrels, and things like that, and from that

facing page:
Head, 1977. Unfired clay and paint, 9 x 6 x 6½". Center for Southern Folklore, Memphis. Cat. no. 266.

129

I went to making birds. . . . The first time I made a skull I was living with my grandpapa in Yazoo County. I made a great big skeleton head and I had corn in his mouth for teeth. I brought it in the house and set it up on the shelf. We didn't have no electric lights then. My granddaddy was scared of dead folks, and one night he had stayed up late. He came in and lit a match to light the lamp and, first thing, he looked in the skeleton's face. Instead of pulling the globe of the lamp, he jumped and dropped the globe and run into my room and told me, said, 'Boy, you get this thing out of my house and don't bring another in here. I already can't rest at night for spooks now.'"

Thomas earned money to buy his first guitar in 1942 through his wages as a cotton picker. Since that early time, he has labored in several endeavors, including farming, yard work and, most frequently, grave digging. Thomas presently lives in Leland, Mississippi, in a community whose members clearly admire and honor him. He has several children; one of his sons regularly plays guitar in the local "20 Grand Club," an institution which spawned more than one notable black musician in its earlier years as "Red Ruby's." Thomas frequently performs in Vicksburg, Mississippi and other Southern towns, and has toured Holland, Belgium and Germany on several occasions. He is no longer married, but lives surrounded by family and friends. He is able to live primarily by his performing and sculpting.

Like many of the artists in the present exhibition, Thomas generally receives ideas both for his blues lyrics and his sculptures in dreams. "I'm liable to dream anything. That gives you in your head what to do. Then you get up and try. If you can't hold it in your head, you can't do it in your hand." William Ferris, who has been Thomas's friend for several years and written on both his music and sculpture, notes that Thomas's esthetic refers to a characteristically black notion of the ugly as being equated with the beautiful—"The preference for ugliness is an aesthetic choice which reverses traditional white concepts of beauty somewhat like the black use of 'bad' to mean 'good.'" Ferris has exposed Thomas to various materials and techniques of craftsmanship, and the artist has easily assimilated new processes and materials in making his sculpture. But he maintains his distinctive style, and rarely becomes slick or mechanical.

Thomas's work was exhibited in "Made by Hand: Mississippi Folk Art," Mississippi State Historical Museum, Jackson (1980).

1. Quotes are drawn from an interview with Thomas to be published in William Ferris and Brenda McCallum, *Local Color: Folk Arts and Crafts* (Memphis: Center for Southern Folklore, in press).

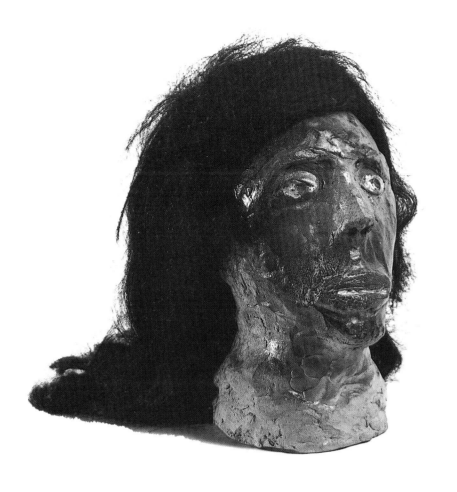

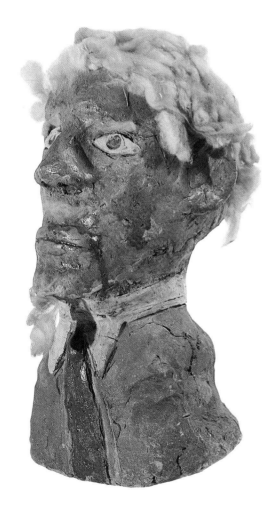

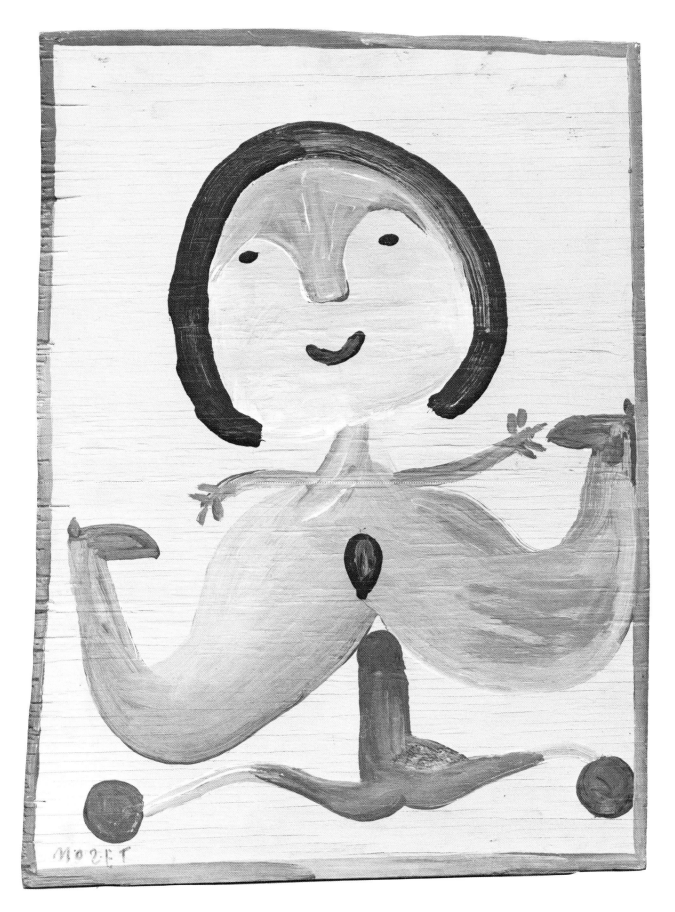

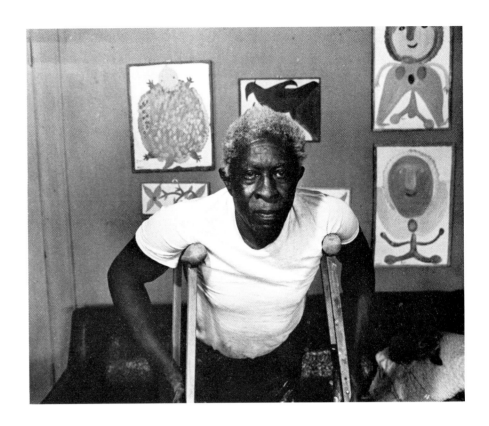

Mose Tolliver

Born c. 1915, Pike Road, Alabama[1]
Lives in Montgomery, Alabama

facing page:
Sexual Fantasy (Lady on Scooter), late 1970s. Enamel on plywood, 24¾ x 18¾". Herbert W. Hemphill, Jr., New York. Cat. no. 284.

Few painters are as prolific as Mose Tolliver, who has been known to produce over ten paintings a day. But more remarkable than the energy that he devotes to painting is the exuberance that he conveys through his unusual chromatic choices and his fantastical subjects. Birds cluster in exotic trees; turtles and fish, deer and sheep as well as a variety of wholly imagined creatures emerge from alternately bright or brooding backgrounds. Figures appear on busses and women with their legs spread to encircle their heads deliver babies or straddle disembodied phalluses (Tolliver calls these paintings "Ladies on Scooters"). His paintings range from the nearly sweet (*Yellow Figure on Bicycle*) to the truly demonic. In one, a *Self Portrait*, the face represented is one that evokes a sense of absolute terror. The palette tends to be oddly limited in most works, yet hauntingly sophisticated: grey with green, mauve with brown. Tolliver's paintings depict an almost hallucinogenic world of arresting color and phantasmagoric images.

Tolliver frequently repeats his subjects, executing numerous variations of a given theme, such as birds or busses or Ladies on Scooters. But some appear to be unique: one of these is a moose head with a pair of antlers attached. Tolliver has been painting for about ten years. His interest was sparked by a former employer who took him to an art exhibition and

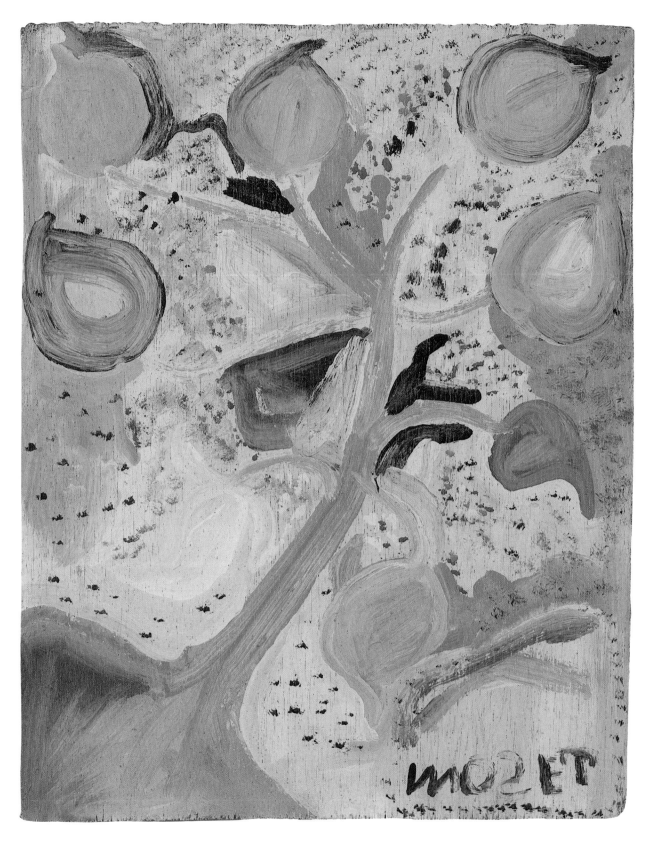

Plant Form, c. 1975. Enamel on wood, 16¼ x 12⅞". Kansas Grassroots Art Association, Lawrence. Cat. no. 275.

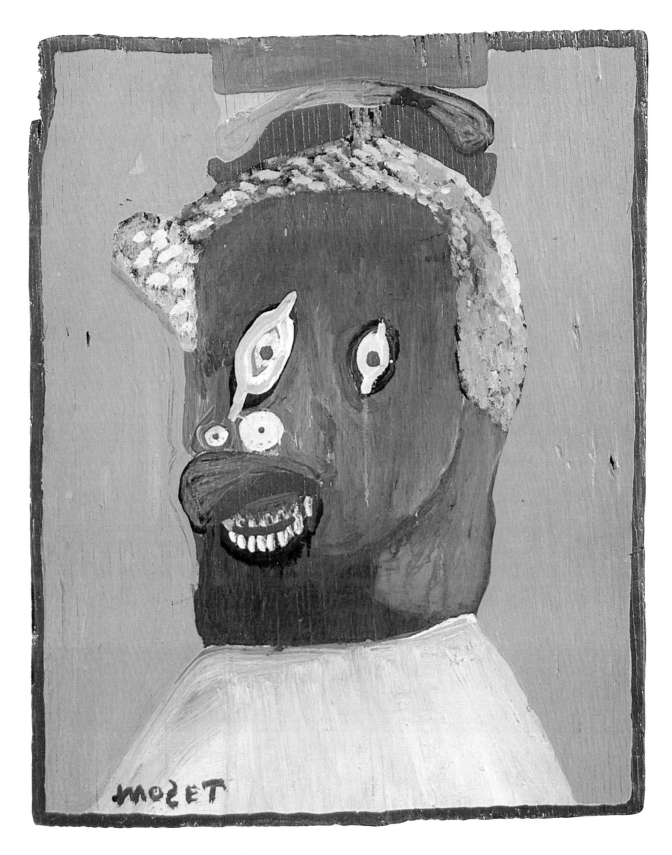

Self-Portrait, 1978. House paint on plywood,
21 x 16¾" (16¼" top). Robert Bishop, New
York. Cat. no. 283.

encouraged him to take lessons. He eschewed lessons, however, feeling he could learn on his own. Previously, Tolliver was employed in the shipping department of a furniture factory; there, in the late sixties, a heavy load of marble fell from a forklift and crushed his feet. He has been on crutches ever since, unable to work or to move about with ease. Much of his time is now devoted to painting.

Tolliver was one of twelve children born to tenant farmers in the Pike Road community south-east of Montgomery. He attended school briefly in Macedonia, also south of Montgomery, where his parents moved while he was still a child. As a teenager, he worked on truck farms and as a gardener; he subsequently moved to Montgomery and continued garden work. He was married in the early forties and is the father of fourteen children, eleven of whom are still living. The eldest is 36, the youngest 22. He served in the army for six months during the Second World War, working as a laborer at a base in Georgia.

Tolliver's work was included in the exhibition "Transmitters: The Isolate Artist in America," Philadelphia College of Art, 1981. He received a solo exhibition the same year at the Montgomery Museum of Fine Arts.

above left:
Face of a Bearded Man, c. 1975. Enamel on cardboard, 13⅞ x 10¹⁵⁄₁₆″. Kansas Grassroots Art Association, Lawrence. Cat. no. 267.

above:
Green Tree with Two Green Birds, 1980. Housepaint on panel, 35¾ x 12″. Mitchell D. Kahan, Montgomery, Alabama. Cat. no. 287.

1. Biographical information is drawn from interviews conducted by Mitchell Kahan in Montgomery, July 1981.

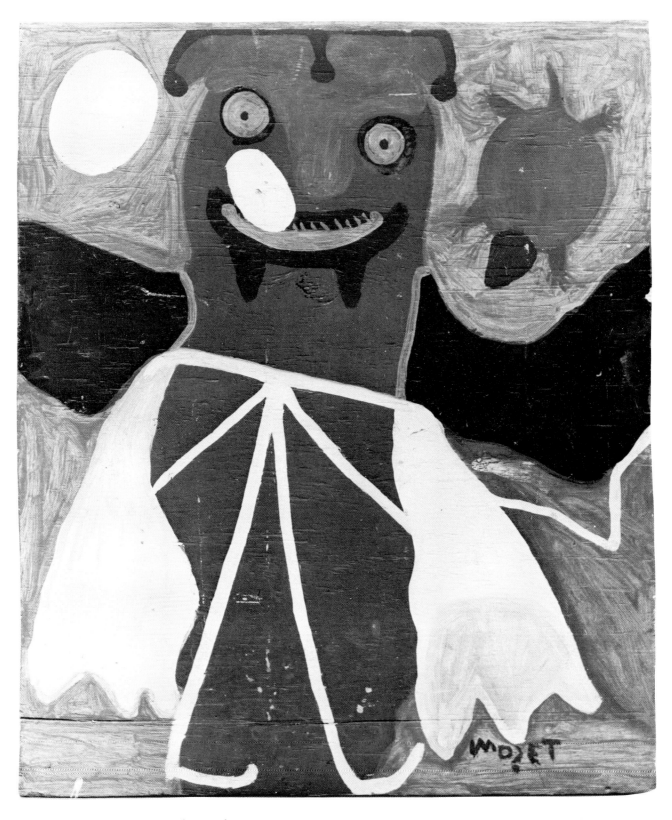

Figure with Turtle, c. 1975. Enamel on wood, 28⅜ x 23¾". Kansas Grassroots Art Association, Lawrence. Cat. no. 270.

137

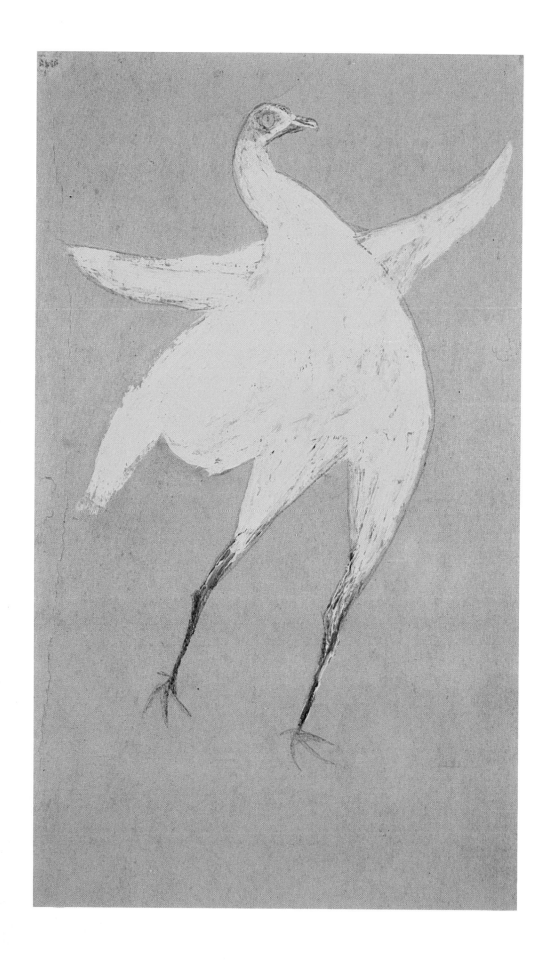

Bill Traylor

Born 1854, near Benton, Alabama
Died 1947, Montgomery, Alabama

Bill Traylor was born a slave on the plantation of George Traylor, near Benton, Alabama, between Selma and Montgomery. After emancipation, he remained as a farm hand at the Traylor place and continued to live there until 1938, when he was eighty-four. Then, with his wife and the Traylors deceased and his approximately twenty children gone, he moved to Montgomery. There he worked briefly in a shoe factory until rheumatism disabled him, when he began receiving financial assistance from the government. Nights he slept in the storage room of a funeral parlor; days he took a seat on the sidewalk in front of a pool hall or under a shed roof by a fruit stand in Montgomery's downtown street market.

In 1939 and at the age of eighty-five, Traylor suddenly began to draw. "It just come to me," he told a *Collier's* reporter.[2] Using a pencil and

facing page:
Yellow Chicken, 1939–42. Pencil, crayon and gouache on paper, 13⅞ x 8¼". Charles Shannon, Montgomery, Alabama. Cat. no. 325.

Blacksmith Shop, 1939–42. Pencil, crayon and gouache on paper, 13⅜ x 26¼". Charles Shannon, Montgomery, Alabama. Cat. no. 293.

straight-edge, he would begin by drawing geometric forms on whatever paper or cardboard—often shirt cardboard—he could find. These simple shapes would be filled in with color and elaborated into full-bodied human or animal figures. Fierce, red-tongued dogs, purple rabbits, green goats, dancers and drinkers, men driving mules, women milking cows: Traylor's subject matter was rooted in the experiences of his life. The work became a kind of visual reminiscence of incidents such as a possum hunt when, while the dogs treed the possum, the drunken preacher danced and twirled his hat on his finger. Traylor apparently worked continuously, almost obsessively, as if he knew he had little time to record all that he had seen.

Soon after he began to draw, Traylor was befriended by a young Montgomery artist, Charles Shannon. Shannon would bring him poster paints and paper and listen while Traylor narrated with laughter stories depicted in the drawings. He began to collect Traylor's work and encouraged others to do the same. Traylor would hang the drawings with strings on a fence behind him and sell them occasionally to passers-by. "Sometimes they buy them when they don't even need them," he told Shannon with amusement.[3]

Traylor's work was interrupted after four years. With the advent of the Second World War, Traylor moved north in 1942 to live with his children in Washington and Detroit. It is not known if he drew during those years; no work remains. After the war, in 1946, he returned to Montgomery and resumed drawing. He slept in a shoe repair shop and drew, as before, from his station on the street. The following year, he lived briefly with a daughter in Montgomery, then in a nursing home until his death.

"Will it live, this bizarre stuff which is primitive and Thurberish at the same time?" questioned the *Collier's* writer in 1946. "Will it blow down the gutters of a little town when Bill is gone? Or will it have some little part of the permanence enjoyed by the rock-immortalized cave pictures

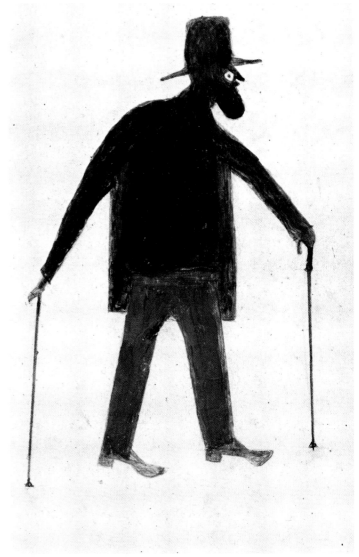

above:
Drinker with Hat and Bottle, 1939–42. Compressed charcoal pencil on paper, 13½ x 7⅝". Mr. and Mrs. Joseph H. Wilkinson, Fairfield, Connecticut. Cat. no. 297.

above right:
Self-Portrait, 1939–42. Pencil, crayon and gouache on paper, 17 x 11". Charles Shannon, Montgomery, Alabama. Cat. no. 318.

which it resembles?" Traylor's work was shown twice in his lifetime, at New South, an art center in Montgomery (1940) and at the Fieldston School in New York City (1941). It was then thirty-eight years until it was seen publicly again, at the R. H. Oosterom Gallery, New York (1979) and in the exhibition *Southern Works on Paper, 1900–1950*, circulated by the Southern Arts Federation (1981–82).

1. We are indebted to Charles Shannon of Montgomery for much of this biographical information.
2. Quoted in Allen Rankin, "He Lost 10,000 Years," *Collier's* (June 22, 1946), p. 67.
3. Quoted in Charles Shannon, "The Folk Art of Bill Traylor," *Southern Works on Paper, 1900–1950* (Atlanta: Southern Arts Federation, 1981), p. 16.
4. Rankin, p. 67.

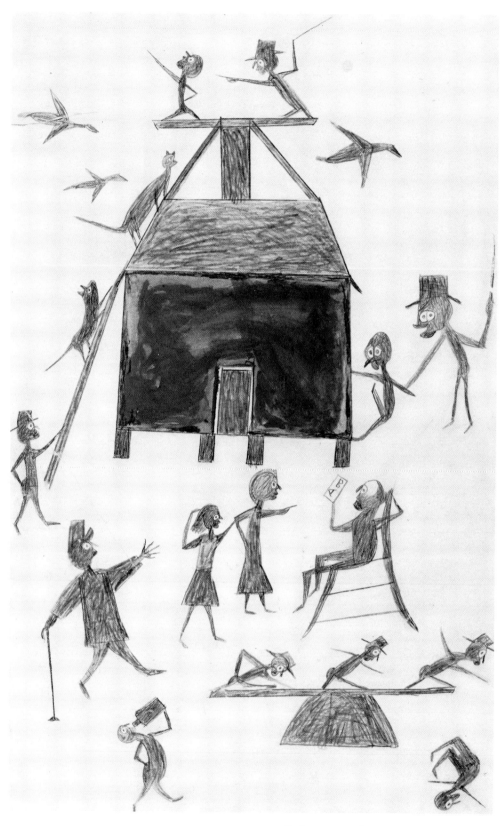

Red House with Figures, 1939–42. Pencil, crayon and gouache on paper, 22 x 13½". Charles Shannon, Mongomery, Alabama. Cat. no. 317.

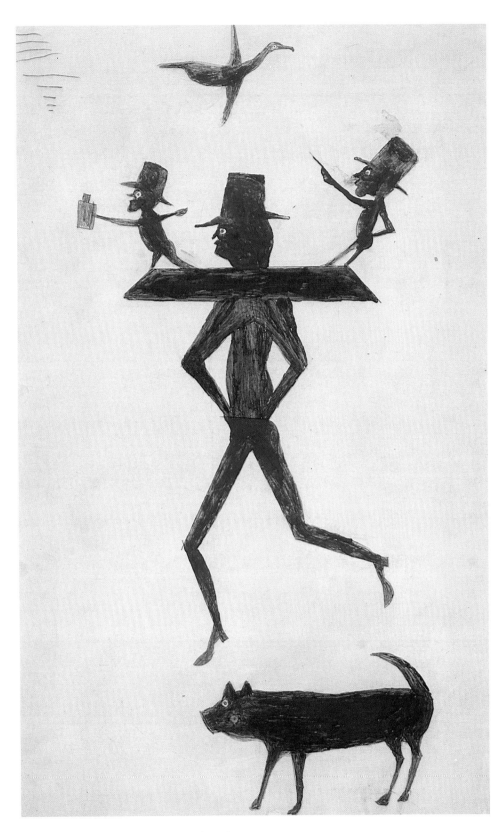

Man with Yoke, 1939–42. Pencil and gouache on paper, 22 x 13⅝". Mr. and Mrs. Joseph H. Wilkinson, Fairfield, Connecticut. Cat. no. 307.

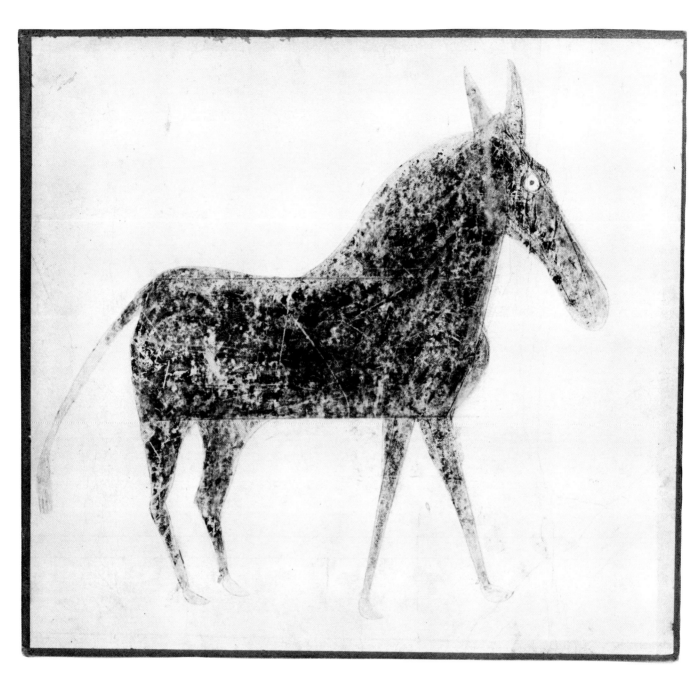

Mule with Red Border, 1939–42. Pencil, crayon and gouache on paper, 18½ x 20½″. Charles Shannon, Montgomery, Alabama. Cat. no. 309.

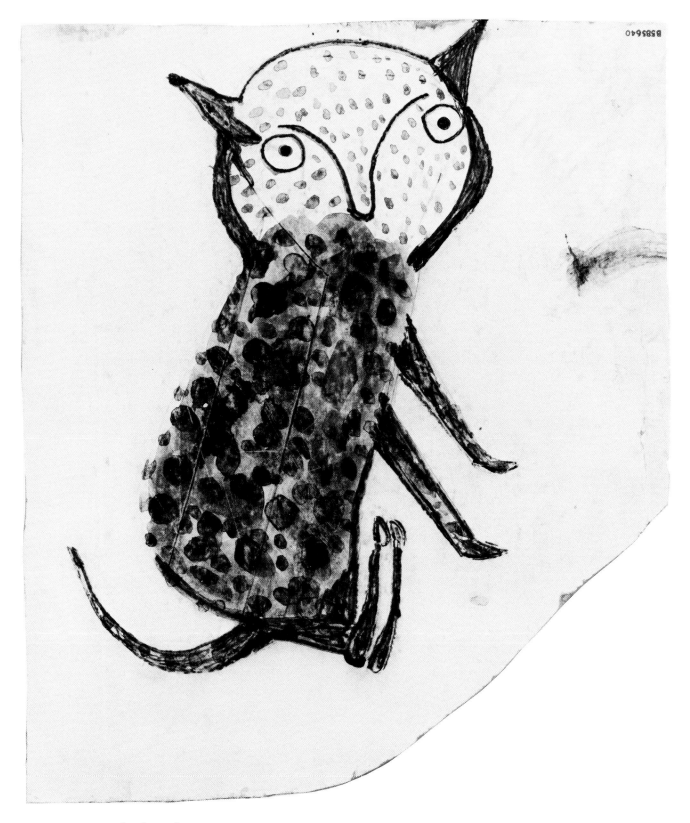

Cat, 1939–42. Pencil and gouache on paper, 12¾ x 11". Mr. and Mrs. Joseph H. Wilkinson, Fairfield, Connecticut. Cat. no. 295.

145

George White

Born 1903, Cedar Creek, Bastrop County, Texas
Died 1970, Dallas

facing page:
Wrestling, 1968. Oil on carved wood relief, 21½ x 24". Jean and Bill Booziotis, Dallas. Cat. no. 340.

This work includes a hinged panel mounted at the center. When the panel is turned to the left, the fight is depicted; to the right, the victor is declared.

George White's roots and experience in Texas—and the fact that he was always proud of his partial Mexican and Indian ancestry—are strongly evident in his relief paintings and sculptures. The paintings especially romanticize ideas of the Wild West, depicting rodeos, boxing matches, lumbering scenes, cowboy-Indian warfare and hunting expeditions. White was himself an adventurer who, before taking up art as a full-time occupation at the age of 58, had farmed with his father in childhood; been an oilfield worker; a cowboy; a bronco rider; veterinarian; soldier (he visited Africa while in the Army in 1937 and learned to carve there); barber and deputy sheriff in Petersburg, Virginia; FBI detective in Washington, D.C.; and leather craft teacher. In 1945, White concocted a bathtub-brewed cure-all called "White's New Discovery Liniment," which he sold on street corners for twelve years. His liniment career ended one night in 1957 (the same year he married and moved to Dallas) when he dreamed of becoming a true artist. He had always been a craftsman in various media, making carved wooden animals, leather belts, smoking pipes and canes, but began now to concentrate exclusively on painting and sculpture. His first painting was a rodeo scene. From that beginning, White, with the support and encouragement of his wife Lucille, would produce a large and complex body of work the importance of which he himself was very much aware: the artist intended from the first to form his own museum, and finally came to refer in that way to the small house where he lived and kept his work.

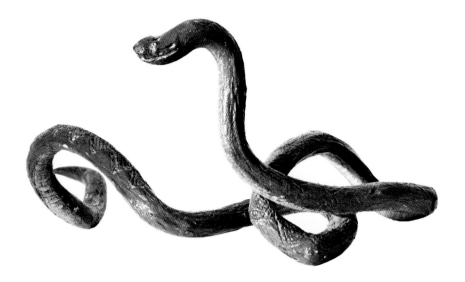

One Bad Snake, 1965. Painted wood, 8½ x 20¾ x 11". Delahunty Gallery, Dallas. Cat. no. 336.

White's work was promoted by the Dallas art dealer Murray Smither, who still stays in close touch with the artist's widow and continues to represent this important artist's interest. Smither wrote in 1975, "I met George White in 1967 through my friend Richard Wilkinson. Richard, master guitar maker and craftsman, had recently seen George's wood carving and they spent hours talking about their craft. The day Richard took me down that narrow little road by the cemetery, George was sitting on his porch with a gun across his lap whittling out a figure with his pocket knife. I remember he had on his handmade boots and a Stetson hat; he wore a full white beard and not a very friendly look on his face.

"Richard told me George was suspicious of strangers, but might invite me inside to see his art work. We sat on the porch a short time talking about painting. George said he once saw a Picasso and didn't like it. He didn't know much about history or other painters nor did he really care to. Finally, I was accepted and invited in to what he called his museum. The inside of White's small house was completely collaged in paintings and filled with carved mechanical figures. The effect was overwhelming. I knew I was seeing a rare collection of folk art and the intimate life of a unique man."[2]

White's two basic approaches to his work—the relief (carved and painted flat wood pieces) and the free-standing sculptural assemblage—seem to reflect a basic division in his thinking as artist and storyteller. For the relief paintings almost always convey an atmosphere of Wild West adventurism, depicting the side of his own nature as a fearless and competent participant in the life of the Texas outdoorsman. The other side of his experience, of course, was as a black man living in the South, sensitive to all the issues of racial psychology implicit in his own recent history. The sculptures treat such subjects as slave emancipation, labor in the cotton fields, black washer-women and *Joe Louis in the Shoe Shine Parlor.* Some of the sculptures, such as *Emancipation House* or *Shoe Repair Shop,* seem slightly parodistic or self-deprecating, as in certain cliches of black rural life: it is as though the artist were both faithfully depicting scenes from his own recollections, and subtly commenting on their stereotypical associations. But the best pieces are always so aesthetically sensitive and so humorous that they communicate a spirit of profound artistic originality.

facing page:
Emancipation House, 1964. Painted wood and mixed media construction, 19½ x 23¼ x 18½". National Museum of American Art, Smithsonian Institution, Washington, D.C. Cat. no. 331.

148

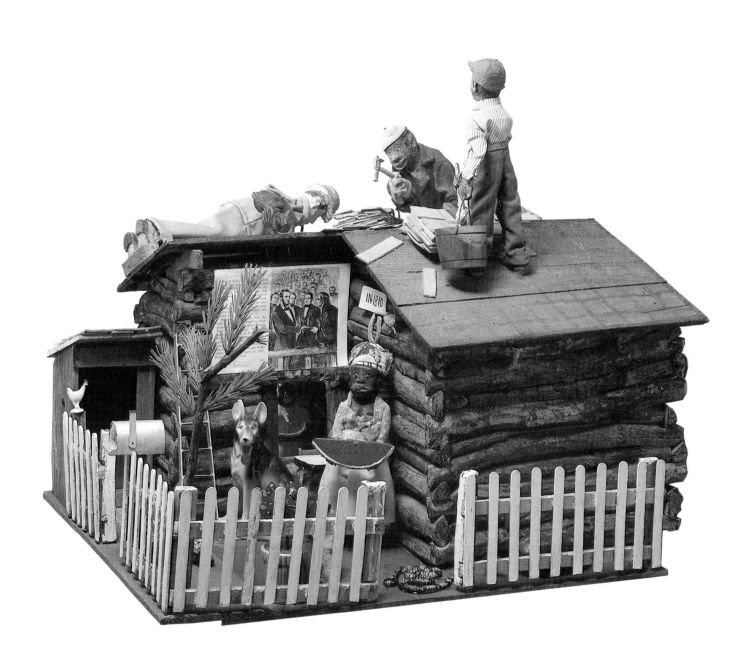

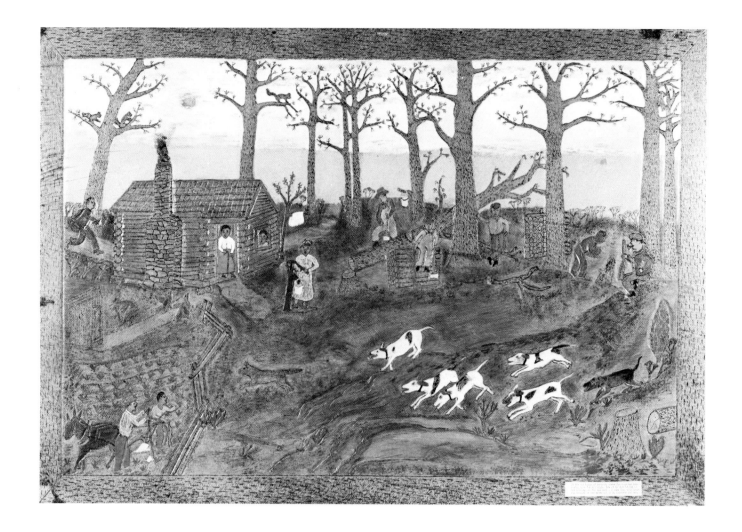

In 1969, the year before he died, George White composed for himself a certificate of award, to summarize and make official his contribution as an artist. It reads: "This is to certify that G. W. White Jr. has reached his destination in arts. As he went along he studies the nature of animals and human beings. He is a great genius because he possessed high, mental powers or faculties of intellect, inventions, talent, taste, nature and character.

"He has carved out of wood thirty-seven pieces. He went back in the old ancient time in 1700 before machinery was in existent. People were doing everything by hand. Over half of them are in action. There are more historical inventions to be made by G W White right at the standpoint he has more than his brains can hold now.

"His characteristics are: leather craft, wood carver, sculpture, artist, cabinet maker, mounting, brick mason, plumber, electrician, physiologist, farming, interior decorator, train horses and dogs, building contractor and barber."[2]

White received a solo exhibition at the Waco (Texas) Creative Art Center in 1975.

Old Hills of Kentucky, 1966. Oil on carved wood relief, 30 x 44". Mrs. George White, Dallas. Cat. no. 337.

1. Smither, Murray, *The World of George W. White, Jr.,* Exhibition catalogue, Waco Creative Art Center, Texas, Feb. 22–March 22, 1975.
2. *Ibid.*

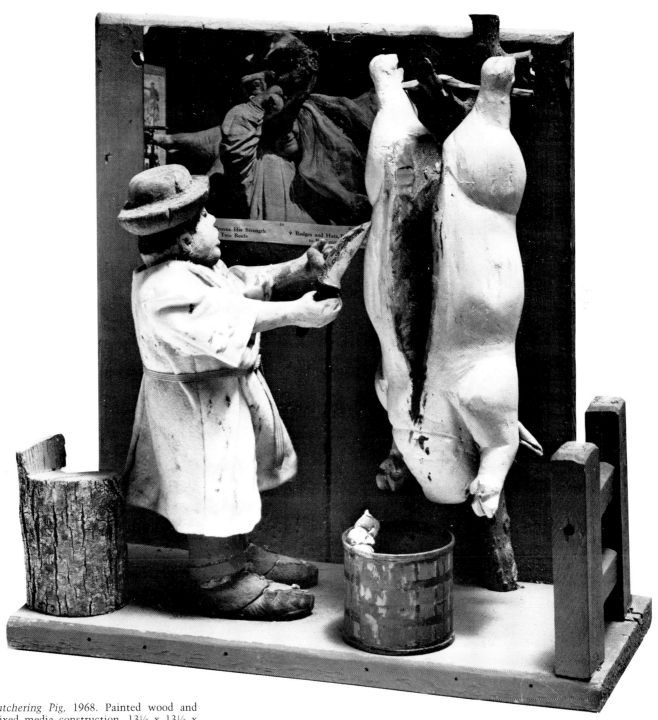

Butchering Pig, 1968. Painted wood and mixed media construction, 13½ x 13½ x 6½″. Mrs. George White, Dallas. Cat. no. 339.

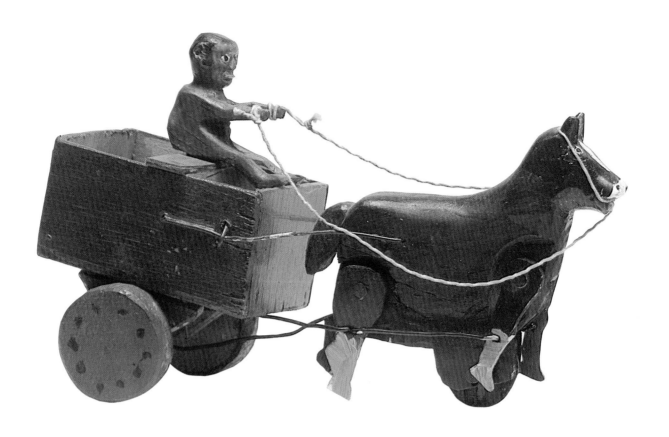

George Williams

Born 1911, Amite County, Mississippi
Lives in Jefferson County, Mississippi, and New Orleans

George Williams was born on February 3, 1911, in southwest Mississippi near the Louisiana border.[1] His grandfather came to this country from the Bahamas, arriving in Florida; he was a migrant laborer, eventually working his way from Florida across to Louisiana. His son, George Williams's father, was a farmer who also made white oak baskets and axe handles and did some blacksmith work. He married a woman from Clinton, Louisiana, who was a seamstress and quilter. They settled in Mississippi just north of the Louisiana border in the area around New Jerusalem and Antioch, where their son George first went to school.

Williams lived on a farm until about the age of 14, when he and a first cousin left home to go to McComb, Mississippi. There he embarked on a long series of jobs, beginning by delivering prescriptions on a bicycle for a drugstore. At about 16, he began delivering meat in an old Model T Ford pick-up; he then went to Louisiana to become successively a road-builder, logger, sugar cane fieldworker and "gandy dancer" (railroad worker).

In his early childhood, Williams recalls seeing elderly men carve walking sticks with figures on them, some fancy and others less so. Later, in his spare time Williams would often "take out my pocket knife and start 'trimming' (whittling or carving) on a piece of wood," as he told photographer Roland Freeman. It was while waiting to hop a train one day that he carved the first in a series of miniature heads which he put on a string and wore around his neck. When Freeman asked him to describe what the heads looked like, he said, "It looked like something from Africa." When asked to explain that statement, he said, "Well, it just looked mysterious, strange, different. I used to gamble a lot and people thought I was winning because of this head I wore around my neck. So people would ask me where did I get that hoodoo head I was wearing and how could they get one." Williams would not tell them he was making them himself, but let the people think they had special power. He would say he could get them one for $1.00. After he had sold about 10 of them, he would hop a train out of that area for fear that the people would soon realize they weren't anything special and start coming after him.

All through southwest Mississippi and parts of Louisiana, Williams has left wood carvings done in his spare time. In Clinton, Louisiana, one day while he was doing day-work, a white farmer named Lee Wilson mentioned

Williams at work on one of his carvings.

to Williams that he was aware of his carving ability and wanted him to do a job. Williams was overjoyed that someone would pay him the same money to carve as for day-work. He spent about a week carving large heads on the top of two cedar posts, which Wilson then used as decorative gate posts. Williams thinks that because of the durability of the cedar the carvings may still be there. Williams would have liked to continue making his living as a wood carver, but, as he says, "First you got to find somebody who wants to buy them."

Many years elapsed between that period and the time when Williams resumed carving. As he puts it, "I never did this steady. It was always something I did in my spare time to pacify myself. Whenever I finished a carving, someone would just take it or I would make someone a gift of it." Williams told Freeman of a head he once carved for a girlfriend when she was sick. The woman is now deceased, but through her daughter, Freeman was able to locate the head, which had been cast off under an old house.

As director/photographer of the Mississippi Folklife Project, Freeman met Williams in about 1975 while doing field research. Freeman collected a group of his sculptures; seven were shown in "Made by Hand: Mississippi Folk Art" at the Mississippi State Historical Museum, Jackson (1980).

facing page left:
Standing Woman, Clothed, 1977. Wood and paint, 16 x 3½". Roland Freeman Collection of Black Folk Art, Washington, D.C. Cat. no. 349.

facing page right:
Standing Man, Clothed, 1977. Wood, paint and tar, 16¼ x 3¼". Roland Freeman Collection of Black Folk Art, Washington, D.C. Cat. no. 348.

1. This text is adapted from a manuscript by Roland Freeman, presently photographer-in-residence/research associate at the Institute for the Arts and Humanities, Howard University, Washington, D.C. Freeman is engaged in an on-going study of traditional black folklife practices. The George Williams wood carvings in this exhibition are from the Roland Freeman Collection of Black Folk Art.

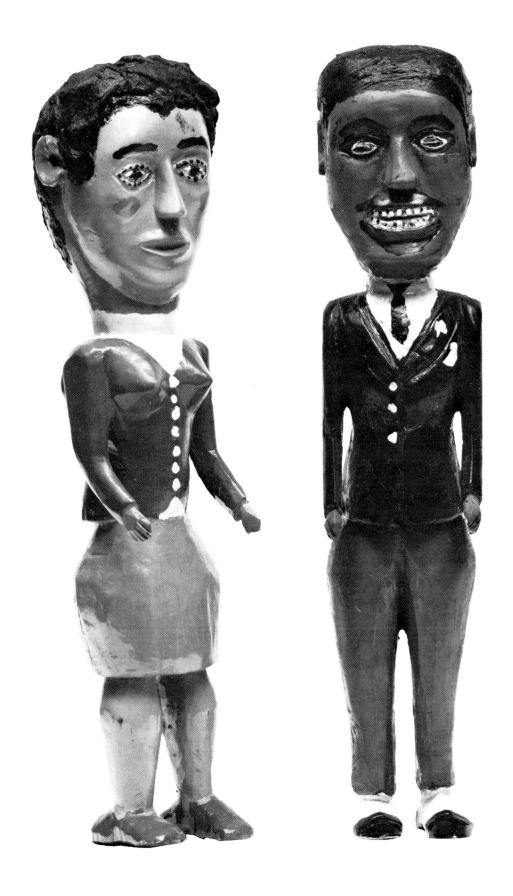

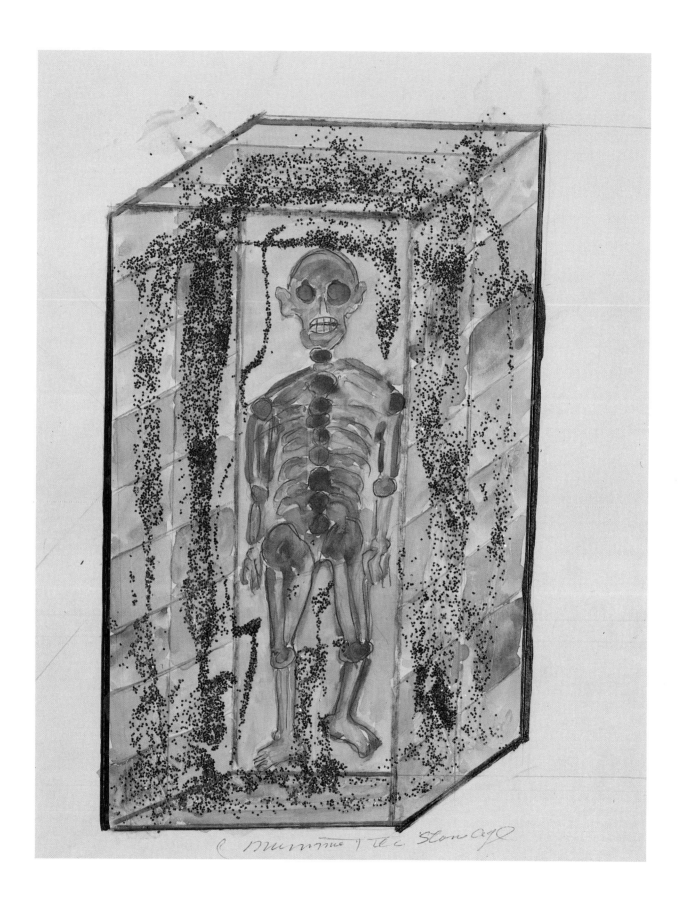

(Mummie of the Stone Age)

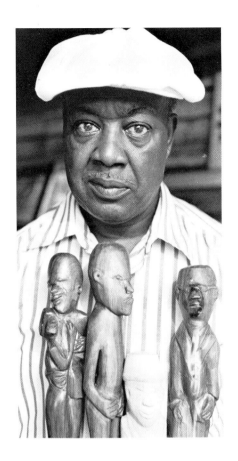

Luster Willis

Born 1913, Hinds County, near Terry, Mississippi
Lives Crystal Springs, Mississippi

Luster Willis is an innately gifted artist who, like Sam Doyle and "Son" Thomas, began drawing and sketching in childhood, rather than late in life as is so often true of self-taught artists. Willis has lived his entire life in the vicinity of his present home in Crystal Springs, Mississippi: he speaks of being chastised for his incessant sketching as a young student at the Egypt Hill Public School, where art was not taught. He remembers that he continued to draw in spite of this. "I just went on through my imagination," he recounts.[1]

Willis has engaged in several professional endeavors, including barbering, farm work and woodcutting; he spent three years in the military service in Europe from 1943–46. He spent time in France and Austria, returning home to Crystal Springs to resume his family existence. Now he and his wife, Louvinia, live in a modest rural house where Luster still occasionally carves canes and makes small paintings.

Willis is a particularly unusual artist on two levels: first, he is an innately sophisticated draftsman, whose command of his technical medium separates him decisively from many of the more blunt and direct styles associated with "folk" art. Willis's major works are subtle and diverse in both their subject and execution as any painting by the most accomplished schooled artists. He does certainly share certain themes or subjects with the folk tradition with which he basically identifies: Biblical stories, depictions of local churches, portraits of friends and acquaintances are all subjects we might expect to see given the artist's environment and tradition. But Willis often weaves complex narratives and makes rather elaborate metaphorical or symbolic statements in his art. In conversation with William Ferris, the artist illuminated the ideas behind some of his paintings, corroborating the sense implicit in his drawings of rather elaborate narrative events: "I did a picture about twenty years ago of a little boy that was killed here in Mississippi. They called him Emmett Till. I think he was mobbed or something. They killed him and threw him

facing page:
Mummie of the Stone Age, 1970s. Watercolor and glitter on poster board, 15½ x 12⅛". Center for Southern Folklore, Memphis. Cat. no. 365.

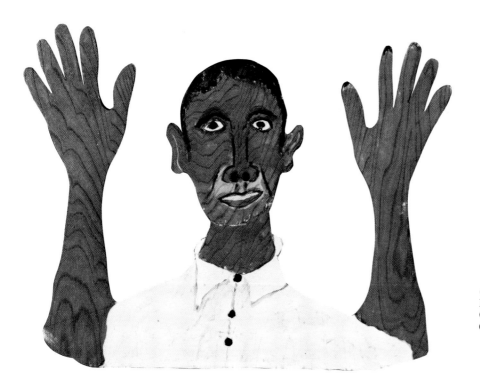

Cut-Out Red Figure, Hands Raised, 1970s. Pencil and tempera on wood, 19½ x 25". Center for the Study of Southern Culture, Oxford, Mississippi. Cat. no. 362.

in the river. Maybe I saw a newspaper clipping or something, and I imagined what it was about. I drew him in his casket in the funeral home, with people passing to view the body. I used to like to draw a lot of caskets and put imaginary figures in them. I think death is interesting because it's something that, sooner or later, we all will have to meet." Willis tends to generalize from his personal, anecdotal subjects, to themes which have larger significance. He has a highly developed sense of justice and injustice and a drive to deal with these issues in his work, which lends to his best paintings some of their intricacy and sense of being somehow *major,* and intellectually derived, rather than being merely anecdotal or humorous or broadly depictive. *Woman and Baby Confront Husband and Mistress* suggests a personal morality; *Rich Man/Poor Man,* which depicts a thin man with a bone and a fat one with a cigar, represents Willis's thoughts on a more broadly social issue.

"I get my feeling for drawing when I get a little lonesome or something like that," Willis explains. "You have to have that feeling to do something." *Lonely Soul* evokes this kind of feeling, as do the paintings of cave men. Some are more enigmatic, such as *This Is It.* A woman leans over an enormous fish, holding something in her hands. Both she and the fish are embellished with brightly-colored glitter.

Willis's highly developed craft as a cane carver is quite a separate matter from his approach as a painter. In his paintings he is amazingly improvisatory: he uses mostly watercolor, finger paint and sometimes shoe polish, but seldom oil. He often cuts into the paper to create empty spaces, as in the painting of a preacher who is emphasized by the silhouette. He also collages onto the paper surface with cut-out segments. It is in both his experimental approach as a manipulator of physical materials and in his layered meanings within a given painting, that Luster Willis is seen to be an artist of the utmost complexity and sophistication.

Willis's work was included in "Made by Hand: Mississippi Folk Art" at the Mississippi State Historical Museum, Jackson (1980).

1. All quotes are drawn from an interview with Willis to be published in William Ferris and Brenda McCallum, *Local Color: Folk Arts and Crafts* (Memphis: Center for Southern Folklore, in press).

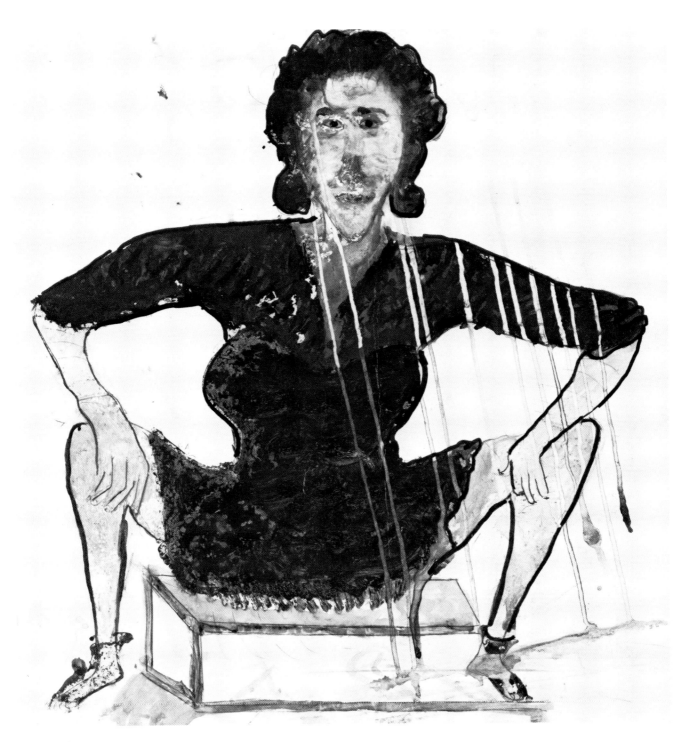

Lady in the Rain, 1963. Tempera on paper,
23½ x 24". Center for Southern Folklore,
Memphis. Cat. no. 352.

Music at Home, c. 1974. Ink, tempera and glitter on paper, 22⅝ x 28½". Center for Southern Folklore, Memphis. Cat. no. 355.

This Is It, c. 1970. Tempera and glitter on plywood, 15¾ x 24¾". Center for Southern Folklore, Memphis. Cat. no. 354.

Joseph Yoakum

Born 1886, Window Rock, Arizona[1]
Died 1972, Chicago, Illinois

Little of certainty is known about the life of Joseph Yoakum. As he told it, he was born into a family of twelve or thirteen children on a Navajo reservation in Arizona, where his father was a farmer and perhaps a hunting guide.[2] His mother he described as a "strong woman" and a "doctor," explaining that she knew a great deal about herbal medicine. Yoakum insisted at times that he was a full-blooded "Nava-joe" Indian, though at others he said that he was an "old black man." Shortly after his birth, the family moved to Kansas City, Missouri, where Yoakum's father worked briefly in the railroad yards. They subsequently settled more permanently on a farm near Walnut Grove in southwest Missouri. Yoakum apparently attended school for only three or four months in all his childhood, as he noted on one of his drawings from 1972.

Yoakum was in his early teens when he ran away from home and joined the circus as a handyman. He reported that he worked first with Adams and Forpaugh in 1901, joining Buffalo Bill and later the Sells Flota circus in 1902. With the latter, he said he visited China. In 1903, he became attached to the Ringling Bros. Circus as the personal valet to John Ringling. By 1908, he was apparently traveling the world as a hobo and a stowaway, visiting Europe, Russia, the Middle East, China, Siberia, Australia and Canada. Mexico, Central and South America were added in 1911 to his inventory of places seen. At about the same time (1910) he was married and eventually became the father of five children; in 1929 he was married a second time. He served in the First World War, and was posted for a time in Clermont-Ferrand, France.

From the First World War until the mid-sixties, when Yoakum began to achieve recognition through his drawings, the details and chronology of his life are still more vague. He said he worked at numerous occupations, including those of the sailor, railroad porter and custodian, in places that ranged from California to Florida, Missouri and Indiana. Sometime in this period he settled in Chicago and, with his second wife, operated an ice cream parlor on the South Side. By the late fifties he was retired and living on Social Security and a veteran's pension in a housing project for senior citizens. On a drawing dated October 2, 1964, he gave his address as 150 South Campbell Avenue; about 1966, he moved to a storefront on 82nd Street on the South Side. There he remained until he was hospitalized and then placed in a nursing home in 1971. He died on Christmas Day, 1972.

In one capacity or another, Yoakum claimed he had visited every continent except Antarctica.[3] "Girl," he said to Chicago painter Christina

facing page:
C.S. Valentin Crater, 1964. Watercolor and pen on paper, 19 x 24". Phyllis Kind Gallery, New York and Chicago. Cat. no. 377.

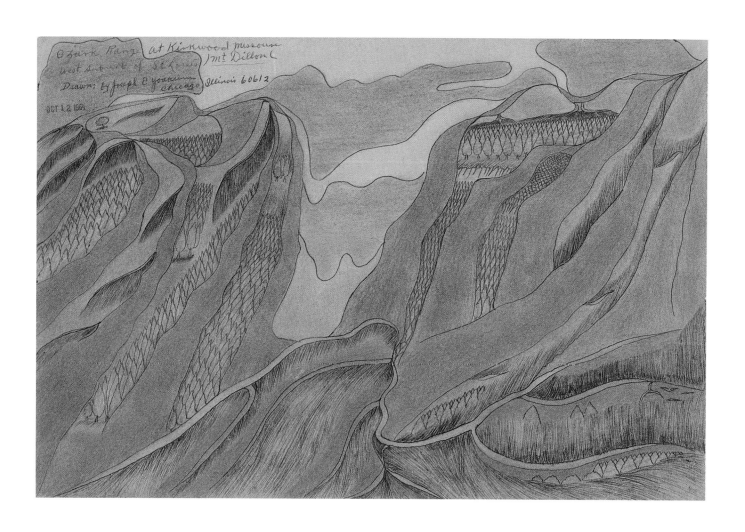

164

Ramberg, "I've taken long chances to see things for myself."[4] Whether these epic wanderings were real or imagined, they provided the central imagery for his astounding drawings. For although there are depictions of other subjects, such as a *Gun Boat* or *The First Steam Engine*, and portraits of such contemporary figures as Nat King Cole and Josephine Baker and a mythological character, *Great Assirea, The Only Woman Ruler of Assirea Asia*, it is almost exclusively the landscape that was Yoakum's preoccupation. He drew it in countless variations, with subjects drawn from every continent including Antarctica, the one he had not visited. Most, however, are of the United States.

Motivated by a dream, Yoakum began to draw in about 1962. He worked by a process that he described as a "spiritual unfoldment."[5] By this he seems to have meant that his images were revealed to him as he drew. The extent of his travels becomes less important in the context of this notion, as the drawings can be understood thereby to be a blend of fact and fantasy, of landscapes remembered and landscapes imagined. Certainly Yoakum's idiosyncratic depiction of mountains through the use of sinuous, attenuated forms suggests that he drew what most had impressed him in his travels, in a form that was largely invented. Yoakum was known to have kept a selection of travel books, an atlas, a Bible and a set of the Encyclopedia Brittannica in his store-front home.[6] It is not known to what extent he used the atlas or travel books for source material, though he sometimes drew landscapes important in various Biblical stories. Chicago art historian Whitney Halstead has suggested that postcards may have been an important visual stimulus.[7]

Yoakum's drawings began on a small scale (8x10 or 9x12) on white or manila paper. The first were executed in plain pen or pencil with little or no color. By 1964 or '65 Yoakum had begun to use watercolor, which was darkened in the works on manila paper by the yellow-brown color that material turns as it ages. The years 1965 to '70 mark Yoakum's most productive period. He was working on a larger scale and executing an average of one drawing a day. All were in pen with pastel color added and rubbed smooth with tissue paper. Mountains and water were favorite subjects, as were groves of trees and roads that wandered through the landscape and disappeared. Yoakum's line was emphatic and instinctively correct; he seems never to have made a mark he regretted. Indeed, some forms he would outline twice for emphasis. Combined with his extraordinary chromatic sense, Yoakum's draftsmanship resulted in works of great authority that reveal the artistic self-confidence of their maker.

Exhibitions of Yoakum's work include those at the Sherbeyn Gallery, Chicago (1968), Pennsylvania State University Art Museum, University Park (1969), the School of the Art Institute of Chicago (1971), the Whitney Museum of American Art, New York (1972), and the University of Rhode Island, Kingston (1973). He was included in "Outsider Art in Chicago" at Chicago's Museum of Contemporary Art (1979) and "Transmitters: The Isolate Artist in America" at the Philadelphia College of Art (1981).

1. Yoakum usually gave his birthdate as February 20, 1886. However, a drawing dated 11/11/65 is inscribed "Back where I were Born 2/20/1888 A.D.".

2. This and all other biographical information is drawn from an unpublished manuscript on Yoakum by Whitney Halstead in the collection of the Department of Prints and Drawings at the Art Institute of Chicago.

3. Interestingly, however, there is no reported mention of Africa.

4. Quoted in Halstead, p. 7.

5. Halstead, pp. 24, 50.

6. Halstead, p. 33.

7. Halstead, p. 38.

facing page:
Ozark Range at Kirkwood Missouri West Suburb of St. Louis Mount Dillon, 1964. Pen and pastel on paper, 12 x 18". Christina Ramberg and Philip Hanson, Chicago. Cat. no. 378.

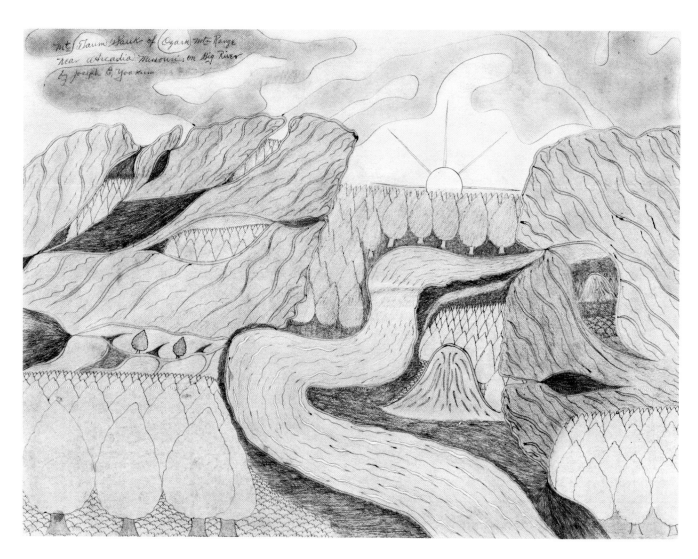

Mt. Taum Sauk of Ozarks, late 1960s. Pencil, pen and pastel on paper, 18 x 23¾″. Phyllis Kind Gallery, New York and Chicago. Cat. no. 386.

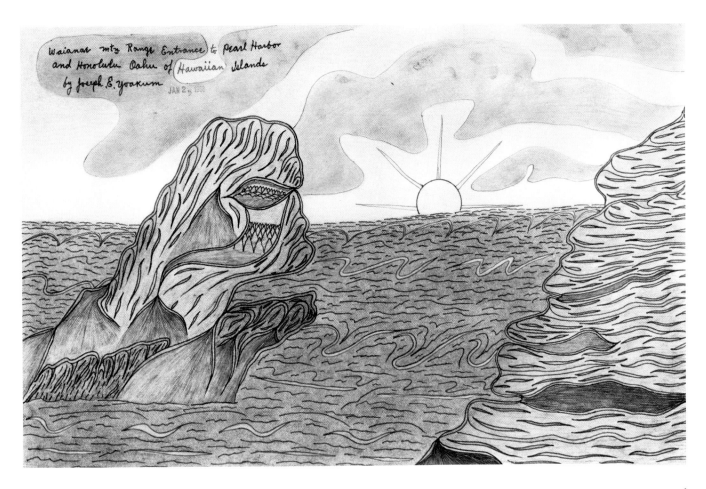

Waianae Mountain Range Entrance to Pearl Harbor and Honolulu Oahu of Hawaiian Islands, 1968. Pen and pastel on paper, 12 x 19". Christina Ramberg and Philip Hanson, Chicago. Cat. no. 383.

Catalogue of the Exhibition
Selected Bibliography

Catalogue of the Exhibition

Jesse Aaron

1. *Bulldog*, 1969
cedar, fiberglass and bone, 25½ x 12½ x 26"
Stuart and Mary Purser Collection, Gainesville, Florida

2. *Bird*, 1970
burnt oak and fiberglass, 14½ x 14 x 33"
Stuart and Mary Purser Collection, Gainesville, Florida

3. *Hunter with Dogs*, 1971
mimosa root, fiberglass and marbles, 21 x 27 x 25"
Stuart and Mary Purser Collection, Gainesville, Florida

4. *Pig's Head*, 1970s
burnt wood, 19½ x 15 x 10½"
William Arnett, Atlanta

5. *Shark*, 1970s
wood, plastic and shark's teeth, 14 x 52 x 10"
William Arnett, Atlanta

6. *Totem*, 1970s
wood and fiberglass, 70½ x 10 x 8"
Donald N. Cavanaugh, Jr., Gainesville, Florida

7. *Totem*, 1970s
wood and fiberglass with felt hat, 58 x 24 x 5"
William Arnett, Atlanta

Steve Ashby

8. *Mermaid*, c. 1965
wood and metal, 21 x 35 x 15"
Ken and Donna Fadeley, Birmingham, Michigan

9. *Musician and Dancers*, c. 1965
wood and mixed media, 19 x 13½ x 16½"
Ken and Donna Fadeley, Birmingham, Michigan

10. *Bird*, 1970s
painted wood and metal, 10½ x 20¾ x 22¼"
Phyllis Kind Gallery, New York and Chicago

11. *Cat Head*, 1970s
painted wood, plastic and metal, 12½ x 6 x ⅞"
Phyllis Kind Gallery, New York and Chicago

12. *Couple*, 1970s
painted wood and mixed media, 20¼ x 12 x 7"
Herbert W. Hemphill, Jr., New York

13. *Goat*, 1970s
wood, paint and mixed media, 21 x 34 x 28"
John Freimarck, Mechanicsville, Virginia

14. *Horse*, 1970s
wood, leather and brass tacks, 10 x 16 x 4"
Herbert W. Hemphill, Jr., New York

15. *Male Figure in Baseball Cap*, 1970s
painted wood and metal, 28½ x 5½ x 1¾"
Phyllis Kind Gallery, New York and Chicago

16. *Pregnant Woman*, 1970s
painted wood and mixed media, 25 x 13 x 8"
Herbert W. Hemphill, Jr., New York

17. *Relief with Train*, 1970s
carved and painted wood, 11¾ x 19⅞"
Herbert W. Hemphill, Jr., New York

18. *Standing Woman in Red Striped Skirt*, 1970s
painted wood, cloth and metal, 46½ x 15 x 7"
Phyllis Kind Gallery, New York and Chicago

19. *Turtle*, 1970s
wood, cloth and metal, 5 x 14½ x 10½"
Phyllis Kind Gallery, New York and Chicago

20. *Woman and Mule*, 1970s
painted wood, cloth and metal, 13 x 24 x 24½"
Phyllis Kind Gallery, New York and Chicago

21. *Woman in White Hat*, 1970s
painted wood and mixed media, 19¾ x 7¼ x ¾"
Phyllis Kind Gallery, New York and Chicago

22. *Man Playing Drums*, c. 1973
painted wood, 12 x 5 x 3"
Chuck and Jan Rosenak, Bethesda, Maryland

23. *Woman in Wool Skirt*, c. 1973
painted wood, cloth and costume jewelry, 12 x 3½ x 2"
Chuck and Jan Rosenak, Bethesda, Maryland

24. *Cow Being Milked*, 1973/74
painted wood and leather, 14½ x 24¼ x 2¾" (cow)
7¾ x 6¾ x 1½" (man)
Jeffrey and C. Jane Camp, American Folk Art Co.,
Tappahannock, Virginia

25. *Figure (Self-Portrait)*, 1974
painted wood and mixed media, 15 x 6 x 1¼"
Elinor L. Horwitz, Chevy Chase, Maryland

26. *Standing Woman*, 1974
painted wood and mixed media, 47 x 18 x 9"
John Freimarck, Mechanicsville, Virginia

27. *Races at Upperville*, c. 1975
painted wood and found objects, 15 x 57 x 10½"
Chuck and Jan Rosenak, Bethesda, Maryland

28. *Guinea Hen*, 1976
painted wood and mixed media, 14 x 16 x 6"
Jeffrey and C. Jane Camp, American Folk Art Co.,
Tappahannock, Virginia

29. *Snake*, 1976
painted wood and brass tacks, 3¼ x 23 x 2½"
Jeffrey and C. Jane Camp, American Folk Art Co.,
Tappahannock, Virginia

30. *Bull*, 1977
painted wood and mixed media, 9½ x 19 x 2½"
Sal Scalora, Storrs, Connecticut

31. *Standing Woman*, 1977
painted wood and mixed media, 64¾ x 27½ x 15"
Museum of American Folk Art, New York,
Gift of Mr. and Mrs. Charles Rosenak

32. *Giraffe*, c. 1978
wood and mixed media, 68 x 80 x 7¼"
Jennie Lea Knight and Marcia Newell, Rectortown, Virginia

33. *Man with Scythe*, c. 1978
wood, paint, cloth and metal, 66 x 27 x 27"
Chuck and Jan Rosenak, Bethesda, Maryland

34. *Woman in Bath*, 1979
painted wood and mixed media, 8 x 15 x 15"
Sal Scalora, Storrs, Connecticut

35. *Black Duck*, c. 1979
painted wood and metal, 14 x 7½ x 3"
Mr. and Mrs. John McCarty, Delaplane, Virginia

36. *Man Fishing*, c. 1979
painted wood and mixed media, 32 x 15 x 29"
Mr. and Mrs. John McCarty, Delaplane, Virginia

David Butler

37. *Windmill with Elephants and Cowboys Riding Horses*, 1975
painted tin, wood and plastic, 28 x 62 x 30½"
New Orleans Museum of Art, Gift of the Artist

38. *Windmill with Man Riding Flying Elephant*, 1975
painted tin, wood and plastic, 30 x 47 x 29"
New Orleans Museum of Art, Gift of the Artist

39. *Whirligig*, n.d.
painted tin, wood, plastic and wire, 29¾ x 49½ x 24¼"
Museum of American Folk Art, New York, Gift of William A. Fagaly in honor of Bruce Johnson

40. *Animal*, c. 1975
painted tin and plastic, 16¾ x 21¼"
Private Collection

41. *Animal*, c. 1975
painted tin and plastic, 10 x 12½"
Private Collection

42. *Camel*, c. 1975
painted tin and plastic, 18¾ x 26½"
Private Collection

43. *Dumbo the Flying Elephant*, 1975
painted tin, plastic and wood, 10¼ x 14½ x 16"
William Fagaly, New Orleans

44. *Mermaid*, c. 1975
painted tin and plastic, 13¾ x 28"
Private Collection

45. *Monkey Climbing Pole*, c. 1975
painted tin, wood and button, 8½ x 10"
William Fagaly, New Orleans

46. *Rabbit*, c. 1975
painted tin and plastic, 9¼ x 13¼"
William Fagaly, New Orleans

47. *Skunk*, c. 1975
painted tin and plastic, 6½ x 16⅝"
William Fagaly, New Orleans

48. *Walking Stick with Figure*, c. 1975
umbrella handle, painted tin, plastic and wood, 33¾ x 17¼ x 1½"
William Fagaly, New Orleans

49. *Wise Man on Camel*, c. 1975
painted tin and plastic, 26¼ x 27½"
Private Collection

50. *Poll Parrot*, 1977
painted tin and plastic mounted on wooden post, 22 x 21 x 10½"
Martin and Enid Packard, Comstock Park, Michigan

51. *Moon and Star*, 1978
painted tin and plastic, 9⅞ x 15⅛"
Private Collection

52. *Creature with Rooster*, c. 1980
painted tin and plastic mounted on wooden post, 25½ x 17½ x 5½"
Private Collection

53. *Locomotive Engine with Rooster*, c. 1980
painted tin and plastic mounted on wooden post, 39½ x 29 x 6"
William Fagaly, New Orleans

54. *Rooster*, c. 1980
painted tin mounted on plastic pipe, 34 x 15 x 8½"
Private Collection

55. *Walking Stick with Figure*, c. 1980
painted tin, plastic, paper and umbrella handle, 33 x 12 x 1½"
Private Collection

56. *Winged Creature with Gourd*, c. 1980
painted tin, plastic and gourd mounted on wooden post, 40 x 31½ x 7¾"
Private Collection

Ulysses Davis

57. *Lizard*, c. 1938
wood and paint, 3 x 25 x 3"
Ulysses Davis, Savannah

58. *Boy Milking Cow*, late 1930s
carved and painted relief, 11½ x 23½"
Ulysses Davis, Savannah

59. *Samson and Lion*, late 1930s
carved and painted relief, 10¼ x 13"
Ulysses Davis, Savannah

60. *Bust of Abraham Lincoln*, 1940
wood, 9½ x 7½ x 3½"
Ulysses Davis, Savannah

61. *Bust of George Washington*, c. 1940
wood, 9½ x 7½ x 3½"
Ulysses Davis, Savannah

62. *Crucifix*, c. 1940
carved and painted relief, 11 x 22"
Ulysses Davis, Savannah

63. *Farmhouse with Airplanes*, 1943
carved and painted relief, 13 x 15⅝"
Ulysses Davis, Savannah

64. *Abe Lincoln*, 1944
wood, 15 x 4 x 3"
Ulysses Davis, Savannah

65. *Jesus on the Cross*, 1946
house paint on cedar, mahogany crown of thorns with toothpicks, 40½ x 13½ x 6"
Virginia Kiah, The Kiah Museum, Savannah

66. *Bust of Martin Luther King*, 1968
wood, 9½ x 5 x 5"
Ulysses Davis, Savannah

67. *Portrait of the Artist's Father*, c. 1970
wood, 16 x 4⅝ x 2¼"
Ulysses Davis, Savannah

68. *Forty Presidents* (39 busts, 1 presidential seal), 1970s
mahogany and paint, approximately 8 x 4 x 2½" each
Ulysses Davis, Savannah

William Dawson

69. *Bell Shape with Triangular Designs*, 1970s
carved and painted wood relief, 10½ x 9"
Roger Brown, Chicago

70. *Black Horse*, 1970s
carved and painted wood, varnish, 3¾ x 6 x 1"
Susann E. Craig, Chicago

71. *Brown Dog*, 1970s
carved and painted wood, varnish, 1½ x 2½ x ¾"
Susann E. Craig, Chicago

72. *Brown Horse*, 1970s
carved and painted wood, varnish, 3¾ x 5 x 1"
Susann E. Craig, Chicago

73. *Dream House*, 1970s
carved and painted wood, varnish and glitter, 16 x 8 x 8"
Roger Brown, Chicago

74. *Horse in Fence*, 1970s
carved and painted wood, varnish, 3¼ x 6 x 2½"
Susann E. Craig, Chicago

75. *Horse Pulling Man in Wagon*, 1970s
carved and painted wood, varnish, plastic and metal, 6 x 9 x 4"
Roger Brown, Chicago

76. *Man in Striped Shirt*, 1970s
carved and painted wood, varnish, 9¼ x 4½ x 1½"
Susann E. Craig, Chicago

77. *Totem (with one house and three heads)*, 1970s
carved and painted wood, varnish, 17½ x 3¼ x 2¾"
Susann E. Craig, Chicago

78. *White Dog*, 1970s
carved and painted wood, varnish, 1 x 2½ x ¾"
Susann E. Craig, Chicago

79. *Woman in Orange Skirt*, 1970s
carved and painted wood, varnish, 8½ x 2½ x 1½"
Susann E. Craig, Chicago

80. *Woman in White Skirt*, 1970s
carved and painted wood, varnish, 10 x 2 x 2"
Susann E. Craig, Chicago

81. *Man in Orange Trousers*, 1975
carved and painted wood, varnish, 14¼ x 5 x 3½"
Roger Brown, Chicago

82. *Man in Striped Shirt*, 1975
carved and painted wood and hair, 13 x 4¾ x 3"
Susann E. Craig, Chicago

83. *Man Standing with White Hat and Revolver*, 1976
carved and painted wood, varnish, 16½ x 4¾ x 2½"
Roger Brown, Chicago

84. *Man with Rifle*, 1976
carved and painted wood, varnish, 10¼ x 3½ x 2"
Roger Brown, Chicago

85. *Totem (with two houses and six heads)*, 1976
carved and painted wood, varnish and feather, 36½ x 3½ x 2½"
Susann E. Craig, Chicago

86. *Chicken George*, 1977
carved and painted wood, varnish, 18 x 4½ x 3"
Roger Brown, Chicago

87. *Gorilla*, 1977
carved and painted wood, varnish, 10½ x 5½ x 2″
Roger Brown, Chicago

88. *Idi Amin Walking His Pet Pig*, 1977
carved and painted wood, found objects and string, 13½ x 5½ x 2½″
Chuck and Jan Rosenak, Bethesda, Maryland

89. *Man in Black Hat*, 1977
carved and painted wood, varnish, 14½ x 4¾ x 2″
Susann E. Craig, Chicago

Sam Doyle

90. *Abe Kane*, 1970s
oil on plywood, 30⅛ x 48″
Leo and Dorothy Rabkin, New York

91. *Alligator*, 1970s
tar on wood, oil paint, nails and metal, 7 x 55¾ x 14¾
Leo and Dorothy Rabkin, New York

92. *Dr. Buz*, 1970s
oil on sheet metal, 49½ x 26½″
Leo and Dorothy Rabkin, New York

93. *Fisherman Chased By Monster*, 1970s
watercolor, enamel and pencil on paper, 13¼ x 17¹/₁₆″
Private Collection

94. *I'll Go Down*, 1970s
oil on wood, fabric and metal, 41½ x 25 x 5″
Leo and Dorothy Rabkin, New York

95. *Lincoln Preaching to the Slaves*, 1970s
watercolor and pencil on paper, 13¹/₁₆ x 17¹/₁₆″
Private Collection

96. *Lizard*, 1970s
tar on wood, oil paint, metal, 15 x 19 x 17½″
Leo and Dorothy Rabkin, New York

97. *Pheasant*, 1970s
tar on wood, chicken feathers, paint, glass beads, 7 x 11 x 12¼″
Leo and Dorothy Rabkin, New York

98. *Sin*, 1970s
oil on sheet metal, 48 x 27″
Leo and Dorothy Rabkin, New York

99. *Turtle*, 1970s
tar on wood, oil paint, glass beads, 6⅝ x 17½ x 9¾″
Leo and Dorothy Rabkin, New York

100. *We We*, 1970s
oil on metal door, 36 x 20¾″
Leo and Dorothy Rabkin, New York

101. *Whooping Boy*, 1970s
watercolor and pencil on paper, 17¹/₁₆ x 13⁵/₁₆″
Private Collection

102. *Dr. Buz*, c. 1980
enamel paint and tar on metal (with conch shell), 57 x 27″
Private Collection

103. *Fear Not U.S.N.*, c. 1980
enamel paint on metal, 45 x 28¼″
Private Collection

104. *Wass A. Guin Mon/U. Dig Me?*, c. 1980
enamel paint on metal, 28 x 22¾″
Private Collection

William Edmondson

105. *Tombstone for Bernice Williams*, c. 1931
limestone, 17½ x 11¾ x 5½″
Dr. and Mrs. Virgil S. LeQuire, Franklin, Tennessee

106. *Bird*, 1930s
limestone, 9½ x 11¾ x 4½″
Mrs. Alfred Starr, Nashville

107. *Bride*, 1930s
limestone, 19 x 6 x 14″
University of Tennessee, Knoxville

108. *Critter*, 1930s
limestone, 12½ x 31¼ x 14″
Austin Peay State University, Clarksville, Tennessee

109. *Crucifix*, 1930s
limestone, 20½ x 14½ x 4½″
Mrs. Alfred Starr, Nashville

110. *Lady with Bustle*, 1930s
limestone, 15 x 6 x 7⅜″
Private Collection

111. *Lion*, 1930s
limestone, 22 x 30¾ x 6½″
Mr. and Mrs. Walter G. Knestrick, Nashville

112. *Mary and Martha*, 1930s
limestone, 13⅞ x 16¾ x 5¼″
Hirshhorn Museum and Sculpture Garden,
Smithsonian Institution, Washington, D.C.

113. *Noah's Ark*, 1930s
limestone, 22¼ x 14¾ x 16¼″
Mrs. Alfred Starr, Nashville

114. *Preacher*, 1930s
limestone, 18¼ x 8 x 7½″
University of Tennessee, Knoxville

115. *Rabbit*, 1930s
limestone, 13³/₁₆ x 5 x 7½″
Mr. and Mrs. Walter G. Knestrick, Nashville

116. *Relief, Mother and Daughter*, 1930s
limestone, 16¾ x 11½ x 4″
Mrs. Alfred Starr, Nashville

117. *School Teacher, Female*, 1930s
limestone, 16¼ x 5½ x 7½″
Mr. and Mrs. Carl Zibart, Nashville

118. *School Teacher, Male*, 1930s
limestone, 16¼ x 5½ x 7½″
Mr. and Mrs. Alan Zibart, Nashville

119. *Squirrel*, 1930s
limestone, 12¾ x 5 x 8″
Dr. and Mrs. Clark B. Tippens, Nashville

120. *Angel*, c. 1935
limestone, 23 x 12½ x 6½″
Estelle E. Friedman, Washington, D.C.

121. *Ram*, c. 1937
limestone, 18 x 24½ x 7″
Estelle E. Friedman, Washington, D.C.

122. *Speaking Owl*, c. 1937
limestone, 22½ x 18 x 7½″
Estelle E. Friedman, Washington, D.C.

123. *Angel*, c. 1940
limestone, 39 x 24 x 12″
First Tennessee Banks, Memphis

James Hampton

124. Selections from *The Throne of the Third Heaven of the Nations Millenium General Assembly*, c. 1950–64
gold and silver foil and paper over wooden furniture and cardboard, 28 objects of various sizes
National Museum of American Art, Smithsonian Institution, Washington, D.C. Anonymous gift

i.–vi. *Pair of vase stands (Jesus and Moses) with matching pair of winged vases and a complementary pair of floor vases*
stands: 40½ x 36 x 28¾″ each
winged vases: 17 x 18 x 16½″ each
floor vases: 16¾ x 15 x 15½″ each

vii.–x. *Pair of virgin vision stands with a matching pair of decorated glasses*
stands: 44 x 23½ x 23½ each
glasses: 8¼ x 5¾″ each

xi.–xvi. *Pair of tall vase stands with matching pair of winged vases (Elijah and David) and a complementary pair of floor vases.*
stands: 37¼ x 23¾ x 20½″ each;
winged vases: 15⅞ x 14⅞ x 13″ (Elijah), 16⅜ x 15½ x 13½″ (David);
floor vases: 28 x 25½ x 14¼″ each.

xvii.–xxii. *Six crowns*
purple (two): 7 x 10¼ x 9½″ each
silver (two): 4½ x 10¼ x 9″ each
gold (two): 6¾ x 10½ x 9½″ each

xxiii.–xxviii. *Six plaques*
gold (two): 14½ x 11½ x 1″ each
black (two): 14½ x 11¼ x 1″ each
brown (two): 13 x 9 x ¾″ each

Sister Gertrude Morgan

125. *Alphabet of the Bible*, c. 1965–70
oil and watercolor on paper, 18 x 28″
Robert Bishop, New York

126. *And I Looked*, c. 1965–70
ink and acrylic on paper, 12½ x 20″
Susann E. Craig, Chicago

127. *Angel Called Joseph*, c. 1965–70
ink and acrylic on paper, 11½ x 11⅝″
Susann E. Craig, Chicago

128. *The Ark Rested on Mt. Ararat*, c. 1965–70
ink and watercolor on cardboard, 7⁵/₁₆ x 12″
Alan Jaffe, New Orleans

129. *Book of Daniel 7.1*, c. 1965–70
pencil, pastel, and watercolor on paper, 9 x 16⅛″
Alan Jaffe, New Orleans

130. *Book of Revelation*, c. 1965–70
paint on windowshade, 4' x 6'
Herbert W. Hemphill, Jr., New York

131. *Captain Jesus*, c. 1965–75
pencil, ink and acrylic on cardboard,
8½ x 3¼"
Dr. Gladys-Marie Fry, College Park,
Maryland

132. *Chart of Revelation, 11, 12, 13*, c.
1965–70
pencil, ink and acrylic on paper, 21½
x 27¼"
Susann E. Craig, Chicago

133. *Chart of Revelation*, 1970s
ink and acrylic on paper, 21¾ x 27¾"
Regenia Perry, Richmond

134. *Christ Coming in His Glory*, c.
1965–70
crayon and acrylic on cardboard, 6 x
9¼"
Alan Jaffe, New Orleans

135. *Double Fan*, late 1960s
pencil, acrylic and pen on cardboard,
12¾ x 26½"
Mr. and Mrs. Christopher Botsford,
New Orleans

136–140. *Fans* (five), c. 1965–75
ink and acrylic on cardboard, each
approximately 12 x 12"
Susann E. Craig, Chicago

141–142. *Fans* (two), c. 1975
acrylic on cardboard, approxi-
mately 13 x 13" each
Regenia Perry, Richmond

143. *The Lamb Standing on Mt. Sion*, c.
1965–75
acrylic on fiberboard, 23¾ x 23¾"
Alan Jaffe, New Orleans

144. *Lamb's Bride Resting in His Chariot*,
c. 1965–75
ink and acrylic on paper, 14¼ x 25½"
Susann E. Craig, Chicago

145. *Lazarus Come Forth*, c. 1965–75
ink and acrylic on paper, 13 x 26¼"
Susann E. Craig, Chigago

146. *Lord I Don't Want to be Buried in the
Storm*, 1970
pen and acrylic on cardboard, 7⁵⁄₁₆ x 4"
Alan Jaffe, New Orleans

147. *Megaphone with Airplane*, c. 1965–75
ink and acrylic on paper, 19¼ x 6½ x
2"
Susann E. Craig, Chicago

148. *New Jerusalem*, late 1960s
pencil, acrylic and pen on paper, 18 x
20"
Mr. and Mrs. Christopher Botsford,
New Orleans

149. *New Jerusalem*, c. 1965–75
pen, pencil and acrylic on cardboard,
10 x 13"
Alan Jaffe, New Orleans

150. *New Jerusalem*, c. 1965–75
pen, pencil, and acrylic on cardboard,
22 x 28¹⁄₁₆"
Alan Jaffe, New Orleans

151. *New Jerusalem*, 1972
ink and acrylic on paper, 22 x 28"
Regenia Perry, Richmond

152. *Noah's Ark*, c. 1965–75
acrylic on cardboard, 19¹⁄₁₆ x 27"
Alan Jaffe, New Orleans

153. *Numbers 20:7, 8: Get Your Business
Straight*, c. 1965–75
pen and acrylic on cardboard, 6⅝ x
10½"
Alan Jaffe, New Orleans

154. *Pilgrims*, c. 1965–75
ink and acrylic on paper, 10½ x 15"
Susann E. Craig, Chicago

155. *A Poem of My Calling*, 1972
ink and acrylic on paper, 9¾ x 15"
Susann E. Craig, Chicago

156. *Revelation I. John*, c. 1965–75
pen, pencil and acrylic with string and
nails on cardboard, 21¾ x 30¹⁄₁₆"
Alan Jaffe, New Orleans

157. *Revelation 7. Chap.* c. 1965–75
acrylic on wood, 32½ x 15⅜"
Alan Jaffe, New Orleans

158. *Revelation 14:6: And I Saw Another
Angel*, c. 1965–75
acrylic on fiberboard, 18 × 30"
Alan Jaffe, New Orleans

159. *The Saints Eternal Home*, c. 1965–75
pen, pencil and watercolor on card-
board, 8½ x 15½"
Alan Jaffe, New Orleans

160. *Self-Portrait with Jesus and God*, c.
1965–75
ink and acrylic on cardboard, 3¾ x 6½"
Regenia Perry, Richmond

161. *Self-Portrait with Mother Margaret
Parker and Sister Cora Williams*, c.
1965–75
ink and acrylic on paper, 8½ x 11"
Susann E. Craig, Chicago

162. *Seven Last Plagues*, c. 1965–75
acrylic on wood, 32 x 60"
Alan Jaffe, New Orleans

163. *The Sign to the Believers*, c. 1965–75
pen, pencil, watercolor and crayon on
cardboard, 8³⁄₁₆ x 8¹⁄₁₆"
Alan Jaffe, New Orleans

164. *Sister Gertrude Morgan Did Some
Great Work*, c. 1965–75
ink and acrylic on paper, 11¾ x 10⅝"
Susann E. Craig, Chicago

165. *There Is An Eye Watching You*, c.
1965–75
pen and gouache on paper, 6¹³⁄₁₆ x 11"
Alan Jaffe, New Orleans

166. *The Two Beasts of Revelation*, c.
1965–75
pen, pencil, pastel and watercolor on
cardboard, 8⅜ x 15¼"
Alan Jaffe, New Orleans

167. *Vision of Death*, c. 1965–75
ink and acrylic on paper, 7½ x 8"
Alan Jaffe, New Orleans

168. *Window Shade: Book of Revelation*, c.
1965–75
ink and acrylic on window shade, 4' x
7'
Lee Friedlander, New City, New York

Inez Nathaniel-Walker

169. *Pariel Hanase*, c. 1971
pencil and colored pencil on paper,
11¾ x 17¾"
Estelle E. Friedman, Washington, D.C.

170. *Woman on a Bicycle*, 1972
colored pencil on paper, 17 x 14"
The Hall Collection of American Folk
and Isolate Art,
Bloomfield Hills, Michigan

171. *Man* (part of a pair), 1973
colored pencil on paper, 17 x 14"
The Hall Collection of American Folk
and Isolate Art,
Bloomfield Hills, Michigan

172. *Man and Woman on Yellow*, 1973
pencil and colored pencil on paper,
11¾ x 17¾"
Estelle E. Friedman, Washington, D.C.

173. *Woman* (part of a pair), 1973
colored pencil on paper, 17 x 14"
The Hall Collection of American Folk
and Isolate Art,
Bloomfield Hills, Michigan

174. *Baby*, 1974
pencil and colored pencil on paper,
11¾ x 17¾"
Estelle E. Friedman, Washington, D.C.

175. *Call Me*, 1974
pencil and colored pencil on paper,
17¾ x 23¾"
Estelle E. Friedman, Washington, D.C.

176. *Couple*, 1975
colored pencil on paper, 18 x24"
The Hall Collection of American Folk
and Isolate Art,
Bloomfield Hills, Michigan

177. *Three Figures, Woman on Shell*, 1975
pencil and colored pencil on paper,
17⅞ x 23⅞"
Phyllis Kind Gallery, New York and
Chicago

178. *Woman and Purple Curtain*, 1975
pencil and colored pencil on paper,
24⅛ x 18"
Phyllis Kind Gallery, New York and
Chicago

179. *Single Woman in Green*, 1976
crayon and colored pencil on paper,
29½ x 21½"
Amelia Parsons, Bedford Hill, New
York

180. *Two Figures* (red and brown), 1976
crayon and colored pencil on paper,
29¾ x 41⁷⁄₁₆"
Webb and Parsons, New Canaan, Con-
necticut

181. *Two Heads* (brown and pink), 1976
crayon and colored pencil on paper,
23⅛ x 28⅞"
Webb and Parsons, New Canaan, Con-
necticut

182. *Two Women*, 1976
pencil and colored pencil on paper, 22
x 28"
Phyllis Kind Gallery, New York and
Chicago

183. *Orange Face with Hat*, 1977
crayon and colored pencil on paper, 18 x 11¾"
Webb and Parsons, New Canaan, Connecticut

184. *Brown Face with Hat*, 1978
crayon and colored pencil on paper, 18 x 11¾"
Webb and Parsons, New Canaan, Connecticut

185. *Face with Hat*, 1978
crayon and colored pencil on paper, 18¾ x 24"
Webb and Parsons, New Canaan, Connecticut

186. *Figure with Red Face*, 1978
crayon and colored pencil on paper, 24 x 18¾"
Webb and Parsons, New Canaan, Connecticut

187. *Three Figures, Woman on Couch*, 1978
pencil and colored pencil on paper, 22½ x 30⅛"
Phyllis Kind Gallery, New York and Chicago

188. *Woman with Beret*, 1978
pencil, colored pencil and crayon on paper, 17½ x 11½"
Estelle E. Friedman, Washington, D.C.

Leslie Payne

189. *Fish*, 1970s
painted wood and metal, 13 x 45¼ x 7½"
George Schoelkopf, New York

190. *G. H. McNeal*, 1974
wood, plastic, metal and enamel paint, 21½ x 29½ x 5"
Jeffrey and C. Jane Camp, American Folk Art Co.,
Tappahannock, Virginia

191. *G. H. McNeal in Year 1929*, 1970s
painted wood and mixed media, 33½ x 52 x 10"
Herbert W. Hemphill, Jr., New York

192. *G. H. McNeal (with Cape Hatteras Light House)*, 1970s
painted wood and metal, 27 x 42¼ x 14½"
H. Marc Moyens, Alexandria, Virginia

193. *Hitler*, 1970s
painted wood, cloth and metal, 46 x 31 x 12"
Patricia Olsen, Richmond

194. *Lindbergh Bottle*, 1970s
glass and paper, 4 x 13½ x4"
Patricia Olsen, Richmond

195. *New York Lady*, 1970s
tin, copper, paint, costume jewelry, reflector, 26½ x 14"
Chuck and Jan Rosenak, Bethesda, Maryland

196. *Sunrise, Sunset* (with airplane), 1974
painted wood, metal and mixed media, 10'4 x 5'3 x 8" (sign)
24 x 37 x 41" (airplane)
John Freimarck, Mechanicsville, Virginia

197. *Two Soldiers*, 1970s
painted wood, metal, knives, 71½ x 83 x 15¼"
Phyllis Kind Gallery, New York and Chicago

198. *War Year (2) 1945*, 1970s
painted wood and metal, 10¼ x 13 x 3½"
Patricia Olsen, Richmond

Elijah Pierce

199. *Man Being Chased By Lion and Rhino*, 1928
carved and painted wood, glitter, 14 x 24"
Jeffrey Wolf and Jeany Nisenholz-Wolf, New York

200. *Sports*, c. 1930
carved and painted wood, 22½ x 17½"
Mr. and Mrs. Ellsworth Taylor, Lexington, Kentucky

201. *Monday Morning Gossip*, 1935
carved and painted wood, 33½ x 24"
The Hall Collection of American Folk and Isolate Art,
Bloomfield Hills, Michigan

202. *Universal Man*, 1937
carved and painted wood, 16¾ x 27¾"
The Hall Collection of American Folk and Isolate Art,
Bloomfield Hills, Michigan

203. *Crucifixion*, 1940
carved and painted wood on painted wood panel, 47 x 30½"
The Elijah Pierce Art Gallery, Columbus

204. *Pearl Harbor and the African Queen*, 1941
carved and painted wood, 23¾ x 26¾"
The Hall Collection of American Folk and Isolate Art,
Bloomfield Hills, Michigan

205. *Monkey Family*, 1942
carved and painted wood on painted cardboard panel, 32 x 25¼"
The Elijah Pierce Art Gallery, Columbus

206. *Before Death All Are Equal*, 1946/47
carved and painted wood, 13½ x 13½"
Columbus Museum of Art, Purchased with funds from the Alfred L. Willson Charitable Fund of the Columbus Foundation

207. *Father Time Racing*, 1950
carved and painted wood, 13 x 29"
The Hall Collection of American Folk and Isolate Art,
Bloomfield Hills, Michigan

208. *Louis vs. Braddock*, c.1950
carved and painted wood, 21½ x 23"
Jeffrey Wolf and Jeany Nisenholz-Wolf, New York

209. *Elijah*, 1953
carved and painted wood, glitter, 13¾ x 25"
Estelle E. Friedman, Washington, D.C.

210. *The Power of Prayer*, 1960
carved and painted wood, 41 x 19⅞"
The Hall Collection of American Folk and Isolate Art,
Bloomfield Hills, Michigan

211. *Berry Tree*, n.d.
carved and painted wood, glitter, 37 x 17¾"
Jeffrey Wolf and Jeany Nisenholz-Wolf, New York

212. *Lion*, 1973
carved and painted wood, glitter, 9 x 15½ x 3½"
Chuck and Jan Rosenak, Bethesda, Maryland

213. *The Parable of the Gnat and the Camel*, 1974
carved and painted wood, 18¾ x 17¾"
Jeffrey Wolf and Jeany Nisenholz-Wolf, New York

214. *Alligator*, 1975
carved and painted wood, glitter, 4½ x 23 x 3"
Chuck and Jan Rosenak, Bethesda, Maryland

215. *Horse and Rider*, 1975
carved and painted wood, 13⅜ x 16⅝ x 3"
John Wiley Fendrick, Chevy Chase, Maryland

216. *Goat*, c. 1975
carved and painted wood, glass and chicken bones, 8½ x 8½ x 2½"
Scott H. Lang, Washington, D.C.

217. *Leopard*, c. 1975
carved wood, ink and rhinestones, 6 x 9¾ x 3½"
Scott H. Lang, Washington, D.C.

218. *Picking Cotton*, c. 1975
carved and painted wood, 22½ x 27½"
Scott H. Lang, Washington, D.C.

219. *Leroy Brown*, 1970s
carved and painted wood, glitter and rhinestones, 19¾ x 10¼"
Phyllis Kind Gallery, New York and Chicago

220. *Nixon Being Chased By Inflation*, 1970s
carved and painted wood, glitter, 7¼ x 9¼"
Dr. Gladys-Marie Fry, College Park, Maryland

221. *Kids Don't Care About Race*, 1978
carved and painted wood, 20½ x 19½"
Janet Fleisher Gallery, Philadelphia

222. *Tiger*, 1981
carved and painted wood, 8¾ x 15¼ x 1¾"
Private Collection

Nellie Mae Rowe

223. *White Horse*, 1964
crayon on paper, 9½ x 14"
Judith Alexander, Atlanta

224. *Blue Horse*, n.d.
crayon on paper, 8½ x 13½"
Alexander Gallery, Atlanta

225. *Fish*, n.d.
ink on graph paper, 8¼ x 13″
Alexander Gallery, Atlanta

226. *Head of a Woman*, n.d.
crayon on paper, 10½ x 8″
Alexander Gallery, Atlanta

227. *Sailor*, n.d.
crayon on paper, 11 x 8½″
Alexander Gallery, Atlanta

228. *Self-Portrait as a Little Girl*, n.d.
cotton fabric and metal chair, 24″h
(26″h in chair)
Nellie Mae Rowe, Atlanta

229. *Woman with Earrings*, n.d.
crayon on paper, 11 x 8½″
Alexander Gallery, Atlanta

230. *Doll*, 1974/1975
cotton fabric, 21 x 13 x 4½″
Jeffrey and C. Jane Camp, American
Folk Art Co., Tappahannock,
Virginia

231. *Purple Pig*, c. 1975
wood, chewing gum and watercolor,
7½ x 6 x 8½″
Chuck and Jan Rosenak, Bethesda,
Maryland

232. *Mulberry Tree*, 1978
crayon on paper, 19 x 24″
Alexander Gallery, Atlanta

233. *Voting*, 1978
felt tip pen and photograph on paper,
20 x 30″
Lucinda Bunnen, Atlanta

234. *Wrestler*, 1978
crayon on paper, 13½ x 8½″
Alexander Gallery, Atlanta

235. *Blue Bull*, 1979
crayon and pencil on paper, 19 x 24″
Dr. and Mrs. Thomas M. Hooton, At-
lanta

236. *Something That Hasn't Been Born Yet*,
1979
ink and pencil on paper, 15 x 20″
Alexander Gallery, Atlanta

237. *Fish*, 1980
crayon and ink on paper, 18 x 23″
Alexander Gallery, Atlanta

238. *Fish on Spools*, 1980
acrylic on wood, 7½ x 25 x 1½″
Alexander Gallery, Atlanta

239. *Pig on Expressway*, 1980
crayon on paper, 18 x 23″
Alexander Gallery, Atlanta

240. *Red and Blue Fish*, 1980
acrylic on wood, 23 x 9½ x ¾″
Judith Alexander, Atlanta

241. *Red and Yellow Fish*, 1980
acrylic on wood, 8¼ x 33 x ¾″
Judith Alexander, Atlanta

242. *Two-Faced Head*, 1980
painted gum and mixed media, 5½ x
4¼ x 4¼″
Judith Alexander, Atlanta

243. *Two-Headed Rooster*, 1980
crayon on paper, 24¾ x 28¾″
Alexander Gallery, Atlanta

244. *Molly*, n.d.
crayon, ink and pencil, 17¾ x 21¾″
Sidney Mindlin, Pittsburgh

245. *Black Fish*, 1981
acrylic on wood, 26½ x 37″
Alexander Gallery, Atlanta

246. *Cat*, 1981
painted gum and mixed media, 5½ x
7¾ x 7½″
Alexander Gallery, Atlanta

247. *Rocking Chair*, 1981
felt tip pen and pencil on paper, 18 x
23″
Alexander Gallery, Atlanta

James 'Son Ford' Thomas

248. *Bird*, c. 1970
unfired clay and paint, 5½ x 3 x 6½″
Center for the Study of Southern Cul-
ture, Oxford, Mississippi

249. *Blue-Green Duck*, c. 1970
unfired clay and paint, 7 x 12¼ x 5¼″
Center for the Study of Southern Cul-
ture, Oxford, Mississippi

250. *Bream*, c. 1970
unfired clay and paint, 4 x 7 x 1¼″
Center for the Study of Southern Cul-
ture, Oxford, Mississippi

251. *Bust*, c. 1970
unfired clay and paint, 5¼ x 3 x 2″
Center for the Study of Southern Cul-
ture, Oxford, Mississippi

252. *Bust*, c. 1970
unfired clay and paint, 4½ x 2½ x 4¼″
Center for the Study of Southern Cul-
ture, Oxford, Mississippi

253. *Catfish*, c. 1970
unfired clay and paint, 3 x 11½ x 2¼″
Center for the Study of Southern Cul-
ture, Oxford, Mississippi

254. *Crawfish*, c. 1970
unfired clay and paint, 3 x 7½ x 5½″
Center for the Study of Southern Cul-
ture, Oxford, Mississippi

255. *Gar*, c. 1970
unfired clay and paint, 2 x 11¼ x 1¾″
Center for the Study of Southern Cul-
ture, Oxford, Mississippi

256. *Green Frog*, c. 1970
unfired clay and paint, 4½ x 2¾ x 4½″
Center for the Study of Southern Cul-
ture, Oxford, Mississippi

257. *Head with White Hair and Blue Tie*,
c. 1970
unfired clay, paint and cotton, 10 x 5
x 7″
Center for the Study of Southern Cul-
ture, Oxford, Mississippi

258. *Head with White Hair and Moustache*,
c. 1970
unfired clay and cotton, 11 x 10 x 8″
Center for the Study of Southern Cul-
ture, Oxford, Mississippi

259. *Rattlesnake*, c. 1970
unfired clay and paint, 4 x 9 x 9″
Center for the Study of Southern Cul-
ture, Oxford, Mississippi

260. *Skull with Corn Teeth and Foil Eyes*,
c. 1970
unfired clay, corn kernels and tin foil,
7½ x 9 x 5″
Center for the Study of Southern Cul-
ture, Oxford, Mississippi

261. *Spotted Duck*, c. 1970
unfired clay and paint, 6½ x 12 x 5½″
Center for the Study of Southern Cul-
ture, Oxford, Mississippi

262. *Yellow Duck*, c. 1970
unfired clay and paint, 5 x 10 x 3½″
Center for the Study of Southern Cul-
ture, Oxford, Mississippi

263. *Skull with Corn Teeth*, 1973
unfired clay, floor wax and corn ker-
nels, 8 x 5¼ x 8″
Mississippi State Historical Museum,
Jackson

264. *Head of Abraham Lincoln*, 1974
unfired clay, floor wax, paint, 6¾ x 4½
x 5″
Mississippi State Historical Museum,
Jackson

265. *Woman's Head with Wig*, c. 1975
unfired clay, paint and wig, 9½ x 7 x
8″
Center for Southern Folklore, Mem-
phis

266. *Head*, 1977
unfired clay and paint, 9 x 6 x 6½″
Center for Southern Folklore, Mem-
phis

Mose Tolliver

267. *Face of a Bearded Man*, c. 1975
enamel on cardboard, 13⅞ x 10¹⁵⁄₁₆″
Kansas Grassroots Art Association,
Lawrence

268. *The Family*, c. 1975
three panels, each oil on cardboard
with wood frame, 23 x 14¼″
Robert Bishop, New York

269. *Figure on Bicycle*, c. 1975
enamel on wood, 20¼ x 12″
Kansas Grassroots Art Association,
Lawrence

270. *Figure with Turtle*, c. 1975
enamel on wood, 28⅜ x 23¾″
Kansas Grassroots Art Association,
Lawrence

271. *House with Tree and Bird*, c. 1975
enamel on wood, 22⅛ x 23¾″
Kansas Grassroots Art Association,
Lawrence

272. *Large Blue Plant with Two Small Fig-
ures*, c. 1975
enamel on wood, 29¾ x 21¾″
Kansas Grassroots Art Association,
Lawrence

273. *Man's Head with Spheres*, c. 1975
enamel on wood, 15⅝ x 19⅛″
Kansas Grassroots Art Association,
Lawrence

274. *Orange and Gray Abstract*, c. 1975
enamel on wood, 25¼ x 34″
Kansas Grassroots Art Association,
Lawrence

275. *Plant Form*, c. 1975
enamel on wood, 16¼ x 12⅞"
Kansas Grassroots Art Association,
Lawrence

276. *Red Flowering Plant with Birds*, c.
1975
enamel on wood, 23⅞ x 21¾"
Kansas Grassroots Art Association,
Lawrence

277. *Red Horned Animal*, c. 1975
enamel on wood, 10¼ x 17⅝"
Kansas Grassroots Art Association,
Lawrence

278. *Three Trees with Snake*, c. 1975
enamel on wood, 29¾ x 16⅝"
Kansas Grassroots Art Association,
Lawrence

279. *Two Trees*, c. 1975
enamel on cardboard, 18¼ x 12"
Kansas Grassroots Art Association,
Lawrence

280. *Woman and Child*, c. 1975
enamel on wood, 30 x 25"
Kansas Grassroots Art Association,
Lawrence

281. *Woman with Fish Shape*, c. 1975
enamel on wood, 24¹⁵/₁₆ x 10"
Kansas Grassroots Art Association,
Lawrence

282. *Women with Green Background*, c.
1975
enamel on wood, 26½ x 27"
Kansas Grassroots Art Association,
Lawrence

283. *Self-Portrait*, 1978
house paint on plywood, 21 x 16¾"
(16¼" top)
Robert Bishop, New York

284. *Sexual Fantasy (Lady on Scooter)*, late
1970s
enamel on plywood, 24¾ x 18¾"
Herbert W. Hemphill, Jr., New York

285. *Three Cone Trees*, 1979
housepaint on panel, 23¾ x 13"
Mitchell D. Kahan, Montgomery, Alabama

286. *Bus with Birds on a Tree Limb*, 1980
housepaint on panel, 23¼ x 25½"
Mitchell D. Kahan, Montgomery, Alabama

287. *Green Tree with Two Green Birds*,
1980
housepaint on panel, 35¾ x 12"
Mitchell D. Kahan, Montgomery, Alabama

288. *Moose Head with Antlers*, 1981
housepaint, antlers on panel, 22 x 15¼
x 10½"
Mitchell D. Kahan, Montgomery, Alabama

289. *Pink Flowers on a Spotted Blue
Ground*, 1981
housepaint on panel, 12⅛ x 23⅞"
Mitchell D. Kahan, Montgomery, Alabama

Bill Traylor

290. *Abstraction*, 1939–42
pencil, crayon and gouache on paper,
13¼ x 11⅛"
Charles Shannon, Montgomery, Alabama

291. *Big Red Pig*, 1939–42
pencil and gouache on paper, 14 x 20¼"
Mr. and Mrs. Joseph H. Wilkinson,
Fairfield, Connecticut

292. *Black Dairy Cow*, 1939–42
pencil, crayon and gouache on paper,
12 x 16¾"
Charles Shannon, Montgomery, Alabama

293. *Blacksmith Shop*, 1939–42
pencil, crayon and gouache on paper,
13⅜ x 26¼"
Charles Shannon, Montgomery, Alabama

294. *Brown Horse*, 1939–42
pencil and gouache on paper, 13⅝ x
21⅝"
Mr. and Mrs. Joseph H. Wilkinson,
Fairfield, Connecticut

295. *Cat*, 1939–42
pencil and gouache on paper, 12¾ x
11"
Mr. and Mrs. Joseph H. Wilkinson,
Fairfield, Connecticut

296. *Drinker*, 1939–42
pencil, crayon and gouache on paper,
11½ x 8⅜"
Charles Shannon, Montgomery, Alabama

297. *Drinker with Hat and Bottle*, 1939–42
compressed charcoal pencil on paper,
13½ x 7⅝"
Mr. and Mrs. Joseph H. Wilkinson,
Fairfield, Connecticut

298. *Figures*, 1939–42
pencil, crayon and gouache on paper,
12⅝ x 6¾"
Charles Shannon, Montgomery, Alabama

299. *Figures on Blue Construction*, 1939–42
pencil, crayon and gouache on paper,
13¾ x 12¾"
Charles Shannon, Montgomery, Alabama

300. *Green Goat*, 1939–42
pencil, crayon and gouache on paper,
8 x 9⅞"
Charles Shannon, Montgomery, Alabama

301. *Horse and Rider*, 1939–42
pencil and gouache on paper, 13¼ x
15¹/₁₆"
Courtesy Luise Ross; R. H. Oosterom
Inc., New York

302. *Man and Large Dog*, (recto), 1939–42
pencil and gouache on paper, 28⅝ x
22½"
Courtesy Luise Ross; R. H. Oosterom
Inc., New York

303. *Man and Woman*, 1939–42
pencil and gouache on paper, 21⅝ x
13⅞"
Mr. and Mrs. Joseph H. Wilkinson,
Fairfield, Connecticut

304. *Man in Blue House with Rooster*,
1939–42
pencil, crayon and gouache on paper,
15¾ x 11¾"
Charles Shannon, Montgomery, Alabama

305. *Man with Spotted Shirt and Blue
Pants*, 1939–42
pencil and gouache on paper, 22 x 14"
Mr. and Mrs. Joseph H. Wilkinson,
Fairfield, Connecticut

306. *Man with Umbrella*, 1939–42
pencil and gouache on paper, 14 x 9"
Mr. and Mrs. Joseph H. Wilkinson,
Fairfield, Connecticut

307. *Man with Yoke*, 1939–42
pencil and gouache on paper, 22 x 13⅝"
Mr. and Mrs. Joseph H. Wilkinson,
Fairfield, Connecticut

308. *Mule*, 1939–42
pencil and gouache on paper, 11¼ x
15½"
Mr. and Mrs. Joseph H. Wilkinson,
Fairfield, Connecticut

309. *Mule with Red Border*, 1939–42
pencil, crayon and gouache on paper,
18½ x 20½"
Charles Shannon, Montgomery, Alabama

310. *Orange Construction, Blue Bird*,
1939–42
pencil and gouache on paper, 15 x 9¼"
Mr. and Mrs. Joseph H. Wilkinson,
Fairfield, Connecticut

311. *Peg-Legged Figure*, 1939–42
pencil, crayon and gouache on paper,
11¼ x 7⅝"
Charles Shannon, Montgomery, Alabama

312. *Possum Hunt*, 1939–42
pencil and crayon on paper, 21½ x
13⅞"
Mr. and Mrs. Joseph H. Wilkinson,
Fairfield, Connecticut

313. *Purple Rabbit*, 1939–42
pencil, crayon and gouache on paper,
7½ x 12½"
Charles Shannon, Montgomery, Alabama

314. *Rabbit*, 1940
pencil, crayon and gouache on paper,
9¼ x 9¼"
Charles Shannon, Montgomery, Alabama

315. *Red Dog*, 1939–42
pencil and gouache on paper, 11½ x
11¾"
Mr. and Mrs. Joseph H. Wilkinson,
Fairfield, Connecticut

316. *Red Figures, Blue Construction*,
1939–42
pencil and gouache on paper, 12¼ x 8"
Mr. and Mrs. Joseph H. Wilkinson,
Fairfield, Connecticut

317. *Red House with Figures*, 1939–42
pencil, crayon and gouache on paper,
22 x 13½"
Charles Shannon, Montgomery, Alabama

318. *Self-Portrait*, 1939–42
pencil, crayon and gouache on paper,
17 x 11"
Charles Shannon, Montgomery, Alabama

319. *Serpent*, 1939–42
pencil, crayon and gouache on paper,
11¾ x 10"
Charles Shannon, Montgomery, Alabama

320. *Spotted Cat*, 1939–42
pencil, crayon and gouache on paper,
9½ x 14"
Charles Shannon, Montgomery, Alabama

321. *Turtle, Swimming Down*, 1939–42
pencil, crayon and gouache on paper,
11¾ x 7¾"
Charles Shannon, Montgomery, Alabama

322. *Two-Eyed Dog*, 1939–42
pencil, crayon and gouache on paper,
10⅞ x 12⅞"
Charles Shannon, Montgomery, Alabama

323. *Woman in Red Milking*, 1939–42
pencil and gouache on paper, 11½ x
15¼"
Mr. and Mrs. Joseph H. Wilkinson,
Fairfield, Connecticut

324. *Woman with Blue Hands and Brown
Skirt*, 1939–42
pencil, crayon and gouache on paper,
19⅝ x 9"
Charles Shannon, Montgomery, Alabama

325. *Yellow Chicken*, 1939–42
pencil, crayon and gouache on paper,
13⅞ x 8¼"
Charles Shannon, Montgomery, Alabama

George White

326. *Old Ladies Washing and Ironing*, 1958
painted wood and mixed media construction, 18 x 24 x 20"
Fendrick Gallery, Washington, D.C.

327. *Joe Louis in Shoe Shine Parlor*, 1959
painted wood and mixed media construction, 17 x 11½ x 16½"
Marilyn Lubetkin, Houston

328. *Rodeo Rider*, 1959
painted wood and mixed media construction, 14 x 24 x 12"
San Antonio Museum Association

329. *Old Days When Jesse James Robbed
Trains*, 1960
oil on carved wood relief, 16 x 24"
Mr. and Mrs. Roger Horchow, Dallas

330. *Old Pioneer Days*, 1962
oil on carved wood relief, 24 x 25"
Mr. and Mrs. Roger Horchow, Dallas

331. *Emancipation House*, 1964
painted wood and mixed media construction, 19½ x 23¼ x 18½"
National Museum of American Art,
Smithsonian Institution, Washington,
D.C.

332. *Coon in a Tree*, 1965
painted wood and mixed media construction, 16 x 12½ x 20½"
Delahunty Gallery, Dallas

333. *Dodge City Kansas*, 1965
oil on carved wood relief, 18 x 24"
Mr. and Mrs. Roger Horchow, Dallas

334. *Gone Fishing*, 1965
painted wood and mixed media construction, 16 x 8 x 8"
Laura Carpenter, Dallas

335. *Killer Lion*, 1965
oil on carved wood relief, 13¾ x 24¼"
Mrs. George White, Dallas

336. *One Bad Snake*, 1965
painted wood, 8½ x 20¾ x 11"
Delahunty Gallery, Dallas

337. *Old Hills of Kentucky*, 1966
oil on carved wood relief, 30 x 44"
Mrs. George White, Dallas

338. *Killing the Mountain Lion*, 1967
oil on carved wood relief and mixed
media, 10 x 16½"
Murray Smither, Dallas

339. *Butchering Pig*, 1968
painted wood and mixed media construction, 13½ x 13½ x 6½"
Mrs. George White, Dallas

340. *Wrestling*, 1968
oil on carved wood relief, 21½ x 24"
Jean and Bill Booziotis, Dallas

George Williams

341. *Bust of a Man*, c. 1945
wood, paint and tar, 9 x 3"
Roland Freeman Collection of Black
Folk Art, Washington, D.C.

342. *Bust of a Man*, c. 1950
wood, paint and tar, 12½ x 4¾"
Roland Freeman Collection of Black
Folk Art, Washington, D.C.

343. *Bull*, 1975
wood and paint, 5 x 8⅜"
Roland Freeman Collection of Black
Folk Art, Washington, D.C.

344. *Standing Man, Nude*, 1975
wood, 18 x 3½ x 3"
Roland Freeman Collection of Black
Folk Art, Washington, D.C.

345. *Standing Woman, Nude*, 1975
wood, 17 x 3½ x 3¼"
Roland Freeman Collection of Black
Folk Art, Washington, D.C.

346. *Devil on Wheels*, 1976
wood and paint, 7¼ x 6¼"
Roland Freeman Collection of Black
Folk Art, Washington, D.C.

347. *Man Driving a Red Horse Cart*, 1976
wood, paint and wire, 11½ x 17"
Roland Freeman Collection of Black
Folk Art, Washington, D.C.

348. *Standing Man, Clothed*, 1977
wood, paint and tar, 16¼ x 3¼"
Roland Freeman Collection of Black
Folk Art, Washington, D.C.

349. *Standing Woman, Clothed*, 1977
wood and paint, 16 x 3½"
Roland Freeman Collection of Black
Folk Art, Washington, D.C.

Luster Willis

350. *Friends*, 1939–57
five cut-out heads, each tempera and
shoe polish on cardboard, mounted on
cardboard, 40⅜ x 30⅜" overall
Center for Southern Folklore, Memphis

351. *Soup Line*, 1929–56, c. 1956
pencil and tempera on paper, mounted
on cardboard, 17 x 22"
Center for the Study of Southern Culture, Oxford, Mississippi

352. *Lady in the Rain*, 1963
tempera on paper, 23½ x 24"
Center for Southern Folklore, Memphis

353. *Self-Portrait with Martin Luther King*,
1960s
ink and tempera on paper, mounted on
cardboard, 14 x 19½"
Center for the Study of Southern Culture, Oxford, Mississippi

354. *This Is It*, c. 1970
tempera and glitter on plywood, 15¾
x 24¾"
Center for Southern Folklore, Memphis

355. *Music at Home*, c. 1974
ink, tempera and glitter on paper, 22⅝
x 28½"
Center for Southern Folklore, Memphis

356. *Preacher Dealing with Drunks*, c.
1974.
tempera on cardboard, 30½ x 22½"
Center for Southern Folklore, Memphis

357. *Rock and Roll Concert*, c. 1974
tempera and glitter on paper, 17 x 19¼"
Center for Southern Folklore, Memphis

358. *Man in White Glasses*, 1976
tempera on paper, mounted on construction paper, 10⅛ x 12"
Center for Southern Folklore, Memphis

359. *Old Country Revival*, 1976
pencil and tempera on plywood, 23¼
x 37¾"
Center for Southern Folklore, Memphis

360. *Old Time Spinning Wheel*, c. 1976
oil on canvas board, 20 x 24"
Center for Southern Folklore, Memphis

361. *Wash Lady*, c. 1976
tempera and silver paint on cardboard,
22 x 28"
Center for Southern Folklore, Memphis

362. *Cut-Out Red Figure, Hands Raised,* 1970s
pencil and tempera on wood, 19½ x 25"
Center for the Study of Southern Culture, Oxford, Mississippi

363. *Home on the Farm, USA,* 1970s
pen and tempera on poster board, 22⅛ x 28⅛"
Center for Southern Folklore, Memphis

364. *Man on a White Horse,* 1970s
pen and tempera on cardboard, 16 x 17¼"
Center for Southern Folklore, Memphis

365. *Mummie of the Stone Age,* 1970s
watercolor and glitter on poster board, 15½ x 12⅛"
Center for Southern Folklore, Memphis

366. *Wife and Baby Confront Husband and Mistress,* 1970s
tempera, glitter, cut glass, pebbles, glue and staples on paper,
mounted on paper, in painted frame, 24¼ x 18¼" overall
Center for the Study of Southern Culture, Oxford, Mississippi

367. *Two Good Friends,* c. 1980
ink and tempera on paper, 13⅞ x 12³⁄₁₆"
Private Collection

Joseph Yoakum

368. *Beacon Tower, Athens,* early 1960s
pencil, pen and pastel on paper, 9 x 12"
Phyllis Kind Gallery, New York and Chicago

369. *Brehmon 4-Unit Motel,* early 1960s
pencil, pen and pastel on paper, 12 x 18"
Phyllis Kind Gallery, New York and Chicago

370. *Puget Sound,* early 1960s
watercolor and pen on paper, 9 x 12"
Phyllis Kind Gallery, New York and Chicago

371. *View of Blue Mounds, Kansas,* early 1960s
pencil, pen and pastel on paper, 9 x 12"
Phyllis Kind Gallery, New York and Chicago

372. *Biscian Bay at St. Nazair, France,* 1960s
pen and pastel on paper, 19 x 24"
Roger Brown, Chicago

373. *Grand Coulee Dam on Columbia River Washington State,* 1960s
pen and pastel on paper, 9 x 12"
Roger Brown, Chicago

374. *Kern Creek, Escadero, Kern County, California,* 1960s
pen and pastel on paper, 9 x 12"
Roger Brown, Chicago

375. *Rock of Gibraltar,* 1960s
pen and pastel on paper, 12 x 18"
Roger Brown, Chicago

376. *Chiri-San Mountain Range Near Namnoh South Korea,* 1964
pencil and pen on paper, 12 x 18"
Christina Ramberg and Philip Hanson, Chicago

377. *C.S. Valentin Crater,* 1964
watercolor and pen on paper, 19 x 24"
Phyllis Kind Gallery, New York and Chicago

378. *Ozark Range at Kirkwood Missouri West Suburb of St. Louis Mount Dillon,* 1964
pen and pastel on paper, 12 x 18"
Christina Ramberg and Philip Hanson, Chicago

379. *A Suburb of the City of Deming, New Mexico,* 1964
pencil, pen and pastel on paper, 12 x 17¾"
Phyllis Kind Gallery, New York and Chicago

380. *The First Steam Engine,* 1968
pen and pastel on paper, 12 x 19"
Roger Brown, Chicago

381. *Mt. Everest,* 1968
pencil, pen and pastel on paper, 19¾ x 13"
Phyllis Kind Gallery, New York and Chicago

382. *Mt. Thousand Lakes in Bryce Canyon National Park Near Hanksville Utah,* 1968
pen and pastel on paper, 12 x 19"
Christina Ramberg and Philip Hanson, Chicago

383. *Waiane Mountain Range Entrance to Pearl Harbor and Honolulu Oahu of Hawaiian Islands,* 1968
pen and pastel on paper, 12 x 19"
Christina Ramberg and Philip Hanson, Chicago

384. *The Dolomites in North Italy,* c. 1968
pencil, pen and pastel on paper, 12 x 17¾"
Phyllis Kind Gallery, New York and Chicago

385. *Mt. Tabor,* 1969
pencil, pen and pastel on paper, 17½ x 23"
Phyllis Kind Gallery, New York and Chicago

386. *Mt. Taum Sauk of Ozarks,* late 1960s
pencil, pen and pastel on paper, 18 x 23¾"
Phyllis Kind Gallery, New York and Chicago

387. *The Great Scenic Mounds Hanford Desert,* 1970
pen and pastel on paper, 12 x 19"
Roger Brown, Chicago

388. *Mounds on Sugar Plantation of Maui,* 1970
pen and pastel on paper, 12¼ x 19"
Roger Brown, Chicago

389. *Giant Rock in Angles Landing Zion National Park, Utah,* c. 1970
pen and pastel on paper, 12 x 19"
Christina Ramberg and Philip Hanson, Chicago

390. *The Dolomites in North Italy,* 1971
pencil, pen and pastel on paper, 12 x 19"
Phyllis Kind Gallery, New York and Chicago

391. *Gun Boat,* 1971
pen and pastel on paper, 12 x 19"
Roger Brown, Chicago

Selected Bibliography

The following bibliography is divided into two sections. The first lists general texts—books, articles and exhibition catalogues—on Afro-American folklore and art history. It is excerpted from a more comprehensive bibliography prepared by Simon J. Bronner and Christopher Lornell for the book *Afro-American Folk Art and Crafts*, William Ferris, editor, to be published by G. K. Hall in late 1982. Selections were made for this condensed bibliography on the basis of their relevance to the work of contemporary self-taught painters and sculptors. For example, texts on eighteenth and nineteenth-century slave society have been included, as have works on late nineteenth-century black material culture, especially those on carving, quilting and pottery. European texts on naive art have been added, as many contain references to black Americans. Those interested in the fuller bibliography are referred to the Ferris book.

The second section lists texts on the twenty artists featured in this publication, organized alphabetically by artist. Short entries refer to writings listed in full in the general bibliography.

Adams, Jeanne Marie. "The Harriet Powers Pictorial Quilts." *Black Art* 3, No. 4 (1979): 12–28.

Adler, Elizabeth Mosby. "It Takes a Smart Guy to . . . Take a Look at a Rock and Do Like That: George 'Baby' Scott (1865–1945), a Carver and His Repertoire." *Mid-South Folklore* 3 (1975): 47–60.

Ames, Kenneth L. *Beyond Necessity: Art in the Folk Tradition.* New York: W.W. Norton, 1977.

Barnes, Albert C. "Negro Art and America." *Ex Libris* 1 (1924): 323–27.

Bearden, Romare and Henderson, Harry. *Six Black Masters of American Art.* New York: Zenith Books, 1972.

Bihalji-Merin, Oto. *Modern Primitives: Masters of Naive Painting.* New York: Harry Abrams, 1959.

Bishop, Robert. *American Folk Sculpture.* New York: E.P. Dutton, 1974.

———. *Folk Painters of America.* New York: E.P. Dutton, 1979.

———, and Koblentz, Patricia. *A Gallery of American Weathervanes and Whirligigs.* New York: E.P. Dutton, 1981.

Black, Patti C., ed. *Made by Hand: Mississippi Folk Art.* Jackson, Mississippi: Mississippi Department of Archives and History, 1980.

Black, Mary and Lipman, Jean. *American Folk Painting.* New York: Bramhall House, 1966.

Blasdel, Gregg. "The Grass Roots Artist." *Art in America* 56 (September–October 1968): 24–41.

Blassingame, John W. *The Slave Community: Plantation Life in the Antebellum South.* New York: Rev. & Enl. Ed. Oxford University Press, 1979.

———. *Black New Orleans, 1860–1880.* Chicago: University of Chicago Press, 1973.

Brawley, Benjamin Griffith. *The Negro in Literature and Art in the United States.* New York: Duffield and Co., 1921.

Burrison, John A. "Prolegomenon to a Study of Afro-American Folk Pottery in the South." *Southern Folklore Quarterly* 42 (1978): 175–200.

Cardinal, Roger. *Outsider Art.* New York: Praeger Publishers, 1972.

———. *Primitive Painters.* London: Thames and Hudson, 1978.

Chase, Judith Wragg. *Afro-American Art and Craft.* New York: Van Nostrand Reinhold, 1971.

Craftsmanship: A Tradition in Black America. New York: RCA Corporation, 1976.

Crum, Mason. *Gullah Negro Life in the Carolina Sea Islands.* Durham: Duke University Press, 1940.

Dabbs, Edith M. *Face of an Island: Leigh Richmond Miner's Photographs of Saint Helena Island.* New York: Grossman, 1971.

Deetz, James. *In Small Things Forgotten: The Archaeology of Early American Life.* Garden City, New York: Anchor Press/Doubleday, 1977.

Dover, Cedric. *American Negro Art.* Greenwich, Connecticut: New York Graphic Society, 1960.

Driskell, David C. *Two Centuries of Black American Art.* New York: Alfred A. Knopf, 1976.

DuBois, W. E. Burghardt, and Dill, Augustus Granville. *The Negro American Artisan.* Atlanta University Publications, Number 17. Atlanta: Atlanta University Press, 1912.

Dubuffet, Jean. *L'Art Brut.* Paris: Musée des Arts Décoratifs, 1967.

Dunn, Mamie. "He Builds His Angel to Inspire Motorists." *Durham Morning Herald* (January 12, 1975).

Fax, Elton C. *Seventeen Black Artists.* New York: Dodd, Mead, 1971.

Ferris, William, Jr. *Blues From the Delta.* Garden City, New York: Anchor Press/Doubleday, 1978.

———. "Introduction." *Southern Folklore Quarterly* 42 (1978): 99–108.

———. "Black Folk Arts and Crafts: A Mississippi Sample." *Southern Folklore Quarterly* 42 (1978): 209–242.

———. "Local Color: Memory and Sense of Place in Folk Art". In *Made By Hand: Mississippi Folk Art,* ed. Patti Black. Jackson, Mississippi: Mississippi Department of Archives and History, 1980. Pp. 11–22.

———, and McCallum, Brenda. *Local Color: Folk Arts and Crafts.* Memphis: Center for Southern Folklore, in press.

Fine, Elas Honig. *The Afro-American Artist.* New York: Holt, Rhinehart and Winston, 1973.

Freeman, Roland. "Folkroots: Images of Mississippi Black Folklife." In *Long Journey Home: Folklife in the South,* ed. Allen Tullos. Chapel Hill: Southern Exposure, 1977. Pp. 29–35.

———. "Images of Mississippi Black Folklife: A Photographic Essay." In *Made By Hand: Mississippi Folk Art,* ed. Patti Black. Jackson, Mississippi: Mississippi Department of Archives and History, 1980. Pp. 23–27.

Fry, Gladys-Marie. "Harriet Powers: Portrait of a Black Quilter." In *Missing Pieces: Georgia Folk Art 1770–1976,* ed. Anna Wadsworth. Atlanta: Georgia Council for the Arts and Humanities, 1976. Pp. 16–23.

Genovese, Eugene D. *Roll, Jordan, Roll: The World the Slaves Made.* New York: Pantheon Books, 1974.

Georgia Federal Writers' Project. *Drums and Shadows: Survival Studies Among the Georgia Coastal Negroes.* Athens: University of Georgia Press, 1940.

Ghent, Henri. *Artistes afro-americains.* Geneve: Musée Rath, 1971.

Glassie, Henry. *Pattern in the Material Folk Culture of the Eastern United States.* Philadelphia: University of Pennsylvania Press, 1968.

Goldin, Amy. "Problems in Folk Art." *Artforum* 14 (June 1976): 48–52.

Hall, Gaye and Hickman, David. *Eyes of Texas: an Exhibition of Living Texas Folk Artists.* Houston: University of Houston, 1980.

Hall, Michael. *Six Naives—An Exhibition of Living Contemporary Naive Artists.* Akron: Akron Art Institute, 1974.

Harris, Middleton. *The Black Book.* New York: Random House, 1974.

Hemphill, Herbert W., Jr., ed. *Folk Sculpture USA.* Brooklyn: Brooklyn Museum, 1976.

———, and Weissman, Julia. *Twentieth Century American Folk Art and Artists.* New York: E.P. Dutton, 1974.

Herskovits, Melville. *The Myth of the Negro Past.* Boston: Beacon Press, 1941; 1958 rpt.

Horwitz, Elinor. *Contemporary American Folk Artists.* Philadelphia and New York: J.B. Lippincott, 1975.

———. *The Bird, the Banner and Uncle Sam: Images of America in Folk and Popular Art.* Philadelphia and New York: J.B. Lippincott, 1976.

Hudson, Ralph M. *Black Artists/South.* Huntsville, Alabama: Huntsville Museum of Art, 1979.

Janis, Sidney. *They Taught Themselves.* New York: Dial Press, 1942.

Johnson, Rhonda S. "Harmon Young: Georgia Wood Sculptor." *Southern Folklore Quarterly* 42 (1978): 243–256.

Kan, Michael. "American Folk Sculpture: Some Considerations of Its Ethnic Heritage." *In Folk Sculpture USA,* ed. Herbert Hemphill. Brooklyn: Brooklyn Museum, 1976. Pp. 55–71.

180

Kemble, Frances Anne. *Journal of a Residence on a Georgian Plantation in 1838–39*. Chicago: Afro-Am Press, 1969.

Kind, Phyllis. "Some Thoughts About Contemporary Folk Art." *American Antiques* (June 1976): 28–44.

Lewis, Samella. *Art: African American*. New York: Harcourt, Brace, Jovanovich, 1978.

Locke, Alain. *The Negro in Art*. Washington, D.C.: Associates in Negro Folk Education, 1940.

Long, Worth, and Freeman, Roland. "Leon Rucker, Woodcarver." In *Black People and Their Culture*, ed. Linn Shapiro. Washington, D. C.: Smithsonian Institution, 1976. Pp. 33–34.

———. "Mississippi Black Folklife." *Southern Exposure* 3 (1975): 84–89.

Montell, William Lynwood. *The Saga of Coe Ridge*. Knoxville: University of Tennessee Press, 1970.

Newton, James E., and Lewis, Ronald L., eds. *The Other Slaves: Mechanics, Artisans, and Craftsmen*. Boston: G. K. Hall, 1978.

Olmstead, F. L. *A Journey in the Seaboard Slave States in the Years 1853–54*. New York: Dix and Edwards, 1856.

Outsiders: An Art Without Precedent or Tradition. London: Arts Council of Great Britain, 1979.

Parrish, Lydia. *Slave Songs of the Georgia Sea Islands*. New York: Creative Age Press, 1942.

Peek, Phil. "Afro-American Material Culture and the Afro-American Craftsman." *Southern Folklore Quarterly* 42 (1978): 109–134.

Perry, Regenia. *Selections of Nineteenth Century Afro-American Art*. New York: Metropolitan Museum of Art, 1976.

Porter, James A. *Modern Negro Art*. New York: Dryden Press, 1943.

———. "One Hundred and Fifty Years of Afro-American Art." In *The Negro in American Art*. Los Angeles: UCLA Art Galleries, 1966. Pp. 5–12.

Rawick, George P., ed. *The American Slave: Composite Autobiography* (31 volumes). Westport, Connecticut: Greenwood Press, 1972.

Rhodes, Lynette I. *American Folk Art: From the Traditional to the Naive*. Cleveland: Cleveland Museum of Art, 1978.

Rodman, Selden. *Horace Pippin: A Negro Painter in America*. New York: Quadrangle Press, 1947.

Rosengarten, Theodore. *All God's Dangers: The Life of Nate Shaw*. New York: Alfred A. Knopf, 1974.

Rumford, Beatrix. *Folk Art in America: A Living Tradition*. Atlanta: The High Museum of Art, 1974.

Szwed, John F., and Abrahams, Roger D. *Afro-American Folk Culture: An Annotated Bibliography of Material from North, Central and South America and the West Indies*. Philadelphia: Institute for the Study of Human Issues, 1978.

Taylor, Ellsworth. *Folk Art of Kentucky*. Lexington: University of Kentucky Fine Arts Gallery, 1975.

Teilhet, Jehanne. *Dimensions in Black*. La Jolla, California: La Jolla Museum of Art, 1970.

Thévoz, Michel. *Art Brut*. New York: Rizzoli International Publications, 1976.

Thomas Day, Cabinetmaker. Raleigh: North Carolina Museum of History, 1975.

Thompson, Robert Farris. *The Transatlantic Tradition*. New York: Random House, in press.

———, and Cornet, Joseph. *Four Moments of the Sun: Kongo Art of Two Worlds*. Washington, D.C.: National Gallery of Art, 1981.

———. "African Influence on the Art of the United States." In *Black Studies in the University: A Symposium*, ed. Armstead L. Robinson, Craig C. Foster, and Donald H. Ogilvie. New Haven: Yale University Press, 1969. Pp. 122–70.

Thurm, Marcella. *Exploring Black America: A History and Guide*. New York: Atheneum, 1975.

Transmitters: The Isolate Artist in America. Philadelphia: Philadelphia College of Art, 1981. Foreword by Elsa Weiner, preface by Marcia Tucker, essay by Richard Flood, dialogue by Michael and Julie Hall.

Turner, Lorenzo Dow. "African Survivals in the New World with Emphasis on the Arts." In *Africa as Seen by American Negroes*. Paris: Presence Africaine, 1958. Pp. 101–18.

Twining, Mary Arnold. "An Examination of African Retentions in the Folk Culture of the South Carolina and Georgia Sea Islands." Ph.D. dissertation, Indiana University, 1977.

Vlach, John M. "Phillip Simmons: Afro-American Blacksmith." In *Black People and Their Culture: Selected writings from the African Diaspora*, ed. Linn Shapiro. Washington, D.C.: Smithsonian Institution, 1976. Pp. 35–37.

———. "Graveyards and Afro-American Art." In *Long Journey Home: Folklife in the South*, ed. Allen Tullos. Double issue of *Southern Exposure* (Summer/Fall, 1977): 161–65.

————. "Slave Potters." *Ceramics Monthly* 26 (September 1978): 66–69.

————. *The Afro-American Tradition in Decorative Arts.* Cleveland: Cleveland Museum of Art, 1978.

————. "The Craftsman in the Communal Image: Phillip Simmons, Charleston Blacksmith." *Family Heritage* 2 (1979): 14–19.

————. "Black Creativity in Mississippi: Origins and Horizons." In *Made by Hand: Mississippi Folk Art*, ed. Patti Black. Jackson: Mississippi Department of Archives and History, 1980. Pp. 28–32.

————. "Arrival and Survival: The Maintenance of an Afro-American Tradition in Folk Art and Craft." In *Perspectives on American Folk Art*, Ian Quimby and Scott Swank, eds. New York: W. W. Norton, 1980. Pp. 177–217.

Wadsworth, Anna, ed. *Missing Pieces: Georgia Folk Art, 1770–1976.* Atlanta: Georgia Council on the Arts and Humanities, 1976.

Wahlman, Maude. "The Art of Afro-American Quiltmaking: Origins, Development and Significance." Bloomington: University of Indiana Press, in press.

Walker, Alice. *In Love and Trouble: Stories of Black Women.* New York: Harvest, 1979.

Welty, Eudora. *One Time, One Place.* New York: Random House, 1971.

Wiggins, William, Jr. "Religious Images and Afro-American Art." Proceedings of the First National Afro-American Crafts Conference and Jubilee. Memphis: Links, Inc., in press.

Wood, Peter H. *Black Majority: Negroes in Colonial South Carolina From 1670 Through the Stone Rebellion.* New York: Alfred A. Knopf, 1974.

Woofter, Thomas J. *Black Yeomanry: Life on St. Helena Island.* New York: Henry Holt and Co., 1930.

Yetman, Norman, ed. *Life Under the Peculiar Institution: Selections from the Slave Narrative Collection.* New York: Holt, Rinehart and Winston, 1970.

Jesse Aaron

*Jesse Aaron.*Palatka: Florida School of the Arts, 1980.

Purser, Mary. "If I Bring You a Piece of Wood, Would You Do a Carving?" *The Christian Science Monitor* (September 17, 1969): 17.

Purser, Stuart R. *Jesse J. Aaron, Sculptor.* Gainesville: Purser Publications, 1975.

Van Horn, Donald. "Carve Wood: The Vision of Jesse Aaron." *Southern Folklore Quarterly* 42 (1978): 257–270.

Wood Sculpture by Jesse J. Aaron. Gainesville: University Gallery, University of Florida, 1970.

Steve Ashby

Birchfield, Jim. "Folk Art or Inspired Toys?" *Piedmont Virginian* (April 18, 1973): 2, 4.
Hall, Michael.
Rhodes, Lynette I.
Rosenak, Charles. "A Visit with Steven Ashby," *The Clarion* (Winter 1981): 63.

David Butler

Bishop, Robert, and Koblentz, Patricia.
Fagaly, William A. *David Butler.* New Orleans: New Orleans Museum of Art, 1976.

Ulysses Davis

Kiah, Virginia. "Ulysses Davis: Savannah Folk Sculptor." *Southern Folklore Quarterly* 42 (1978): 271–86.
Wadsworth, Anna.

Sam Doyle

Trask, Fred. "Sea Islander Discovery." *Sea Islander* (Beaufort, S. C., July 4, 1969): unpaginated.

William Edmondson

Bishop, Robert. *Sculpture.*

Fuller, Edmund. *Visions in Stone: The Sculpture of William Edmondson.* Pittsburgh: University of Pittsburgh Press, 1973.

Hemphill, Herbert, and Weissman, Julia.

Le Quire, Louise. "Edmondson's Art Reflects His Faith, Strong and Pure." *Smithsonian* 12 (August 1981): 50–55.

Transmitters.

Will Edmondson's "Mirkels". Nashville: Tennessee Fine Arts Center at Cheekwood, 1964.

William Edmondson: A Retrospective. Nashville: Tennessee State Museum, in press. Includes essays by William Wiggins, John Vlach.

Woolsey, Bill. "Persistent Primitive." *The Nashville Tennessean Magazine* (December 14, 1947).

Woolsey F. W. "Edmondson's Visions in Stone." *Look* (October 21, 1952): 61–63.

"Works of Faith: The Stone Bird." *Harper's Bazaar* (December 1952): 77.

James Hampton

Bishop, Robert. *Sculpture.*

Blasdel, Gregg.

Conroy, Sarah. "Battered Tables, Broken Chairs . . . And a Vision." *Durham Morning Herald* (August 7, 1973).

Foy, James L. and McMurrer, James P. "James Hampton, Artist and Visionary." In *Psychiatry and Art*, Vol. 4. Basel: Karger, 1975. Pp. 64–75.

Geremia, Ramon. "Tinsel, Mystery, Are Sole Legacy of Lonely Man's Strange Vision." *The Washington Post* (December 15, 1964): C2.

Hartigan, Lynda. *The Throne of the Third Heaven of the Nations Millenium General Assembly.* Montgomery: Montgomery Museum of Fine Arts, 1977.

Hemphill, Herbert, and Weissman, Julia.

Horwitz, Elinor. *Folk Artists.*

Rhodes, Lynette.

Roscoe, Lynda. "James Hampton's Throne." In *Naives and Visionaries.* Minneapolis: Walker Art Center/New York: E. P. Dutton, 1974. Pp., 13–20.

Sigel, Barbara. "Glittering Garage was His Throne: The Late James Hampton's Tinfoil Treasure." *The Evening Star* (Washington, D. C., December 11, 1964): B-1.

Thompson, Toby. "The Throne of the Third Heaven of the Nations Millenium General Assembly." *The Washington Post Magazine* (August 9, 1981): 26–32, 36–37.

Sister Gertrude Morgan

Alexander, Wade. *God's Greatest Hits.* New York: Random House, 1970. Illustrations by Sister Gertrude Morgan.

Bishop, Robert. *Painters.*

Calas, Ted. "Sister Gertrude: Painting With Total Honesty." *Vieux Carre Courier* (New Orleans, May 8, 1970).

Cossit, F. D. "Sister Gertrude: Artist, Musician." *Richmond Times-Dispatch* (Nov. 26, 1972).

Donnelly, Sandi. "The Red Light Came On: She's Painting to Speak the Gospel in New Form." *The Times-Picayune* (New Orleans, December 12, 1972): Sec. 2, p. 2.

Everett, James. "Gospel Sung, Painted by Sister Gertrude." *Clarion Herald* (New Orleans, April 9, 1970).

Fagaly, William A. *Louisiana Folk Paintings.* New York: Museum of American Folk Art, 1973.

Hemphill, Herbert, and Weissman, Julia.

Horwitz, Elinor. *Folk Artists.*

Landrum, Lynn. "Sister Gertrude: Soul Saver Sings Sermons." *The Tulane Hullabaloo* (New Orleans, November 30, 1973): 7.

Mendes, Guy. "The Gospel According to Sister Gertrude Morgan." Unpublished manuscript, Versailles, Kentucky, 1974.

"Retired Street Preacher Gaining Fame as Naive Artist." *Sunday Advocate* (Baton Rouge, July 2, 1972): 3F. Unsigned.

Inez Nathaniel-Walker

Hall, Michael.

Horwitz, Elinor. *Folk Artists.*

"Self-Taught Artist Discovered in Prison." *Correctional Services News* 3 (Albany, August 1978) 5, 8. Unsigned.

Transmitters.

Leslie Payne

Lazarus, Jerry. "His Love Began at 1918 Show." *Richmond Times-Dispatch* (August 4, 1972).

Elijah Pierce

Almon, Leroy. "Elijah Pierce Story" *Maccabeus* 9 (August-September 1979): 9–11.

Bishop, Robert. *Sculpture.*

Blodgett, Richard. "Collectors Flock to Folk Art." *The New York Times* (September 12, 1976): D33.

Brewster, Todd. "Fanciful Art of Plain Folk." *Life* 3 (June 1980): 112–122.

Elijah Pierce: Painted Carvings. New York: Bernard Danenberg Galleries, 1972.

Elijah Pierce. Philadelphia: Pennsylvania Academy of the Fine Arts, 1973.

Garrett, Betty. "Elijah Pierce: Sculptor, Preacher, Barber." *Artnews* 73 (March 1974): 114–15.

Horwitz, Elinor. *Folk Artists.*

Jones, Carolyn. *Elijah Pierce: Woodcarver.* Columbus: Columbus Gallery of Fine Arts, 1973.

Kernan, Michael. "Piercing, Wondrous Woodcarvings." *The Washington Post* (March 21, 1976): G1.

Marty, Kathy. "Impressions of a Folk Artist: An Afternoon with Elijah Pierce." Journal of the Ohio Folklore Society, new series, 1 (1972): 29–36.

Moore, Gaylen. "The Vision of Elijah." *The New York Times Magazine* (August 26, 1979): 28–34.

"Sermons in Wood: Carvings of Elijah Pierce, an Ohio Barber, Win Acclaim of International Art World." *Ebony* (July, 1974): 67–74.

Transmitters.

Nellie Mae Rowe

Burnett, W. C."Vinings Artist Nellie Mae Rowe Draws Random Line, Gives Form to Memories That Crowd In." *Atlanta Journal Constitution* (December 14, 1978): 8B.

Haggerty, Michael. "Art and Soul" *Atlanta Weekly* (June 29, 1980): 16–19, 28–35.

Wadsworth, Anna.

Yarborough, Cathy. "All I Got Out There is Junk." *Atlanta Journal Constitution* (May 13, 1973): G1, 2.

James 'Son Ford' Thomas

Black, Patti C., ed.

Ferris, William, Jr. "If You Ain't Got It In Your Head, You Can't Do It With Your Hands: James Thomas, Mississippi Delta Folk Sculptor." *Studies in the Literary Imagination* 3 (1970): 89–101.

———."Vision in Afro-American Folk Art: The Sculpture of James Thomas." *Journal of American Folklore* 88 (1975): 115–32.

———. "Black Folk Arts and Crafts . . ."

———, ed. *Afro-American Folk Arts and Crafts.* Boston: G. K. Hall, in press.

O'Neill, Thomas. *Back Roads America: A Portfolio of Her People.* Washington, D. C.: National Geographic Society, 1980. Pp. 89–93.

Thompson, Robert Farris, and Cornet, Joseph.

Mose Tolliver

Bishop, Robert. *Painters.*

Sanford, Susan. "I Just Want to Paint my Pictures." *The Montgomery Advertiser/Alabama Journal* (February 8, 1981): 10C.

Transmitters.

Bill Traylor

Coker, Gylbert. "Bill Traylor at R. H. Oosterom." *Art in America* 68 (March 1980): 125.

Larson, Kay. "Bill Traylor." *The Village Voice* (January 7, 1980).

Rankin, Allen. "He Lost 10,000 Years." *Collier's* (June 22, 1946): 67.

Shannon, Charles. "The Folk Art of Bill Traylor." In *Southern Works on Paper: 1900–1950.* Atlanta: Southern Arts Federation, 1981. P. 16.

Wallis, Brian. "Bill Traylor." *Arts Magazine* 54 (May 1980): 25.

George White

Porterfield, Bill. "The Genius." *The Texas Observer* (November 1, 1974): 15–16.

Smither, Murray. *The World of George W. White, Jr.* Waco: Waco Creative Art Center, 1975.

George Williams

Black, Patti C., ed.

Luster Willis

Black, Patti C., ed.

Ferris, William, Jr. "Black Folk Arts and Crafts . . ."

———, and McCallum, Brenda.

Joseph Yoakum

Chapin, Louis. "A 'Naive' Artist Views the World." *The Christian Science Monitor* (December 11, 1972): 8.

Halstead, Whitney. "Joseph Yoakum." Unpublished manuscript, collection of Department of Prints and Drawings, Art Institute of Chicago.

Hayden, Harold. "Eighty Year Old is New Kind of Primitive." *Chicago Sun Times,* (April 7, 1968).

Joseph E. Yoakum. New York: Whitney Museum of American Art, 1972. Essay by Whitney Halstead.

Joesph E. Yoakum: Chicago's Own Primitive. Chicago: Edward Sherbeyn Gallery, n.d.

Mark, Norman. "My Drawings Are a Spiritual Unfoldment." *Chicago Daily News: Panorama* (November 11, 1967).

Transmitters.

PHOTO CREDITS

All photographs by Joel Breger unless otherwise noted.

Melinda Blauvelt: pp. 2–3: The yard of Nellie Mae Rowe's home in Vinings, Georgia, c. 1970; pp. 52–53: Sam Doyle displays his paintings against a shed near his home in Frogmore, South Carolina, to attract the attention of passersby; pp. 71, 81, 123; pp. 168–169: The interior of Ulysses Davis's barber shop, Savannah, 1981.

Courtesy of Jym Knight: pp. 12, 32, 86, 90, 91.

Courtesy National Gallery of Art: p. 25.

Courtesy Art Institute of Chicago: p. 26.

Courtesy Abby Aldrich Rockefeller Folk Art Center: p. 27.

Courtesy University Museum, Philadelphia: p. 28.

Courtesy Yale University Art Gallery: p. 29 left.

Courtesy Mrs. William Bascom: p. 29 center.

Courtesy Metropolitan Museum of Art: p. 30.

Courtesy Smithsonian Institution: p. 33.

Courtesy Museum of Fine Arts, Boston: p. 35.

Courtesy Milwaukee Art Museum: p. 36.

Edward Weston, Courtesy Weston Gallery: p. 40.

Robert Jones: pp. 41, 42 top, 111, 112 top.

Joshua Horwitz: pp. 42 bottom, 43.

Courtesy National Museum of American Art: pp. 45, 92, 93, 94, 95, 149.

Guy Mendes: pp. 46, 97.

Courtesy Stuart Purser: p. 55.

Courtesy Ken Fadeley: p. 59.

Courtesy William Fagaly: p. 65.

John Beardsley: p. 66.

Courtesy David Kargl: p. 77.

Louise Dahl-Wolfe: p. 87.

Courtesy Michael and Julie Hall: p. 105.

Courtesy John Freimarck: p. 112 bottom.

Jeff Wolf: p. 117.

Courtesy Columbus Museum of Art: p. 119.

Courtesy Judith Alexander: p. 122.

William Ferris, Courtesy Center for Southern Folklore: pp. 129, 157.

Jerry Welch: p. 133.

Scott Photographic Services: p. 136.

Charles Shannon: p. 139.

Courtesy Delahunty Gallery: pp. 147, 150.

Roland Freeman: pp. 153, 154.

Courtesy Christina Ramberg: p. 163.

Library of Congress Catalogue Number 81-24072
ISBN 0-87805-158-9 AACR2

Black Folk Art in America 1930-1980

This book was set in Trump Medieval by
Monotype Composition Company, Baltimore, Maryland,
printed by Schneidereith and Sons, Baltimore, and
bound by Murphy-Parker, Philadelphia, Pennsylvania.

Book design by Alex and Caroline Castro.